A GUIDE *TO* HISTORIC
St. Augustine
FLORIDA

A GUIDE *TO* HISTORIC
St. Augustine
FLORIDA

STEVE RAJTAR & KELLY GOODMAN

Charleston · London
History
PRESS

Published by The History Press
Charleston, SC 29403
www.historypress.net

Cover art: Bayfront St. Augustine, from an original painting by Judy Lavoie
(www.judy-lavoie-art.com) © 2003 St. Francis Inn.

First published 2007

Manufactured in the United Kingdom

ISBN 978.1.59629.336.6

Library of Congress Cataloging-in-Publication Data

Rajtar, Steve, 1951-
A guide to historic St. Augustine, Florida / Steve Rajtar.
p. cm.
Includes bibliographical references and index.
ISBN-13: 978-1-59629-336-6 (alk. paper)
1. Saint Augustine (Fla.)--History. 2. Saint Augustine Region
(Fla.)--History. 3. Historic sites--Florida--Saint Augustine. 4. Historic
buildings--Florida--Saint Augustine. 5. Architecture--Florida--Saint
Augustine. 6. Neighborhood--Florida--Saint Augustine. 7. Saint Augustine
(Fla.)--Buildings, structures, etc. 8. Saint Augustine (Fla.)--Tours. 9.
Saint Augustine Region (Fla.)--Tours. 10. Walking--Florida--Saint
Augustine--Guidebooks. I. Title.
F319.S2R24 2007
975.9'18--dc22
 2007023335

Contents

PART TWO: WALKING TOURS

Introduction

The story of St. Augustine is actually the story of several cities. In a small geographic area between Jacksonville and Daytona Beach, Florida, are a typical early 1900s city (called the North City); an ambitious but aborted 1920s Mediterranean Revival development near a nineteenth-century neighborhood of winter cottages (Anastasia Island); a settlement begun by freed slaves with many large Victorian homes (Lincolnville); a late nineteenth-century development with a variety of styles (West St. Augustine); and the well-known Ancient City.

In addition to its various phases of destruction and rebuilding, today's Ancient City, the "downtown" of the city with a population of about fourteen thousand, has experienced several distinct historical periods:

1565–1763	first Spanish colonial period
1763–1784	British colonial period
1784–1821	second Spanish colonial period
1821–1845	U.S. territorial period
1845–	U.S. state

Each historical period had its own culture, government, architectural styles and societal structure. At the beginning of the first Spanish colonial period, nearly the entire native population was removed and replaced by Spanish colonists. At the start of the British colonial period, only a handful of the Spanish population was allowed to remain, and the homes and businesses were emptied so that new British colonists could occupy them and modify the structures to suit their needs.

The Spanish repopulated the city at the beginning of the second Spanish colonial period, with the ouster of the British. When Florida became a part of the United States, much of the population was again removed and replaced with a new contingent of residents. This trend was somewhat unique to St. Augustine and adds an interesting dynamic to its rich history.

The streets and structures of St. Augustine show the varied styles preferred by its changing population. On the same street, one may find an original second Spanish colonial period home near a British home near a modern home, all near others that bear a combination of styles resulting from modifications made by a succession of owners.

This book is a comprehensive guide to St. Augustine's rich history, paired with detailed walking tours through some of the city's most fascinating boroughs. You can follow the suggested routes or just wander through the Ancient City and discover your own favorite parts of our nation's oldest city.

Highlights of St. Augustine History

The 1510s

Ponce de León

In April of 1513, while on an expedition to find Bimini, Juan Ponce de León arrived on the east coast of a land that he named La Florida and claimed on behalf of Spain. He did not stay long, but did discover the existence of the Gulf Stream, which could be used in returning to Europe.

The 1560s

René de Laudonnière

In 1564, a French expedition to the New World, led by Captain René de Laudonnière, had a goal of establishing a colony and landed at the present harbor of St. Augustine, at the time called the River of Dolphins. He then headed north with his three hundred colonists to the mouth of the St. Johns River and in June of 1564 established Fort Caroline for France.

Founding of St. Augustine

As a teenager, Don Pedro Menéndez de Avilés y Alonso de la Campa joined a fleet to fight the Barbary pirates. Later, King Philip (Felipe) II of Spain appointed him as the captain-general of the Indies fleet and sent him to the New World in 1565 to conquer and colonize Florida. He sailed from Cádiz with about 2,650 men aboard thirty ships, but because of a storm only 600 men aboard five ships made it as far as Puerto Rico. Menéndez headed to Florida and sighted its coast on August 28, the feast day of St. Augustine, Bishop of Hippo and the patron saint of Avilés, which was the home city of Menéndez.

Menéndez headed north and encountered the small fleet of Jean Ribault of France. After Menéndez threatened to kill all the non-Catholics, the French set sail. Menéndez returned to St. Augustine, and on September 8 formally claimed the land for Spain. A settlement was set out in an area that had been the Saturiba Timucuan village of Seloy, and its chief presented his home as a gift to the Spaniards. Earth embankments were constructed around it and eighty cannon were placed for defense. A 14-foot-wide moat surrounded what had been turned into a fort. The site of the landing of Menéndez is marked by a 208-foot stainless steel cross at the Mission of Nombre de Dios.

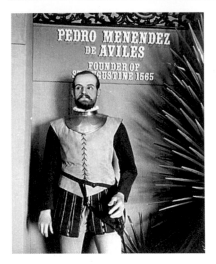

Pedro Menéndez

Shown here in a 1959 photo is a wax sculpture of Pedro Menéndez de Avilés, whose expedition in 1565 resulted in the founding of St. Augustine. The sculpture is on display in Potter's Wax Museum. *Courtesy of the Florida Photographic Collection.*

THE HUGUENOTS

Menéndez headed back north to the area near present-day Jacksonville and destroyed the 1564 Fort Caroline, killing most of the French Huguenot (Lutheran) inhabitants including those who attempted to surrender to the Spaniards. The French who had put to sea to avoid a confrontation with Menéndez, including Captain Ribault, were wrecked by a hurricane, and those who made it to shore near present-day Ponce Inlet and walked north to Anastasia Island were taken prisoner. All were killed, except for a scant few who claimed to be Catholics. The killing of the nearly two hundred Lutherans, known as a *matanza* ("slaughter"), is memorialized in the name of the river which passes by St. Augustine, the Matanzas.

Menéndez was recalled to Spain in 1572 to command an armada to rid the Flanders coast of pirates. In his place, his nephew, Pedro Menéndez Marqués, took command of the St. Augustine fort. Don Pedro Menéndez died on September 17, 1574, from a fever. He is buried in the San Nicolás Church in Avilés.

MISSION OF NOMBRE DE DIOS

The first Catholic mission in the area was founded with the name of Nombre de Dios ("Name of God"). The first Catholic Mass was conducted on this site by Father Francisco López de Mendoza Grajales. The parish of today's Cathedral of St. Augustine dates its beginning to that Mass on September 8, 1565, making it the oldest Catholic parish in the United States.

EARLY FORTS

The first fort, believed to have been a fortified house previously belonging to the chief of an Indian village, was located on today's site of the Shrine of Nuestra Señora de la Leche and the Fountain of Youth. It was burned by the Timucuans in April of 1565, about seven months after its construction. During 1566, a second fort was built on Anastasia Island, and the city moved with it. A third fort was built on the mainland during 1566, followed by a fourth in 1571 and a fifth in

1579. In 1586, the sixth fort was erected and called San Juan de Pínas, but it was destroyed that same year by Francis Drake.

In July of 1586, it was rebuilt as the seventh fort, called San Marcos. A stone powder magazine was added to the wooden fort a decade later. The eighth fort was built in 1604, followed by the ninth in 1653. The tenth and final fort, the Castillo de San Marcos, was built in 1672–95.

THE 1570s

TOWN LAYOUT

In 1573, King Philip II of Spain established regulations (the "Leyes de Las Indies") for the layout of new towns, and they affected what we now find in St. Augustine. The main feature of the town was to be a plaza, near the landing if the town was near the coast, and from the plaza the streets would run outward.

The plaza's corners were to face the four principal winds, thereby protecting the streets coming from the plaza from the winds' unpleasant effects. The plaza was to be reserved for church and government use, and no lots on the plaza were to be privately owned.

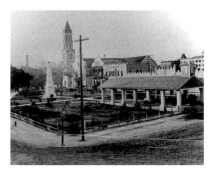

Plaza de la Constitución
This photo from the 1880s shows St. Augustine's plaza, the central park set out according to Spanish rules promulgated more than three hundred years earlier. It was required to be at least one and a half times longer than its width if it was to be a venue for fiestas that used horses. *Courtesy of the Florida Photographic Collection.*

Houses in the town were to face where they could enjoy the north and south winds. They were to be arranged so that they could double as defense barriers and all reflect the same architectural style. Yards and corrals for horses and other work animals were to accompany the homes. The cathedral was supposed to be visible from the ocean and usable in the defense of the town.

INDIAN ATTACK

During 1577, the town of St. Augustine was destroyed during an Indian attack. It was rebuilt by the settlers.

THE 1580S

FRANCIS DRAKE

Sir Francis Drake in 1585 commanded an English expedition to the West Indies while England and Spain were at war. The following year, Drake arrived at St. Augustine with two thousand men aboard forty-two ships and landed at Anastasia Island. He intended to attack the following morning, but that night the Spanish left their octagonal fort, abandoning their armament and money. Drake crossed the river, took the valuables and destroyed the fort.

Drake's sergeant major was shot and killed by a Spaniard,

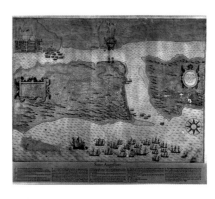

Attack by Drake
In 1589, this map was prepared by Baptista Boazio of Italy to illustrate the attack on St. Augustine by the fleet of Sir Francis Drake. It is part of a series that appeared in a book about Drake's expedition to the West Indies, authored by Walter Bigges. *Courtesy of the Florida Photographic Collection.*

so as revenge Drake burned down the town and destroyed the gardens. After the English sailed away, the Spanish returned and rebuilt the earth and wooden fort, the seventh in a series of fortifications to protect St. Augustine, and named it San Marcos.

THE 1590S

GOVERNOR MENDÉZ DE CANZO

In June of 1597, Governor Gonzalo Mendéz de Canzo arrived in St. Augustine and brought with him several varieties of seeds, including the Granada orange. He laid out the town plaza, known as the Plaza de Armas (renamed the Plaza de la Constitución in 1813), and established an official system of weights and measures.

With him came Spanish civil officials, tradesmen, soldiers, settlers and Father Richard Arthur, an Irish diocesan priest. He was confirmed as pastor of St. Augustine on February 10, 1598. Arthur served until he died in 1606. He was the first parish priest to serve in what became the United States, and he was the sole ecclesiastical judge for all of Florida.

Eventually, some in Spain urged their king to abandon St. Augustine, but the governor advised against it. He saw it as a haven for shipwrecked individuals, a base for exploration of North America

and an opportunity to convert the natives to Christianity. Later, the English established a colony at Jamestown and Spain had to continue to support St. Augustine in order to keep its foothold along the Atlantic Coast.

DISASTERS

St. Augustine finished out the century with a pair of damaging events during 1599. Much of the town was devastated by fire, which was later followed by a tsunami.

THE 1630s

CONFLICT WITH APALACHEES

During 1638, the Spanish fought and conquered the Apalachee Indians, who lived west of the Suwannee River. By 1640, many had been taken prisoner and forced to work in St. Augustine. Their labor was utilized in public works projects, especially the strengthening of its fortifications.

THE 1660s

SPANISH QUARRIES

On Anastasia Island, within the boundaries of the present Anastasia Island State Recreation Area, were the Old King's Quarries. There, a native shellac called scouring was cut into blocks, which were then ferried across the river to St. Augustine. That material was used in the construction of the Castillo de San Marcos and several other buildings in the city. On the island were also coquina quarries, where a type of limestone composed of donax shells and sand was found.

One of the quarries was filled in during the 1920s to serve as a playing field. Later, the R.B. Hunt Elementary School was built there near the intersection of State Route A1A and Old Beach Road.

Across the road from the quarries are a well and a chimney ruin, likely belonging to the home of a Spanish quarry overseer, the master masons and stonecutters. The overseer at the time of the construction of the Castillo was Alonso Diaz Majia. The quarries were added to the National Register of Historic Places on February 23, 1972.

LOOTING BY PIRATES

In 1668, St. Augustine was looted by freebooter Captain John Davis of England, also known as Robert Searles, who brought seven or eight ships from Jamaica to attack the Spanish fleet as it headed back to Europe with treasure from Mexico. His timing was off and he missed

the fleet, so he continued up the Florida coast to St. Augustine where he sacked and plundered the town. Sixty residents of St. Augustine were killed. The activities of Davis, and those of other British contingents, helped motivate the Spanish to construct the Castillo de San Marcos beginning in 1672.

CASTILLO DE SAN MARCOS

In 1669, the construction of a stone fortress to protect St. Augustine was authorized by Queen Regent Mariana of Spain. Construction began in 1672. Following attacks by pirates and others and faced with expected colonization attempts by the British, the Castillo de San Marcos needed a building material stronger than that used in the previous wooden forts. Coquina ("little shells"), a soft limestone made from crushed shells and coral, was chosen as the primary building material, largely because it was accessible from nearby Anastasia Island. Rock was quarried and roughly hewn, then carried by boat to the open area just south of the fort where Cuban stonemasons cut it into blocks. These blocks were then used with mortar made from baked oyster shells, sand and water to build the walls. Construction was completed in 1695.

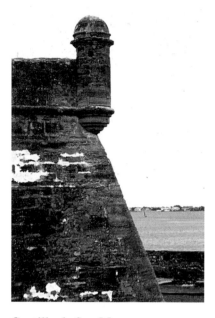

Castillo de San Marcos
This is a corner of the fort which faces the water, giving guards a panoramic view of any possible attack by ship. The walls and the corner tower strongly resemble those of Fort San Felipe del Morro, construction of which began in San Juan, Puerto Rico, in 1539. *Courtesy of the Florida Photographic Collection.*

During the Siege of 1702, the Castillo provided shelter for approximately 1,500 people. Cannonballs launched by British cannon did no damage, as they were absorbed by the soft coquina. The heavy cannonballs merely became part of the Castillo's twenty-six-foot-tall walls.

A major modification of the Castillo began in 1738 when interior rooms were moved into the fort's courtyard, and enlarged and vaulted ceilings were built to protect the rooms from bombs that might fall on the roof. Heavy guns in the corner bastions were supplemented by garrison guns stationed along the entire perimeter of the gun deck. The walls were increased in height to thirty-three feet. As they had in

1702, the Castillo's walls withstood the attack by General Oglethorpe in 1740.

Although construction of the Castillo had been completed sixty-one years before, engineer Don Pedro de Brazos y Garay in 1756 claimed credit for finishing it. There is still a plaque permanently affixed to the fort announcing de Brazos's supposed accomplishment.

In 1763, control of the city and the Castillo was transferred by the Spanish to the British, who renamed the facility Fort St. Mark. The British also allowed the fort to deteriorate until the Revolutionary War motivated them to repair, improve and modify it, turning it into an up-to-date military facility. Living quarters were expanded and the fort's well was improved. The fort was returned to Spanish control in 1784.

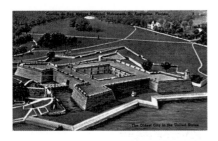

Castillo de San Marcos
This 1947 postcard shows the fort essentially as it appeared in 1821, when it was taken over by the United States. Through the south wall (on the left in this image) is a tunnel that meets up with a drawbridge crossing a moat. It is the oldest standing fort in the continental United States. *Courtesy of the Florida Photographic Collection.*

The Spanish resurrected the name of the Castillo de San Marcos and continued the repairs and improvements that had been started by the British. In 1821, Spain transferred the Castillo to the United States, which renamed it Fort Marion in honor of General Francis Marion, known as the "Swamp Fox" during the Revolutionary War. The next round of modifications included the transformation of old storerooms into prison cells that were used during the Second Seminole War, the 1842–43 reconstruction of the moat on the eastern side as a water battery within the American coastal defense system and the improvement of the sloping land around the fort to slow down attacking ground forces.

During the Civil War, Fort Marion started out as a Union installation before it was turned over to the Confederates in 1861. They removed its artillery, making it easy for the fort to be retaken by Union soldiers in 1862. Thereafter, Fort Marion's chief use was as a prison for Native Americans and U.S. deserters during the Spanish-American War.

Fort Marion ceased to be an active military base in 1900 but continued under the jurisdiction of the Department of War, and in 1924 was designated as a national monument. The National Park Service took over the maintenance and operation of the fort in 1933. In 1942, the fort's name was officially changed back to the Castillo de San Marcos.

The Castillo is the most perfect example of Spanish military architecture in North America, rivaled only by the fort in San Juan, Puerto Rico. It cost more than 138,000 pesos ($218,630) to build.

The Castillo was added to the National Register of Historic Places on October 15, 1966.

Some believe that the Castillo is haunted by the ghosts of Spanish Colonel Garcia Martí's wife, Dolores, and that of the colonel's assistant, Captain Manuel Abela. According to legend, they had an affair in 1784 and disappeared after their romance was discovered by Martí. On July 21, 1833, two skeletons were found in a hollow section of wall in the Castillo's dungeon; they might be the two missing lovers.

The 1680s

More Pirates

In 1683, English pirates sailed north from Mosquito Inlet in an attempt to raid St. Augustine, but they were unsuccessful. Three years later, English freebooter Nicholas Agramont attacked, but the city was successfully defended by Captain Antonio de Arguelles.

Black Refugees

Beginning in 1686, the Spanish government in St. Augustine announced that escaped slaves from the British colonies to the north would be welcome in the city. The following year, a group of eleven arrived. In 1693, King Charles II made the policy official with a royal proclamation, and by 1738, the number of black refugees increased to more than a hundred. These refugees erected Fort Mose north of downtown St. Augustine.

The 1690s

Sea Wall

In 1690, Florida's governor, Don Diego de Quiroga y Losada, proposed the construction of a sea wall to protect the fort and town from erosion. It extended from the Castillo approximately to the Plaza de la Constitución and roughly followed the course of Avenida Menendez, or Bay Street. Much of that roadway was constructed on top of the sea wall. In 1837–43, another sea wall was constructed farther to the east and soil was brought in to fill the gap from the natural shoreline to the sea wall constructed in the shallow Matanzas River, extending the land area of the city.

The section of sea wall protecting the city from the Matanzas River between the St. Francis Barracks and King Street was built between 1833 and 1844 by the U.S. Army Corps of Engineers and slave labor. It was made with coquina quarried on Anastasia Island and was topped by granite from Connecticut and Pennsylvania. Much of the

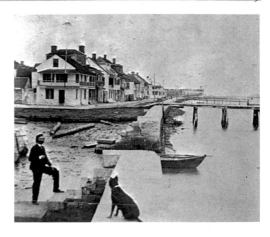

Sea Wall
This mid-1870s photo of St. Augustine's sea wall includes photographer George Pierron. He and Charles Seaver Jr., W.H. Cushing and J.N. Wilson formed the Florida Club, a business cooperative for photographers. *Courtesy of the Florida Photographic Collection.*

work was performed by graduates of West Point, where the country's first engineering school was established. The sea wall was one of the first federally funded projects in Florida.

THE 1700S

SIEGE OF 1702

During Queen Anne's War, or the War of the Spanish Succession, in 1702 South Carolina's governor, James Moore, brought about five hundred soldiers and three hundred Native Americans to St. Augustine. The Spanish inhabitants moved into the Castillo for protection, while the British led by Colonial Robert Daniel traveled by land and captured the essentially abandoned town. Those who arrived by sea, including Moore, unsuccessfully attacked the fort and laid siege to it for three months. Having made no major impression on the Spanish, Moore and his men went back to South Carolina upon the arrival of a Spanish relief fleet from Havana, after first plundering and burning down the town.

The Spanish reacted in 1704 by building the defensive Cubo Line, a log wall to protect the city and mark the northern boundary of St. Augustine. It was made of palm logs and mud and ran from the San Sebastian River eastward to the Castillo, and a moat was dug immediately north of it. Farther north was the Hornwork, an earthen embankment just south of a water-filled ditch, in which opened a single gate.

LAND DEFENSES

During the 1700s, several earthen walls were constructed to protect the city from attacks by Native Americans and enemy armies. The major ones were, from north to south:

Cubo Line

Several walls were constructed around the perimeter of St. Augustine to help defend the city from attackers who might arrive by land. Shown here in a 1950s photo is a replica of a portion of the Cubo Line that connected the Castillo and the San Sebastian River beginning in 1704. *Courtesy of the Florida Photographic Collection.*

Moze Wall—a line that was built in 1762 from Fort Mose southwesterly to a ford on the San Sebastian River.

Hornwork—first constructed in about 1706 from river to river, north of the Castillo. Major improvements were made to it in 1746 and 1776.

Tenaille—built in 1791 from the west end of the Hornwork to the west end of the Cubo Wall, along the east bank of the San Sebastian River.

Cubo Line (or *Cubo Wall*)—built in 1704 from the Castillo westward to the San Sebastian River. It included the City Gate. Major modifications and improvements were made in 1718, 1735, 1773, 1797, 1808 and 1819.

Rosario Line (or *Rosario Wall*)—built in 1718 from the Cubo Line southward 3,575 feet along the east bank of the Maria Sanchez Creek, then eastward to the Matanzas River. The earthworks were reinforced with stone in 1761 and were further improved in 1720, 1740 and 1776.

THE 1710S

CREEK REVOLT

The Creek natives in the Carolina Colony revolted against the English in 1717, and over the next ten years approximately one thousand Creeks and Yamasees resettled in ten villages located near St. Augustine. These villages included Palica, in today's Lincolnville; Nuestra Señora del Rosario de la Punta, south of the St. Francis Barracks; and Nuestra Señora de Guadalupe de Tolomato and Nuestra Señora de la Leche, both in the North City.

The La Punta site was made up of about twenty farmsteads and a mission church and was occupied for about thirty years beginning in the late 1720s. A cemetery for the community of forty to sixty people has been recently excavated at the intersection of Marine and Tremerton Streets. It has been estimated that the remains of about a hundred Native Americans occupy this cemetery.

ORANGES

As early as 1717, St. Augustine was a major port for the shipment of oranges to Charleston, and shipments to Philadelphia, New York

and other British ports peaked during the 1730s. The first crop likely was the result of seeds brought to the New World by Christopher Columbus in 1493. South Carolina began cultivating oranges during the 1730s, followed by Georgia in the 1760s, which reduced the demand for Florida fruit.

THE 1720S

JOHN PALMER

In 1728, Colonel John Palmer marched south to attack St. Augustine but was stopped at the City Gate. He burned the chapel of Nombre de Dios, which was later rebuilt a little to the south behind the protective Hornwork.

THE 1730S

FORT MOSE

In 1738, Fort Mose, also known as Fort Moosa, Fort Mosa and the Negro Fort, was established north of the city on the former site of the Indian village of Macarizi as the first settlement of free black men. Initially called Gracia Real de Santa Teresa de Mose, the original inhabitants had fled slavery in the Carolinas. They were granted freedom by the Spanish in Florida in exchange for their conversion to Catholicism and enlistment in the Spanish militia. The fort, located about two miles north of downtown, was constructed of logs and earth. Inside the walls were thatched huts. About one hundred people lived there and farmed the surrounding lands. The first fort was destroyed in 1740.

A second Fort Mose was built in 1752 on higher ground a little to the northeast of the first site, and it included a church and priest's house, homes and a lookout tower. The fort was occupied by former slaves until 1763, when Florida once again became British. Most of the Fort Mose residents soon moved to Cuba to avoid being returned to slavery or otherwise punished. The British took over the fort and destroyed a portion of it in 1775. From 1783 to 1821, Florida was once again Spanish and the fort site was occupied by Minorcan farmers. In 1821, the fort site was taken over by a group who favored the United States, and then it was briefly retaken by the Spanish before being burned down for the final time.

The site of the two forts is today protected as a historic state park consisting mostly of tidal marsh. Visitors can see the site by walking along the seven-hundred-foot-long boardwalk completed in 2001. Future plans include interpretive kiosks, more parking and a visitors' center.

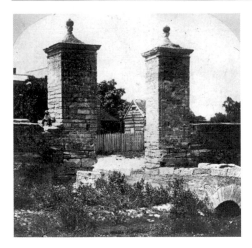

City Gate
This is the City Gate as it appeared on March 16, 1871. It is believed by some to be haunted by a ghost named Elizabeth, age thirteen or fourteen, who during a yellow fever epidemic died near the gate. Often, the police department receives calls reporting a girl in a white dress standing by the gate and waving to cars late at night. *Courtesy of the Florida Photographic Collection.*

CITY GATE

In 1739, a city gate was erected to protect St. Augustine from an invasion by land. In 1808, royal engineer Manuel de Hita added the present pillars. The gate was an opening in the Cubo Line that could have been closed or otherwise blocked to provide an unbroken barrier along St. Augustine's northern boundary.

THE 1740S

SIEGE OF 1740

In 1740, during the War of Jenkin's Ear between Spain and England, Georgia Governor James Edward Oglethorpe brought about two thousand soldiers to attack St. Augustine. His orders were to either destroy the main fort or station British soldiers and Native Americans in it so that it could not be retaken by the Spanish. The inhabitants of Fort Mose were evacuated to the city, and Oglethorpe easily captured that fort before stopping on Anastasia Island to begin a siege of Castillo de San Marcos. From Fort Mose, the British troops attacked Spaniards who went outside the city walls to find horses and food. The Spanish recaptured Fort Mose on June 26, 1740, but it was destroyed in the fighting and the nearby black community was abandoned for twelve years. After thirty-eight days, Oglethorpe gave up the unsuccessful siege of the Castillo and returned to Georgia.

The ongoing war resulted in privateering in and near St. Augustine's harbor, with both Spanish and English sailors taking the ships and cargo of their respective enemies. To retaliate for the 1740 siege, the Spanish marched north to attack in 1742, hoping to destroy the British stronghold in Fernandina. The Spanish troops were routed on July 7 of that year and returned to St. Augustine.

James Oglethorpe

This photo is a mezzotint produced by T. Burford in about 1743. It depicts Georgia Governor James Edward Oglethorpe whose most renowned campaign against St. Augustine was a thirty-eight-day siege in 1740. Although he failed to capture the Castillo, the siege resulted in the destruction of a significant portion of the city. *Courtesy of the Florida Photographic Collection.*

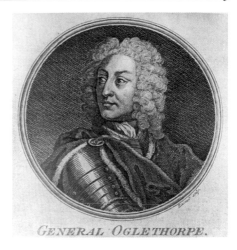

GENERAL OGLETHORPE.

FORT MATANZAS

This small fort was built in about 1742 approximately eighteen miles south of the Castillo to protect the "back door" approach to St. Augustine from the south. Before the fort was built, there had been a watch station for many years to protect St. Augustine from a river attack from the south. The coquina fort was designed by engineer Pedro Ruiz de Olano. Five pre-sighted cannon were mounted in 1750, and two which were

Fort Matanzas
The small fort is located on Rattlesnake Island in the Matanzas River, near the Matanzas Inlet at the south end of Anastasia Island where Jean Ribault and his sailors were massacred in 1565. "Matanzas" is Spanish for "massacre." *Courtesy of the Florida Photographic Collection.*

placed there in 1793 remain today. The fort was restored in 1900, declared a national monument in 1924 and added to the National Register in 1966.

THE 1760S

TREATY OF PARIS

As a result of the Seven Years' War (also known as the French and Indian War), which was officially ended by the Treaty of Paris in 1763, Florida was transferred by Spain to England in exchange for Cuba and the Philippines. The Castillo was conveyed by Governor Melchor Feliú to Captain John Hedges. Major Francis Ogilvie arrived from Cuba and assumed command. Florida was divided into eastern

and western portions with capitals of St. Augustine and Pensacola. The Spanish left St. Augustine in 1764, according to a treaty provision requiring their departure within eighteen months.

Many Spanish homes were left vacant or sold to British soldiers or immigrants. Other Spanish owners transferred their property to a secret trust managed by Jesse Fish, who had moved to St. Augustine in 1735 and resided on Anastasia Island. During the British colonial period, Fish was one of St. Augustine's most prosperous residents.

The Bartrams

In 1765, King George III appointed John Bartram royal botanist in the American colonies. His son, William, joined him on an expedition to gather plants and seeds in Florida.

They arrived in St. Augustine on October 11, 1765. In his journal, John described the area's plants, including oaks, magnolias, sweet gum (which he referred to as liquid-amber), purple-berried bay and chinquapin. In 1766, John returned to Philadelphia and William remained in Florida to run a plantation north of Picolata where he raised indigo and rice. After a few months, William returned to St. Augustine to work as a surveyor, and then moved back to Philadelphia in 1767.

Governor Grant's Plantations

Governor James Grant of British East Florida founded Grant's Villa Plantation in 1768 where the Guana and North Rivers join. Slaves cleared a tract of 1,450 acres and planted it in indigo, a blue dye that was exported to England. Indigo was East Florida's largest crop at the time, and Grant's plantation was the most productive. Indigo ceased to be lucrative by the 1780s.

A second plantation was established in 1781 to the north of the first, at the headwaters of the Guana River. Known as the Mount Pleasant Plantation, it included a pair of slave-constructed dams that enclosed a rice field of 220 acres. One dam kept out the salt water, and the other formed a freshwater reservoir.

Both plantations were abandoned in 1784 as a result of Spain's return to Florida. The slaves were taken to the Bahamas where they were sold to South Carolina rice planters.

St. Francis Barracks

Franciscan monks built a church, convent, monastery and other buildings with logs in about 1588. They were burned on March 14, 1599, and rebuilt in 1610. The new structure was called St. Helena and the Convent of the Immaculate Conception. The church was burned again by Colonial Robert Daniel in 1702. It was rebuilt with the same dimensions—fifty-six yards long, six yards wide and six yards tall.

By 1737, a chapel with a palmetto roof was completed. The rest of the complex was built after 1755. In 1764, Governor James Grant

took over the monastery, using it to serve as quarters for British officers. Other troops occupied the church, which was then called the Convento de San Francisco.

In 1769–71, the church was enlarged to approximately 15,800 square feet. Each of its eight rooms accommodated a company of soldiers and it was given the name of St. Francis Barracks. When the Spanish army reoccupied the town in 1783, they took over the barracks for themselves. The barracks were partially rebuilt during 1792, including the portion on the land now comprising the National Cemetery. The remainder continued as Spanish barracks until 1821, when the area was turned over to the United States.

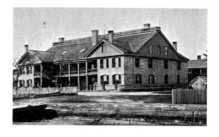

St. Francis Barracks
After serving as a Spanish church and British army barracks, this building passed to the United States in 1821. Soldiers occupied it as an artillery post and for a time it was the home of orphans and nuns of the Sisters of St. Joseph. It appears here in an 1870s photo, decades before it became Florida's military headquarters. *Courtesy of the Florida Photographic Collection.*

Beginning in 1907, the facility was leased to the state for use by the National Guard. A major fire gutted the building on December 13, 1915, but some of the walls were saved and remain in today's rebuilt structure. The St. Francis Barracks were reconstructed and renovated beginning in 1921 utilizing the plans of architect Francis A. Hollingsworth.

TURNBULL PLANTATION

Dr. Andrew Turnbull of Scotland and his partner, Sir William Duncan, each received a grant of land along the east coast of Florida, but the English government stipulated that the land had to be settled within ten years. Partially because Turnbull's wife, Maria Gracia Dura Bin, was of Greek ancestry and

Andrew Turnbull
In 1768, Dr. Turnbull established a large plantation at the location of today's city of New Smyrna Beach. It experienced limited success, and the indentured servants working there rebelled because of broken promises and poor living conditions. The plantation was terminated in 1777 and its residents settled in St. Augustine. *Courtesy of the Florida Photographic Collection.*

came from Smyrna, he decided to recruit his settlers from Greece. He chose land south of St. Augustine and named it New Smyrna and intended to raise indigo, cotton and other products.

From Greece, he went to Minorca and left there with 1,403 colonists from the eastern Mediterranean region on March 28, 1768. They were indentured servants and were promised land ownership after a fixed number of years spent working for Turnbull. The number of colonists had been reduced to 1,255 by the time they reached St. Augustine on June 26. From there, they headed to New Smyrna where they were surprised by the lack of preparation for a large group and the region's swampland, alligators, mosquitoes and poisonous snakes. Many of the settlers rebelled and on August 19 captured a supply ship.

A trial was held for three rebels in January of 1769, and one of the defendants was spared when he carried out his sentence of executing the other two. In the early 1770s the plantation began to be productive, but living conditions were still deplorable. The colonists had satisfied their term of indenture, but received neither land nor freedom. In 1774, Patrick Tonyn became the new governor of East Florida, and the settlers agreed to ask for his help.

Three settlers, including Juan Genopoly (Ioannis Gianopoulos), escaped in March of 1777 and walked and swam to St. Augustine to plead for Tonyn's help. Another ninety walked the seventy-five miles in April to explain the problems. During May and June, they were followed by another six hundred, and on July 17 all of the colonists were set free by Governor Tonyn, Turnbull's political and personal enemy, while Turnbull was away in England. On November 9, 1777, the plantation ceased to exist when the last man remaining, Father Pedro Camps, who had stayed behind to care for those ill with or recovering from malaria, moved to St. Augustine. Minorcans settled north of the Plaza de la Constitución in an area known as the Greek Quarter, the Minorcan Quarter, the Quarter of the Mahonese or simply the Quarter. It was roughly bounded by Cuna Street, the Cubo Line, the Rosario Line and Avenida Menendez.

KING'S ROAD

In 1767, King's Road, constructed by British engineers, was opened from St. Augustine to the St. Marys River north of Jacksonville. The section south from St. Augustine to the Turnbull plantation followed a route blazed by the native Grey Eyes. Improvements and extensions proceeded throughout the British colonial period.

The road reached New Smyrna in late 1774, but after the plantation closed the section south of St. Augustine was not maintained until the 1820s, after the departure of the Spanish. Later roads known as the Dixie Highway and U.S. 1 generally follow portions of the route of King's Road.

THE 1770S

PEDRO CAMPS

Father Pedro Bartolomé Patricia Camps served as the pastor of the San Martin Church for twelve years in Mercadal on the island of Minorca. He was one of the two priests, along with Father Bartomeu Casanovas of the monastery of Toro, who accompanied the settlers brought to work the Turnbull plantation. By 1768, Camps established a brick Church of San Pedro for the plantation workers of New Smyrna. Casanovas was deported to Europe in 1774 for alleged insubordination when he spoke out against Turnbull's policies. That left Camps as the sole priest for 175 Minorcan families and 50 Italians, Corsicans and Greeks.

In 1779, following the demise of the Turnbull colony, Father Camps reestablished his Church of San Pedro on the second floor of a house at 41 St. George Street in St. Augustine. The church began sponsoring a free school beginning in 1787. Attendance became mandatory for white boys and optional for black boys. Classes were taught in Spanish. Although the church officially ceased to exist when the British left St. Augustine in 1784, it continued to function as an informal parish. Despite his poor health, Camps continued to serve the Minorcans because neither of the other two priests in St. Augustine understood their language.

On May 19, 1790, Camps died and his parish merged with the Spanish congregation, moving to the parish church on the north side of the Plaza de la Constitución. Camps was buried in the Tolomato Cemetery on Cordova Street and in 1800 was reburied in the Cathedral of St. Augustine.

EAST FLORIDA GAZETTE

The *East Florida Gazette* was Florida's first newspaper, published by William and John Wells beginning on February 1, 1783, shortly before Florida was returned to Spain by the British pursuant to the Treaty of Paris, which also recognized the independence of the United States. Its final issue was printed on March 22, 1784.

During 1783, David Zubly from Charleston set up a printing press in his St. Augustine home and printed John Tobler's *Almanack*. It was the first book published in Florida.

THE 1780S

CATHEDRAL OF ST. AUGUSTINE

The Catholic congregation of St. Augustine traces its beginning to September 8, 1565, when the first Mass was celebrated by Father Francisco López de Mendoza Grajales.

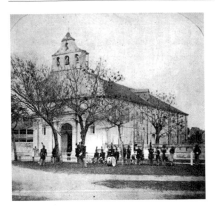

Catholic Church
The parish church facing the Plaza de la Constitución was dedicated on December 8, 1797, and Father Michael O'Reilly served as the pastor. It is shown here with a band gathered in front of it during the Civil War, about a decade before St. Augustine became a diocese and the church was designated as a cathedral. *Courtesy of the Florida Photographic Collection.*

A Catholic church was built of wood in 1655 on the Plaza de la Constitución and was destroyed in the 1702 raid by James Moore. Reconstruction was begun on the site in 1716, but the church was not completed. Instead, services were moved to the parish church located on St. George Street. It had been constructed of coquina and had been used as the hospital of Nuestra Señora de la Soledad since 1597.

By 1784, Father Thomas Hassett came to St. Augustine to be the pastor, assisted by Father Michael O'Reilly, of Irish ancestry but trained in Spain. The Minorcans who had moved from New Smyrna to St. Augustine were absorbed into the larger parish during 1790, following the death of Father Camps.

Mariano de la Rocque designed a new church, the plans for which were approved in 1790. Its cornerstone was laid in 1793 and construction began. Its façade was similar to that of the chapel at La Leche, and some of that earlier structure's stones may have been used in the church. Some of the stones from the ruined chapel at the Tolomato Cemetery may also have been used in the construction of the church.

The parish church was transformed into a cathedral in 1873 when St. Augustine was declared to be a diocese, 172 years after Bishop Diego Evelino de Compostela proposed the creation of a separate Florida diocese so he would not have to travel from his cathedral in Havana. The Cathedral of St. Augustine burned in 1887, but the side walls and façade remained. During the rebuilding process, the chancel, transept and campanile were added.

The bells, including one bearing the inscription of "Sancte Joseph Ora Pro Nobis D 1682," were adversely affected by the extreme heat and were silent from the day of the fire until they were recast and refurbished in the Netherlands, hung in the new six-story bell tower and rung in 1965. Today's floor is composed of 15,000 tiles made by Cuban refugees. The Cathedral of St. Augustine underwent substantial restoration during 1965 and is listed on the National Register of Historic Places.

THE SPANISH RETURN

On July 14, 1784, Spanish governor Vicente Manuel de Zéspedes y Velasco formally took possession of the city. With him from Havana came five hundred soldiers and many civilians to help repopulate the 275 homes in the city. Zéspedes served as the governor until July 7, 1790.

THE 1790s

LIGHTHOUSE PARK

During 1793, land to the west of the Spanish watchtower on Anastasia Island was granted to Lorenzo Rodríguez, who called the land Buena Vista and cultivated it for several years. Five acres of the grant were purchased by the federal government for a lighthouse site in 1871. The remainder of the Rodríguez land was sold to James Renwick Jr. in 1872. The property was divided into parcels, which were developed as subdivisions within the Lighthouse Park neighborhood. Included were the Paul Capo Subdivision, developed in 1886 by bayfront bathhouse owner Paul Capo, and dentist Charles Carver's plat of Anastasia (also known as Carver's Subdivision).

THE 1800s

CLOSING OF THE TERRITORY

After the Spanish reacquired East Florida in 1784, they encouraged its settlement by granting parcels of land to nearly everyone who wanted one. However, many who came were from the nearby states and desired to end Spanish rule in Florida. To protect their position in Florida, the Spanish closed the territory to settlement in 1804.

THE 1810s

PATRIOTS' WAR

In 1811–12, Americans feared that Florida would be taken over by the British, so soldiers, sailors and volunteers from Georgia were mobilized to prevent such an occurrence. In addition to keeping out the British, most also wanted to kick out the Spanish. A garrison was set up on Cumberland Island and the Spanish-held Fernandina garrison was captured. The local patriots led by John Houston McIntosh marched toward St. Augustine but were stopped near Fort Mose by Governor Juan de Estrada, who enlisted the help of local Seminoles to defend the city.

On its way to the city, a wagon train led by Captain John Williams was ambushed by natives on September 12, 1812, and they pulled back from St. Augustine to the St. Johns River. The troops remained in the area until May of 1813, and then headed to Washington to participate in the War of 1812 against the British.

NATIONAL CEMETERY

The area that is now the National Cemetery has been used for burials since 1818. Shortly after the United States took control of Florida in 1821, the land at the barracks was officially designated as a post cemetery. Its first interment with that designation took place in 1828. A tall obelisk was erected to honor the soldiers and Indian Scouts from the Second Seminole War and was paid for by each soldier stationed in St. Augustine donating one day's pay.

Located south of the St. Francis Barracks, it is the oldest military cemetery in the state, and most graves contain veterans of the Second Seminole War. It was designated as a national cemetery as a result of an 1881 proposal made by General Montgomery Meigs. During 1912–13, it doubled in size and reached its capacity during the 1960s.

ADAMS-ONÍS TREATY

In 1819, Secretary of State John Quincy Adams and Spanish Foreign Minister Luis de Onís negotiated the Treaty of Amity, Settlement and Limits Between the United States of America and His Catholic Majesty. Also known as the Transcontinental Treaty of 1819, the Florida Purchase Treaty and the Adams-Onís Treaty, it provided for the payment of $5 million to Spain. In exchange, the United States was to receive Florida and Spain was to give up claims to certain western lands. The treaty was ratified by Spain in 1820 and by the United States in 1821, and that year East and West Florida became U.S. territories.

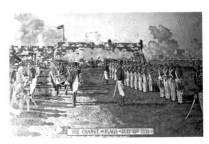

Change of Flags
This painting captures the scene at the Castillo on July 10, 1821, when the Spanish flag was lowered and was replaced by the flag of the United States. *Courtesy of the Florida Photographic Collection.*

THE 1820S

ST. JOHNS COUNTY

St. Johns County was officially created on July 21, 1821, while Andrew Jackson was the territorial governor. St. Augustine was made the county

seat and remains as such. When the county was formed, it included the entirety of Florida east of the Suwannee River, approximately 39,400 square miles. Over the years, other counties have been formed from that land, leaving today's St. Johns County at 609 square miles.

HUGUENOT CEMETERY

In 1821, two months after Florida became a part of the United States, St. Augustine suffered an outbreak of yellow fever. To accommodate the dead, the city set aside a half-acre just to the northwest of the City Gate. It is known as the Burying Ground, the Public Burying Ground, the Protestant Ground, the St. Augustine Ground, the City Gate Cemetery and the Huguenot Cemetery. It includes several Protestants, but not a single one of the sixteenth-century French Huguenots massacred by Menéndez, for which it is named.

One of the first to die during the yellow fever outbreak was Judge Thomas Fitch on September 10, 1821. Later that month, a committee recommended that the property near the moat and City Gate be used for the cemetery and had it fenced off. Initially, burial plots sold for four dollars each. Individuals interred there include Dr. Seth Peck, John Manucy, Douglas D. Pacetti and Elizabeth Whitehurst.

It served for four years as a city-owned cemetery and then was purchased by Reverend Thomas Alexander who deeded it to the Trustees of the Presbyterian Church in 1832. It was given the name Huguenot either to honor the victims of the 1565 massacre or to attract tourists who might be looking for their graves. The property reached its capacity and had its last burial in 1884. Since 1993, it has been maintained by the Friends of the Huguenot Cemetery.

Some believe the cemetery to be haunted by the ghost of John B. Stickney who died of typhoid fever and was buried there in 1882, but was later reburied in Washington, D.C. His spirit supposedly roams through the cemetery wearing a black top hat and flowing black cape. Some also believe the cemetery to be haunted by the ghost of a fourteen-year-old girl whose body was dropped off at the cemetery and who allegedly appears on the City Gate after midnight.

NEWSPAPERS

Publication of the *Florida Gazette* began on July 14, 1821, making it the first newspaper in the East Florida Territory. It was published by Richard W. Edes, whose death from yellow fever on October 15, 1821, ended the newspaper.

The *East Florida Herald*, known as the *Florida Herald* starting in 1829, began in August of 1822 and continued into the 1850s. It was published by Elias B. Gould until 1834, when it was taken over by his son, James M. Gould. A fire in January of 1835 destroyed the newspaper office, but it was back in print in April of the same year.

FIRST PRESBYTERIAN CHURCH

Florida became a part of the United States in 1821 when there were no Protestant churches in St. Augustine. Several denominations sent missionaries, and the Presbyterians sent Eleazer Lathrop that year. The Presbyterians by 1823 decided to construct their own church, and Reverend William McWhir arrived to organize the congregation. The First Presbyterian Church was established in 1824, and a cornerstone was laid for its first sanctuary on St. George Street, where it remained until 1890.

THE 1830S

CITRUS

By 1830, growers in St. Augustine exported over 2,500,000 oranges to Northern markets each year. The citrus industry was nearly destroyed by a killing freeze on February 7, 1835, during which the temperature dropped to seven degrees. Damaged trees were replaced by new groves, and when they were about to become productive in 1841, they became infested with the fruit-destroying insect, the orange coccus. During the 1870s, an orange blight disease essentially eliminated what remained of a formerly important local industry.

FLORIDA HOUSE HOTEL

This hotel belonging to Mr. Cole opened in 1835, bringing the city's tourist accommodations to three hundred. It featured gas lighting and a steam elevator for guests.

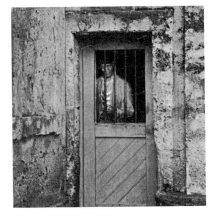

Osceola

Seminole chief Osceola is shown here during his imprisonment in the Castillo. He was transferred to Charleston, South Carolina, and died in prison there at Fort Moultrie in 1838. His body was buried there except for his head, which was removed and brought to St. Augustine by Dr. Frederick Weedon. *Courtesy of the Florida Photographic Collection.*

OSCEOLA

In 1837, Seminole Chief Osceola attended a meeting with soldiers under a flag of truce at Moultrie, just west of St. Augustine. He came unarmed to meet with General Hernandez and despite the truce was captured along with others of his party. They were imprisoned in the Castillo. Two of his fellow prisoners, Coacoochee and

Hadjo, escaped by squeezing between iron bars and dropping into the moat, but Osceola remained.

ST. AUGUSTINE NEWS

This newspaper began publication in November of 1838 and continued until 1852. It was founded by Daniel W. Whitehurst, and in 1840 it was taken over by Thomas T. Russell and Aaron Jones Jr.

THE 1840S

PLANTERS' HOTEL

At the corner of Charlotte and Treasury Streets was a house built in 1844, owned by the family of William Wing Loring. It was operated on and off for several years as the Planters' Hotel beginning in about 1848. Loring became famous for his military service in the Second Seminole, Mexican and Civil Wars. Later, he joined other Civil War veterans to serve in the military in Egypt.

MAGNOLIA HOTEL

Burroughs E. Carr owned the Magnolia Hotel, considered to be the finest rooming establishment of the city when

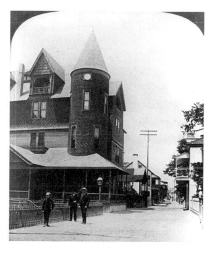

Magnolia Hotel
Shown here in an 1887 photo taken by George Barker is the Magnolia Hotel, located at the southwest corner of St. George and Hypolita Streets beginning in 1847. It burned down on December 27, 1926. *Courtesy of the Florida Photographic Collection.*

it was completed in March of 1847. It initially had 17 rooms and expanded to 45 by 1853. Following an enlargement to 250 rooms and remodeling during the 1880s, the Magnolia was three stories tall and had long verandas.

THE 1850S

NEWSPAPERS

The *Ancient City* and *Examiner* newspapers began publication in 1850. The latter was taken over and published during the Civil War by Union troops.

ST. JOHNS RAILWAY

In 1858, the St. Johns Railway was chartered and gave those traveling from Jacksonville an alternative to taking steamships either along the Atlantic Coast or up the St. Johns River to Picolata, followed by an eighteen-mile overland trip due east to St. Augustine. The railroad was planned to extend fifteen miles due east from Tocoi Landing to the southwest edge of St. Augustine, and the land for the railroad right of way was graded from Tocoi to about a mile and a quarter from the city limits. Track was laid, beginning at Tocoi and extending for five and a half miles, but construction was halted by the outbreak of the Civil War. Iron rails were taken away on a Union gunboat on the St. Johns River, and the rest of the construction was ruined by raiders.

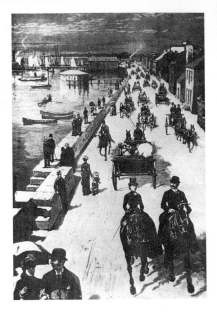

Bay Street

T. de Thulstrup drew this scene of horses, carriages and strollers along St. Augustine's Bay Street, now known as Avenida Menendez. The image is a photograph taken of the drawing during March of 1855. *Courtesy of the Florida Photographic Collection.*

Work resumed on the railroad in 1871, but because of the shortage of metal, the tracks were made of wood covered with strips of iron. Horses or mules pulled the two rail cars, and the fifteen-mile trip from Tocoi took from four to five hours. That was still better than walking or a horse and buggy ride from Picolata. During the 1870s, the railroad was purchased by William Astor who replaced the wooden rails with iron ones and added a pair of wood-burning locomotives.

THE 1860s

CIVIL WAR

On January 7, 1861, 125 Florida artillerymen sympathetic to the cause of secession arrived at the Castillo in an attempt to capture it for the South. A single Union sergeant was the only solider in the fort, and he handed over possession without a fight.

On March 12, 1862, Union soldiers from the gunboat *Wabash* were met by town leaders and Union sympathizers who turned St. Augustine over to the army. The night before, the Confederate soldiers and

about five hundred civilians had evacuated the city. The American flag was raised over the Castillo and those who favored the South had to leave town.

Occasionally, a small force led by Captain John J. Dickison raided the town's outskirts, capturing and wounding a few Union soldiers. St. Augustine in 1863 was turned into a Union hospital and convalescent camp. The population grew with arriving Union soldiers and Confederate deserters.

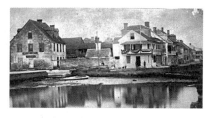

St. Augustine Waterfront
Professional photographer George Pierron captured this view of St. Augustine in 1864 along the Matanzas River. The town was then a collection of Spanish buildings mixed with more recent construction of varied styles, with hotels and tourist attractions, not unlike the present city. *Courtesy of the Florida Photographic Collection.*

SAM COOLEY

In 1862, St. Augustine was visited by Sam A. Cooley, an official photographer serving with the U.S. Army Department of the South. He took many photos of the downtown buildings, which a century or more later became very important. When the public desired to restore homes and other buildings to their original appearance, they used Cooley's photos to show them what they previously looked like.

EMANCIPATION PROCLAMATION

Lincoln's 1863 freeing of the slaves only applied to those areas of the United States under Union control. It had no legal effect in Confederate-held areas. At the time, St. Augustine was occupied by Union troops, so the local slaves became free. The slaves were gathered in a vacant lot between the homes at 234 and 244 St. George Street, and they were told of their new freedom. The lot has become known as Liberation Lot.

LINCOLNVILLE

Some former slaves leased city land on the west side of Maria Sanchez Creek (also known as Santa Maria Creek), which

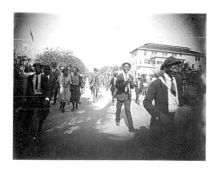

Emancipation Celebration
Annual festivities in Lincolnville celebrated the freeing of the slaves in St. Augustine. This image was made from a glass plate negative produced in the mid-1920s and shows the yearly Emancipation Day Parade. The photo was taken by Richard Aloysius Twine, whose family members played key roles in the civil rights movement of the 1960s. *Courtesy of the Florida Photographic Collection.*

was previously the site of Indian villages. They founded the community of Africa, later renamed as Lincolnville, and constructed schools, churches and a business district. Residential sections included many late Victorian homes, and Lincolnville has the largest number of such homes in St. Augustine.

During 1964, Lincolnville was the center for the organization of demonstrations in St. Augustine that helped to influence the passage of the Civil Rights Act. The fifty-block Lincolnville Historic District was added to the National Register in 1991.

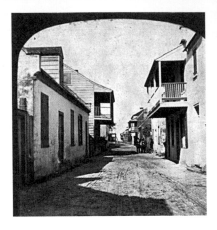

Hospital Street
The Florida Club included several photographers, and its collection included this image from the 1860s or 1870s. It shows a street named for the hospital located along it, which has since been renamed as Aviles Street. It also demonstrates the typical Spanish narrow roadway with overhanging balconies. *Courtesy of the Florida Photographic Collection.*

PEABODY SCHOOLS
In 1868, the Peabody Fund provided funding for two schools in St. Augustine, one for white children and one for black children. The schools opened for classes the following year. They weren't the first schools, as more than thirty private schools had operated in the city during the U.S. territorial period, including the Sarah Mathers School for Young Ladies and George L. Phillip's Academy.

ST. AUGUSTINE HOTEL
In 1869, Edward E. Vaill, Frank H. Palmer and Dr. Andrew Anderson Jr. partnered to construct the St. Augustine Hotel on the north side of the Plaza de la Constitución on the former site of the public jail. The four-story hotel was made of wood and had a dining room that could seat three hundred. It began with 80 rooms and expanded to 140 in 1875. Also in the hotel was a telegraph and pool room. Lighting was provided by gas. The hotel was destroyed when its boiler exploded on April 12, 1887, resulting in a fire that consumed several buildings on and north of the plaza, including the Cathedral of St. Augustine.

THE 1870S

WHITNEY NEWSPAPERS
Two newspapers were begun during the 1870s by men named Whitney. J.P. Whitney started the *Augustine Press* in 1870. Three years

later, the *Florida Press* was founded by J.W. Whitney. In 1879, another newspaper was begun by C.M. Cooper called the *St. Johns Weekly*.

SUNNYSIDE HOTEL

During 1871, land at the northwest corner of King and Cordova Streets, a part of Markland, was sold to Thomas F. House of Vermont. On it, he built a house for himself and later expanded the home as the Sunnyside Hotel. Its tower was described as Oriental Gothic and the porches as New England in style. It was bought by Dr. Andrew Anderson Jr. who resold it to Henry Flagler for the same price.

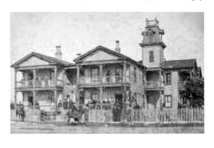

Sunnyside Hotel

This old stereograph image shows the Sunnyside Hotel, located on the present site of Flagler College. It was acquired by Henry Flagler, who filled in the nearby section of Maria Sanchez Creek and on the land built the Ponce de León Hotel, which is now the home of the college. *Courtesy of the Florida Photographic Collection.*

ST. JOSEPH ACADEMY

Members of the order of Sisters of St. Joseph arrived in St. Augustine in 1866 at the request of Bishop Augustin Verot and began teaching classes in a schoolroom on Aviles Street. In 1874, the St. Joseph Academy received a state charter as an educational institution, making it today's oldest continuing Catholic high school in the United States.

It also served as a boarding school for girls of wealthy Northern families wintering in the Flagler hotels. Boarding students were accepted until the late 1960s. During the late 1970s, the Sisters of St. Joseph ended their sponsorship of the St. Joseph Academy and the operation of its St. George Street campus. Jurisdiction passed to the Diocese of St. Augustine.

In 1980, the academy moved to a new facility at 155 State Route 207, and the old buildings at St. George and Cadiz Streets were torn down. A portion of the masonry wall running along its perimeter, dating to about 1816, was allowed to remain standing.

LIGHTHOUSE

At the north end of eighteen-mile-long Anastasia Island, a wooden lookout tower was built. From it, Sir Francis Drake's ships were seen approaching St. Augustine in 1586, giving the Spanish time to organize an evacuation. The tower was later reconstructed of coquina and was used during the 1740 siege.

In 1824, the tower was made into a lighthouse under the supervision of the collector of customs. Juan Antonio Andreu became the first official lighthouse keeper in April of 1824. The original fourteen-inch

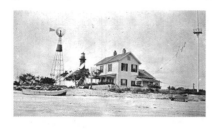

St. Augustine Lighthouse
During World War II the lighthouse was occupied by armed coast guard lookouts who dimmed the beacon's light from twenty thousand to five thousand candlepower so that friendly ships would not be so visible to patrolling German submarines. This postcard image, which also includes the keeper's house, dates to about 1920. *Courtesy of the Florida Photographic Collection.*

reflectors were replaced by a revolving light in 1856. This lighthouse collapsed into the Atlantic Ocean on June 20, 1880, years after it was taken out of service and replaced with a newer structure.

The new lighthouse was built in 1872–74 under the supervision of Hezekiah H. Pittee. It was designed by Paul Pelz and has 219 steps from the base to the top. The tower was painted black and white and was lit for the first time on October 15, 1874. The keeper's house was erected in 1875–82. The light was switched from lard to kerosene in 1885 and to electricity in 1936.

When Coast Guard Chief James L. Pippin retired as the final keeper in July of 1955, the light operation was changed to automatic. The property was purchased by St. Johns County in 1971. The keeper's house had been gutted by a fire and was restored during the 1990s. The Fresnel lens, severely damaged by vandals in 1986, was replaced. Today's office and archaeology laboratory formerly served as barracks for the coast guard personnel. The lighthouse and the keeper's quarters were added to the National Register on March 19, 1951.

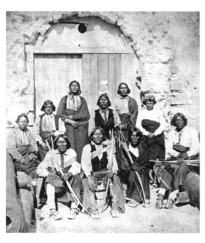

Native Prisoners
After about two years of captivity during the 1870s, most of the incarcerated Kiowa and Caddo natives were returned to their homes out west. In 1880, their supervisor, Captain Richard Henry Pratt, established the Carlisle Indian School in Pennsylvania, and some of the natives from St. Augustine were sent to school there. *Courtesy of the Florida Photographic Collection.*

Some believe the lighthouse at 81 Lighthouse Avenue to be haunted by the ghosts of the lighthouse builder's drowned daughters, a cigar-smoking man in the fuel house and a man who allegedly hanged himself in the basement. There have been reports of the ghosts of two young girls, the drowned daughters of the lighthouse keeper, on the third floor of the keeper's house. Some also believe in the presence of the

ghost of Juan Antonio Andreu who fell to his death during the 1850s while painting the first lighthouse.

PRISONERS

During the mid-1870s, the Castillo served as a prison for Native Americans sent to St. Augustine by the federal government. Included were Arapaho, Cheyenne, Kiowa, Caddo and Comanche. They were kept under the supervision of Captain Richard Henry Pratt of the Tenth U.S. Cavalry. After a time, many were allowed to travel freely along the streets of St. Augustine and attend church and school.

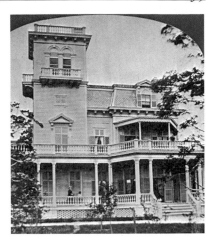

Barcelona Hotel
This former residence was moved a block to the west by Henry Flagler and transformed into the Barcelona Hotel. It was demolished in 1962 and was replaced by a parking lot. This image depicts its appearance during the 1870s, shortly after it had been built for Henry Ball. *Courtesy of the Florida Photographic Collection.*

BARCELONA HOTEL

Henry Ball of New York acquired a strip of land that stretched from Cordova Street to the San Sebastian River, between Valencia and Saragossa Streets. On the center of the property at the corner of Valencia and Sevilla Streets, Ball built a large home in 1874. During the late 1880s, it was moved one block west to the corner of Sevilla and Carerra Streets and converted into the Barcelona Hotel.

THE 1880S

HISTORICAL SOCIETY

In 1881, an informal group of St. Augustinians began meeting in their homes to share information about science and history. They formally organized on January 1, 1883, and took over the management of the Castillo, then formally known as Fort Marion, and ran it until 1935 when it became a national monument.

The St. Augustine Historical Society and Institute of Science had acquired the Tovar and González-Alvarez Houses by 1918, and in 1924 built the structure housing the Webb Memorial Museum in between the two homes. Another site operated by the society is the Fernández-Llambías House. It also maintains a large collection of photographs, maps, documents and other historic materials in its research library in the Seguí-Kirby Smith House.

SAN MARCO HOTEL

In 1884–85 on the west side of San Marco Avenue, just north of the City Gate, the six-story San Marco Hotel was built by contractors McGuire and McDonald. It was owned by Isaac W. Crufts and managed by Osborn D. Seavey, who helped supervise its construction, and it had three seven-story towers. Inside was a theater where, for just a dollar, one could buy a dance, a cup of coffee, a glass of lemonade and a dessert. The hotel burned in 1895 and the site was later donated to the city by Elizabeth Ketterlinus. After the hotel was demolished, the lot was used for playing fields and then a parking lot.

HENRY FLAGLER

During the 1870s, Henry Morrison Flagler came to St. Augustine with his wife for her health, but she died and he returned to New York. In 1883, he came back to St. Augustine with a new wife, this time for his own health, with the hope that the climate would be better for his liver illness. He found the area inhabited by people of the upper class, not merely sick people waiting to die. Flagler was impressed by the architecture, including the San Marco Hotel and Villa Zorayda. Henry Flagler and his second wife, Alice Shourds, honeymooned at the San Marco and he may have been inspired by its size to take on the challenge of building a larger and more opulent hotel.

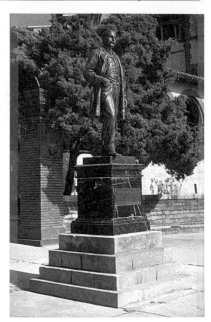

Henry Flagler
This statue of the hotel and railroad magnate was sculpted in 1915 and erected on February 23, 1959, by the National Railroad Historical Society. In 1970, it was relocated to the main entrance of Flagler College, which occupies his former Ponce de León Hotel. *Courtesy of the Florida Photographic Collection.*

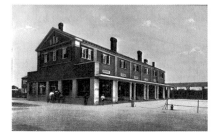

Railroad Depot
This image comes from a series of postcards of St. Augustine that were produced by R.B. Allen and printed in Germany. It depicts the city's railroad depot during the 1910s, which was built along Malaga Avenue on the western edge of the Ancient City by 1905. *Courtesy of the Florida Photographic Collection.*

RAILROAD

In June of 1883, the Jacksonville, St. Augustine and Halifax River Railway connected southern Jacksonville with a terminus about a mile north of the City Gate of St. Augustine. Wood-burning locomotives ran on narrow-gauge light rails. Until 1890, northbound passengers had to get off the train and take a ferry across the St. Johns River if they wanted to reach downtown Jacksonville.

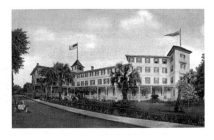

St. George Hotel

This large hotel began as the home of General Peter Skenandoah Smith and was located next to Trinity Episcopal Church. During the 1880s, it was remodeled and converted to the St. George Hotel. It became a fire hazard and was razed during World War II. *Courtesy of the Florida Photographic Collection.*

The railroad was purchased in 1885 by Henry Flagler who widened the gauge to standard size. He also acquired the St. Augustine & Palatka Railway and a little logging railroad that ran from East Palatka to Daytona. He began service with all Pullman railroad cars, which could get one to New York City in only thirty hours.

OCEAN VIEW HOTEL

This hotel with thirty sleeping rooms along Avenida Menendez was built in 1884 by William Slade Macy Pinkham across from his Pinkham's Dock. In 1909, it was sold to H.E. Hernandez. During the 1960s, it was torn down and replaced by the Marion Hotel.

NATIVE PRISONERS

Geronimo's wife and child were imprisoned in the Castillo during October of 1886 and were added to a contingent of about five hundred Chiricahua Apaches. Some departed during the next few months to attend school at the Carlisle Indian School in Pennsylvania, founded by Captain Richard Henry Pratt. The last Apaches left the Castillo on March 27, 1887.

PONCE DE LEÓN HOTEL

This magnificent structure was erected between 1885 and 1887 on the filled-in land of the northern portion of Maria Sanchez Creek by Henry M. Flagler, the hotel and railroad magnate whose activities contributed greatly to the development of Florida's eastern coastal area. It was designed by New York architects Carrere and Hastings with a Spanish Renaissance style.

The $2.5 million hotel was the first major building in the country to be made of poured concrete, a mixture of cement, sand and coquina shell. The interior is decorated with imported marble, carved oak and murals painted by Virgilio Tojetti and George W. Maynard. Its stained-

glass windows were created by Louis Comfort Tiffany of New York.

Electricity was produced by four Edison direct current dynamos in the boiler plant. Water was initially provided by five-hundred-foot-deep artesian wells. Then in 1892 the hotel switched its water supply to a pond.

Located in the city that became known as the "Winter Newport," this resort hotel entertained celebrities from around the world, including several U.S. presidents. During World War II, the hotel served as a Coast Guard Training Center. In 1968, this historic landmark was converted into Flagler College, an accredited liberal arts institution. Independent and coeducational, the college serves students from across the nation.

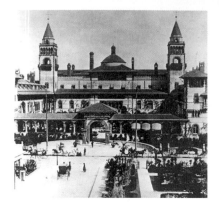

Ponce de León Hotel
This hotel had its grand opening on January 10, 1888, and was the flagship of the Flagler hotel system that soon extended all along Florida's east coast. This photo was taken on July 25, 1891, well outside of its busy winter season when it catered to well-to-do Northerners. *Courtesy of the Florida Photographic Collection.*

HOSPITALS

In May of 1888, the St. Augustine Hospital Association formed to raise funds for a hospital. Flagler himself provided funds to buy the two-story former Dr. Sloggett residence on Marine Street, which was remodeled and converted into the Alicia

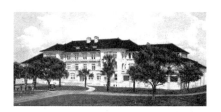

Flagler Hospital
After the original Flagler Hospital burned down in 1916, it was replaced by this new structure with the same name in 1921, following a temporary location in the Stickney House at 282 St. George Street. It has recently been replaced by condominiums and the city is now served by a modern hospital at a different location. *Courtesy of the Florida Photographic Collection.*

Hospital, opening in 1890. That facility was renamed the Flagler Hospital in 1905 to honor its founder.

In 1891, the Florida East Coast Railway Hospital opened for railroad employees and their families. White patients were treated in a former residence and black patients were seen by medical personnel in a former barn. The hospital burned down on November 27, 1901.

THE 1890S

KIRKSIDE

Located next to the Flagler Memorial Presbyterian Church was the mansion of Henry Flagler, which he called Kirkside, meaning "beside the church." It was designed by architects Carrere and Hastings in a Georgian Colonial Revival style with four imposing columns supporting a two-and-a-half-story entrance portico. Construction was begun in July of 1892 by McGuire and McDonald and was completed the following March. Shortly after it was completed, Henry's wife, Ida Alice Flagler, went insane and Henry couldn't bear to live in it. After it ceased to be the home of the Flaglers, Kirkside was owned by their heir, Louise Wise Lewis. During the 1940s, the home was leased to the University Foundation for night and correspondence courses.

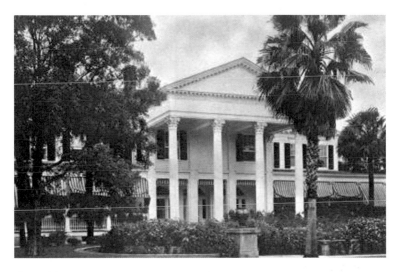

Kirkside
Briefly the home of the Flaglers, this mansion had been allowed to deteriorate by the 1950s. Rather than spend $20,000 for repairs, its owners tore it down and recycled portions into other buildings throughout St. Augustine. Its greenhouse was moved to Jacksonville. *Courtesy of the Florida Photographic Collection.*

NEWSPAPERS

In 1894, the *St. Augustine Daily Herald* newspaper began publication. Henry Flagler bought it, and on August 30, 1899, he merged the *Herald* with the *St. Augustine Evening Record*. The Flagler System sold it to a group of local businessmen headed by A.H. Tebault Sr. in 1942. On July 1, 1966, the newspaper was sold to the Florida Publishing Company of Jacksonville, whose other newspapers included the *Jacksonville Journal* and the *Florida Times-Union*.

City Building

Prior to 1884, the Presbyterian parsonage was located on St. George Street and served as a manse until the construction of the Flagler Memorial Presbyterian Church, when a new manse was built. The old building then served as the Woman's Exchange and was torn down in 1896 when Flagler built the City Building on Hypolita Street, between Spanish and St. George Streets.

Flagler had the U-shaped, three-story, stone building constructed with a massive entrance portico supported by four large columns. His intention was to have it serve the city as a governmental center, and he rented it to St. Augustine to be the city hall. The city market moved out of it in 1890, followed by the city council and fire department the following year. It was torn down in 1973 by the St. Augustine Restoration Foundation.

The 1900s

King Street

In the early part of this decade, the main east-west thoroughfare took on a new appearance. King Street had originally been tree-lined, and during the 1880s its usage necessitated its widening. Henry Flagler opted to build a second lane on the other side of the tree line, producing a median of live oak trees. After the turn of the century, the trees were taken down to make room for streetcar lines.

Elks Lodge

The local chapter of this club was chartered in 1903 and met in the Worth House on Marine Street. That building was later torn down and rebuilt at the intersection of Avenida Menendez and Marine Street, and has been the home of a series of restaurants.

The Elks moved from their original Marine Street home to 16 Avenida Menendez, the later site of the Monterey Motel. In 1975, the Elks Lodge moved to 1420 A1A South on Anastasia Island.

Courthouse

In 1907, St. Johns County moved into a new courthouse at the corner of Charlotte and Treasury Streets, a Spanish-style building with a wide hall extending the length of the courthouse. It had tile floors and the walls were covered with white tile up to a height of four feet with plaster above. The cost of the courthouse was $55,000. It was damaged to the extent of $100,000 by the 1914 fire, at a time when it was insured for only $18,000. It was replaced by a new structure in 1918.

YMCA

In 1907, a brick YMCA building was erected at 59 Valencia Street. It had a clay tile roof and thick carved rafters, plus Victorian wooden details. The construction was financially supported by Henry Flagler and included bowling alleys, a swimming pool and a gymnasium. In 1956, two wing extensions on the east and west sides, perhaps used as carriage passages, were removed.

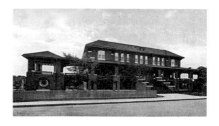

YMCA

This Mediterranean-style brick building bears a resemblance to a railroad depot, perhaps because its construction was partially funded by the railroad. Known as the "Railroad YMCA," it was acquired by Flagler College, which tore it down and replaced it with tennis courts. *Courtesy of the Florida Photographic Collection.*

THE 1910s

ST. AUGUSTINE'S FIRST AIRPLANE IN FLIGHT

In 1911, the residents of St. Augustine were able to watch the area's first airplane in flight. Aboard were James J. Ward and J.A.D. McCurdy, the first man to fly an airplane within the British Empire. Early flights used the beach for takeoffs and landings.

DEVASTATING FIRE

Several Colonial buildings along Charlotte Street were favorite subjects of photographers and painters until April 2, 1914, when a fire destroyed them. They then attracted movie crews who used the rubble to simulate World War I destruction in Europe. Wood shingle roofs were thereafter not permitted in downtown St. Augustine.

The fire began in the four-story Florida House Hotel located at the northeast corner of St. George and Treasury Streets. It was believed to have been caused by rats chewing on matches.

ST. BENEDICT SCHOOL

On Easter Sunday in 1916, three white nuns at St. Benedict School in Lincolnville were arrested for teaching black students. A law had been enacted in 1913 to help prevent bringing equality to the races. Sisters Mary Thomasine Hehir, Mary Scholastica Sullivan and Mary Beningus Cameron were eventually acquitted, but not because the law was found to be unconstitutional. The court merely held that black students being taught by white teachers was a prohibited activity only in Florida's public schools.

FLORIDA MEMORIAL COLLEGE

In 1892, the Florida Baptist Academy, a school for black students, was established in Jacksonville. In 1918, it moved to West King Street in St. Augustine to the site of the former F.N. Holmes livestock farm. In 1941, it merged with the Florida Baptist Institute, which had been founded in 1879, to form the Florida Normal and Industrial Memorial Institute. It became a four-year college and was renamed as the Florida Normal and Industrial Memorial College in 1950. The school was renamed as the Florida Memorial College in 1963 and five years later moved to Miami. It is a United Negro College Fund member school.

THE 1920s

PONCE DE LEÓN STATUE

Ponce de León is buried in San Juan, Puerto Rico, and his grave is marked with a tall statue of his likeness. A replica of that statue was erected in the Plaza de la Constitución in St. Augustine in 1923.

NORTH BEACH

North Beach, located on one of the barrier islands that protects the mainland, was developed in the early 1920s by the Usina and Capo families. In 1924, August Heckscher bought property at the south end of the island and built the elegant Spanish-style Vilano Beach Casino in 1927. It included a 150-foot-long by 50-foot-wide pool.

Unfortunately, the ocean damaged that casino's foundation in the 1930s and what was left of the building was demolished in 1938. That same year, Eunice Capo Banta bought the Surfside Casino from her parents and developed beach property on the Capos' 165 acres.

DAVIS SHORES

David Paul Davis developed land in Miami and dredged sand from the bottom of Tampa Bay to add to two small existing islands, resulting in Davis Islands, an upscale Tampa neighborhood. His most ambitious project, however, was the $60 million Davis Shores development on 1,500 acres of Anastasia Island. He acquired and began reshaping the northern tip of the island, most of which had been owned by a trio of railroads.

Davis planned for the new development to be twice the size of the massive Davis Islands. It was to include a $1.5 million hotel, a yacht club, a Roman pool, a $250,000 country club, a casino and two golf courses. Every homesite was to border either the water or a golf course. Land sales began on November 14, 1925. Land valued at $50 million was sold, but only a small fraction of that was actually paid in cash that the development company could use.

Bridge of Lions
Shown here is one of the lions that guards the western entrance to the bridge, which connects St. Augustine with Anastasia Island. It and its twin were sculpted by F. Romanelli of Florence to resemble that city's lions on the Loggia Dei Lanzi. The lions were donated to St. Augustine by Dr. Andrew Anderson Jr. *Courtesy of the Florida Photographic Collection.*

The timing of the development turned out to be bad and the Davis projects suffered financial setbacks. Davis sold his Tampa project in 1926 to provide funds to keep his St. Augustine development going. He also took out a $300,000 life insurance policy, booked a cruise to France supposedly to investigate a French Riviera development and disappeared at sea on October 12, 1926. The Davis Shores development has few examples of the many homes that Davis had planned, and development of the area was not substantially completed until the 1950s.

BRIDGE OF LIONS

In 1895, a wooden toll bridge first connected St. Augustine with Anastasia Island, and passengers were carried across it by a mule-drawn trolley. It was modified in 1904 to carry the cars of an electric trolley line. It was unattractive and insufficient for the rapidly increasing automobile traffic.

During the 1920s, a new bridge stretching 1,538 feet was planned to provide a better way to get to the Davis Shores development. The modern bridge flanked by four towers opened in 1927 with a drawbridge to allow tall boats to pass through. Called the Bridge of Lions for the pair of lion sculptures at the St. Augustine end, the bridge was added to the National Register of Historic Places on November 19, 1982. After 2000, the bridge began a multi-year renovation including the replacement of the roadbed. That project was still in process as this book went to press.

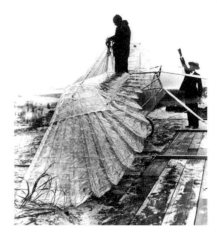

George White
Shown here is aviator George R. White on September 21, 1927, as he was preparing to take off on a test flight in his ornithopter, which he hoped would allow him to fly like a bird. Instead he crashed on his first attempt. White improved his design and was able to fly for limited distances after being towed by a car. *Courtesy of the Florida Photographic Collection.*

GEORGE WHITE

George R. White was an aviator from Stony Brook, New York, who served as a flying instructor during World War I. He chose the beach at St. Augustine to test his ornithopter, which he hoped to use to make man's first successful bird-like flight. His flying machine had a frame of chrome molybdenum covered with celluloid fabric, all of which weighed 118 pounds. It measured 8 feet from nose to tail and 29.5 feet between the tips of the wings, which flapped when he pumped the mechanism with his feet.

THE 1930S

AIRPORT

St. Augustine's first airport opened in 1931 on a site along State Route 16 that was chosen in 1928. It was previously the site of the Lorillard Race Track.

The next airport was built on a larger site known as Araquay Park, 276 acres purchased for $8,000 on December 27, 1933. Construction began during 1934 and it was developed into the St. Augustine Municipal Airport, operated by Lucius Rees and J.W. Richbourg.

ST. AUGUSTINE ARTS CLUB

During 1924, the Galleon Arts Club formed and by the end of the 1930s was known as the St. Augustine Arts Club. The *St. Augustine Record* announced that the city was becoming an art colony. Later, several members of the organization founded the St. Augustine Art Association with several privately owned galleries and more than six hundred members.

THE 1940S

ST. AUGUSTINE MUNICIPAL AIRPORT

The airport was used during World War II by pilots from the Jacksonville Naval Air Station to train cadets. It was also part of the Civil Aeronautics Authority state defense network. Air raid drills for the city began in December of 1941, and lights were dimmed at night. The coastal area of the state was off limits to civilian pilots during the war. The airport closed in 1950 because of competition from airports in Jacksonville and Daytona Beach, and it was allowed to become overgrown. For a time, the site was leased to the Moose Lodge for a dollar a year.

The airport site was used from the mid-1950s until the 1970s by the aircraft division of the Fairchild Engine and Airplane Corporation, which took bombers and dismantled, cleaned and rebuilt them. In the 1980s, the site was used for aircraft modification and remodeling.

OSTRICH FARM

In 1946, James Casper opened an attraction called Casper's Ostrich and Alligator Farm, located about three miles north of downtown on U.S. 1. There, he raised ostriches, rare birds, alligators, crocodiles and other reptiles. Casper made money charging admission to see the live animals. He also raced the ostriches and had a business importing hides from other countries. The St. Augustine attraction closed in 1982.

LIGHTNER MUSEUM

The Lightner Museum opened on January 1, 1948, in the former Alcazar Hotel. In the courtyard is the Coats Bridge, constructed of rubble stone in 1948 by N. Frances Coats of Floral City. It crosses the pool near the grave of Otto C. Lightner, who founded *Hobbies* magazine and donated his Victorian memorabilia collection to the museum.

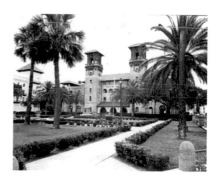

Lightner Museum
What began as Henry Flagler's Alcazar Hotel was later transformed into the St. Augustine City Hall and a museum to hold the collection of Otto C. Lightner. Today, the museum features an eclectic mixture of just about everything from antique musical instruments to Tiffany glass lamps to a large collection of crystal vases. *Courtesy of the Florida Photographic Collection.*

The museum was closed for a time and moved to the casino section of the hotel while the front portion of the Alcazar was remodeled into the city hall. The city hall opened in 1972, and the Lightner Museum reopened in 1974.

THE 1950S

RIPLEY'S BELIEVE IT OR NOT MUSEUM

In 1950, the original Ripley's Believe It Or Not Museum opened in the former Castle Warden. It included artifacts and information collected by Robert Ripley during his travels around the world and featured in his syndicated cartoons, which he began drawing while serving as a sports reporter for the *San Francisco Bulletin*.

Ripley had often visited the building when it was operated as a hotel by Norton Baskin and his wife, Marjorie Kinnan Rawlings. Ripley began taping his own television series in March of 1949, but while taping the thirteenth show of the series, he passed out and soon died of a heart attack. His heirs purchased the Castle Warden and opened the museum in December of 1950.

MYSTERY HOUSE

During the 1950s, St. Augustine had an unusual tourist attraction called the Mystery House, located across the road from the St. Augustine Alligator Farm. It appeared to defy the laws of gravity, as floors, walls, ceilings and furniture appeared to sit normally, yet visitors walked at a severe slant but never fell "down." The optical illusion was owned by Al Mosher.

THE 1960S

TRAGEDY IN U.S. HISTORY MUSEUM

Following the assassination of President John F. Kennedy, L.H. "Buddy" Hough opened a museum with a theme of bad events in American history. He acquired a wax figure of Lee Harvey Oswald, Oswald's bedroom furniture and a car in which Kennedy had once ridden (although not on the day he was shot) as a part of his display about the assassination.

Other exhibits included a mummy, a whistle from a train that had wrecked and the alleged death cars of Bonnie and Clyde and Jayne Mansfield. However, the Bonnie and Clyde car was merely a prop from a movie about their lives and the other car did not match the make of the car in which Mansfield had died. Nevertheless, Hough prepared to tell the stories of historical tragedies in his building at 7 Williams Street.

The St. Augustine City Planning Commission decided that such a museum was inappropriate, and in 1965 the City Commission passed an emergency ordinance prohibiting its opening. Hough sued and the case went to the Florida Supreme Court, which allowed the museum to open. During its existence, however, the Chamber of Commerce

failed to list the museum in its tourist brochures and told those who inquired that the museum had closed, although it had not. Hough operated it until he died in 1996, and his widow then sold the building and auctioned off all of the exhibits.

Civil Rights

During 1963, St. Augustine was the site of demonstrations with sporadic violence. Robert Hayling, a Lincolnville dentist and local NAACP representative, organized campaigns against tourist-oriented segregated public facilities. He encouraged the federal government not to support the upcoming 1965 four-hundredth anniversary celebration of the city's founding. Hayling and others sent letters and telegrams to President Kennedy and Vice President Johnson asking for cooperation.

During the summer of 1963, white lunch counters became sites of sit-ins. Picketing

KKK Rally

This was the scene in St. Augustine on July 23, 1964, days after the enactment of the Civil Rights Act. The Ku Klux Klan held a parade that touched off violence, and white segregationists picketed motels and restaurants that allowed black individuals on their premises. The federal court was forced to take over administration of the city's public order. *Courtesy of the Florida Photographic Collection.*

and harassment increased. In September, the Ku Klux Klan held a rally and severely beat Hayling and three of his black companions. The following month, four white youths driving through a black neighborhood were shot at and one was killed. Shortly thereafter, black homes, stores and other sites were fired on by white individuals. In early 1964, shots were fired into Hayling's house, killing his dog and damaging the property. Hayling requested help from the Southern Christian Leadership Conference, which recruited volunteers from New England universities.

Two of the prominent figures on the pro–civil rights side were Mary Peabody, the mother of the governor of Massachusetts, and Esther Burgess, the wife of the Massachusetts Episcopal bishop. Burgess, a light-skinned black woman, was involved in sit-ins and demonstrations and was arrested during Easter week for trespassing at the Ponce de León Hotel. Their involvement helped to bring national attention to St. Augustine.

In May of 1964, Dr. Martin Luther King Jr. and Andrew Young worked to unite the city's black residents. Marches took place and a federal court blocked the city's attempt to impose a curfew. In June, violence and hatred was common. That month, Dr. King was arrested

for attempting to eat lunch at the Monson Motor Lodge, one of the city's largest white tourist motels. A swim-in resulted in television coverage of the white manager pouring muriatic acid into the pool when black individuals refused to get out of the water. The scene presented to the world was one of typical American racism.

It is believed that publicity generated in St. Augustine, and in particular television coverage of the manager of Monson's pouring the acid, helped focus legislators' attention on a pending civil rights bill and encouraged them to vote to end a Senate filibuster that was delaying its passage. The filibuster was ended on June 10 and the Senate passed the bill on June 19, more than four months after it was passed by the House of Representatives.

The Civil Rights Act of 1964 was signed into law by President Johnson on July 2, the day after King declared a halt to demonstrations. Local businessmen announced that they would comply with the portions of the new law that dealt with public accommodations, allowing both blacks and whites in restaurants and motels. With school beginning in September, most of the out-of-state demonstrators returned to their schools. Although court proceedings lasted for quite a while, the streets of St. Augustine returned to a more peaceful state, and previous whites-only establishments were available to all.

ANNIVERSARY
PROJECTS

In anticipation of the four hundredth anniversary of St. Augustine in 1964, a two-thousand-seat outdoor amphitheatre was constructed for the performance of *Cross and Sword*, a new state play authored by Paul Green. At the Mission of Nombre de Dios, a 208-foot-tall, stainless steel cross was dedicated on October 30, 1966, to mark the landing site of Pedro Menéndez, along with a new church building nearby. The week of celebrations included concerts, speeches, parades and historical reenactments.

The play was expensive to put on, with music, dance and drama, and as the amphitheatre aged it required

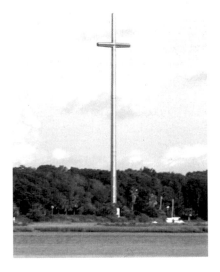

Quadricentennial Cross
In 1966, this 208-foot-tall cross was erected as part of St. Augustine's anniversary celebration. Named the Beacon of Faith, the stainless steel monument at the 1565 landing site of Pedro Menéndez was intended to be a beacon to all faiths. *Courtesy of the Florida Photographic Collection.*

more and more maintenance. Initially, *Cross and Sword* was automatically funded by the state, but it later had to compete with other state-supported arts. It also experienced a decline in attendance as other tourist attractions rose in popularity. Its 1997 request for state funding was denied, making 1996 its last season of production.

In 1998, ownership of the amphitheatre passed to St. Johns County. Five years later, a major renovation of the amphitheatre was begun that would more than double its seating capacity and turn it into a venue that could be used for other stage productions.

Cross and Sword
Actors portray a group of lovely Indian maidens dancing around a tribal totem as part of the official state play, *Cross and Sword*. During its thirty-year run, it entertained thousands with the story of the first two years of the existence of St. Augustine. *Courtesy of the Florida Photographic Collection.*

THE 1970s

HISTORIC DISTRICT
On April 15, 1970, the St. Augustine Town Plan Historic District was added to the National Register of Historic Places. It is bounded by Grove Avenue, the Matanzas River and South and Washington Streets.

MENÉNDEZ STATUE
In 1972, the mayor of Avilés, Spain, presented its sister city, St. Augustine, with a statue of Pedro Menéndez. It stands in the garden at the Lightner Museum.

THE 1980s

HISTORIC DISTRICTS
The Abbott Tract Historic District was added to the National Register of Historic Places on July 21, 1983. It consists of seventeen blocks bounded by Matanzas Bay, Pine Street and San Marco and Shenandoah Avenues. Osceola Street has examples of working-class homes from the past century and a half. The highest proportion of pre-1930 buildings in all of St. Augustine is found in the Abbott Tract, named for Lucy Abbott who owned the land after the Civil War.

The Model Land Company Historic District was added to the National Register on August 2, 1983. The twenty-block area is bordered by Ponce de León Boulevard and King, Cordova and Orange Streets.

THE 1990S

ST. AUGUSTINE TRANSFER COMPANY

In 1877, Louis A. Colee founded the St. Augustine Transfer Company to operate the stage line between St. Augustine and Picolata. As the city grew, Colee had an increasing number of Northern visitors to shuttle from the railroad to their winter homes. The company began with horse-drawn carriages, for a time shifted to trucks and cars and then returned to the quaint carriages. In 1888, Colee obtained the exclusive right to transport guests to and from the Flagler hotels.

The company grew to seventy employees and had more than a hundred wagons, surreys, landaus and cabriolets, and it acquired a reputation as "the best livery this side of Washington, D.C." In 1996, the Colee family sold the company to Stuart Gamsey, who had driven carriages for the Colees beginning in 1970.

NINA HAWKINS

Nina Stanton Hawkins, a newspaper editor who worked for the *St. Augustine Evening Record* from 1910 until 1953, was inducted into the Florida Newspaper Hall of Fame in 1999. She began as a society reporter in 1910, moved up to managing editor by 1925 and in 1926 was appointed editor. She was the first woman in Florida to serve as editor without being related to the owner of a newspaper.

WORLD GOLF HALL OF FAME

In 1998, the nonprofit World Golf Hall of Fame opened in St. Augustine on the grounds of the World Golf Village. Famous golfers' personal memorabilia, historical artifacts and interactive exhibits tell the history of golf and the members of the hall of fame. Adjacent to the hall is an IMAX Theater, the only one associated with a sports hall of fame.

THE TWENTY-FIRST CENTURY

Plans are under way for the celebration of the 450th anniversary of the founding of St. Augustine, which will take place in 2015. It is hoped that the pope and the king of Spain, or at least the crown prince, will attend the festivities.

Part Two

Walking Tours

Following is a list of sites that are historically important because of what was built there, what happened there or who lived there. Included are buildings and other features that still remain extant, plus a few others that are merely memories. Those that no longer exist are marked with asterisks.

Most structures are private residences, commercial establishments or governmental buildings, which are closed to general public access. Although they may be enjoyed from the outside, grounds and interiors are not available without the owners' prior permission.

They are arranged here in five neighborhoods, each with its own tour, which begins and ends at the same place. All may be walked or completed on a bicycle, except that during the Ancient City tour you must walk your bicycle along the pedestrian-only portion of St. George Street.

Four of the tours may be completed by car, but the Ancient City tour cannot. An essential portion is a pedestrian mall that can only be walked. Several streets are one-way and occasionally the walking tour goes in the opposite direction of permitted vehicular traffic. Furthermore, several streets in the Ancient City are very narrow and are often made even more difficult to drive because of oncoming traffic and parked vehicles, so a driver cannot safely see the historical sites and navigate the route.

The instructions given below will navigate you through the neighborhoods of St. Augustine merely by watching for street signs and numbers on the buildings. It is recommended that you also obtain one or more maps of the city, which are available at the Chamber of Commerce (in the Government House), public lodgings and nearly every retail store in the downtown area.

The distances shown below indicate cumulative miles from the respective starting points. The tour for the Ancient City works well as both a nine-mile walk and a pair of walks beginning at the Plaza de la Constitución—a four-mile loop north of King Street and a five-mile loop to the south.

Anastasia Island

Site	Distance	Address
1	0.0	Arredondo Ave. & Oglethorpe Blvd.
2	0.3	57 Comares Avenue
3	0.8	37 East White Street
4	0.8	37 Magnolia Drive
5	0.8	35 Magnolia Drive
6	0.9	46 East White Street
7	0.9	10 Lighthouse Avenue
8	1.0	8 Lighthouse Avenue
9	1.0	7 Lighthouse Avenue
10	1.0	5 Lighthouse Avenue
11	1.1	5 Ponce de León Avenue
12	1.1	15 Ponce de León Avenue
13	1.2	60 Lighthouse Avenue
14	1.2	62 Lighthouse Avenue
15	1.3	74 Lighthouse Avenue
16	1.3	81 Lighthouse Avenue
17	1.8	999 Anastasia Boulevard
18	1.9	400 Old Quarry Road
19	2.0	404 Old Quarry Road
20	3.2	77 Dolphin Drive
21	3.7	107 Oglethorpe Boulevard
22	3.9	12 Arpieka Avenue
23	4.3	10 Montrano Avenue
24	4.5	307 Minorca Avenue
	4.7	Oglethorpe Park

1.) INTERSECTION OF ARREDONDO AVENUE AND OGLETHORPE BOULEVARD

Oglethorpe Monument. This monument to commemorate the Siege of 1740 was dedicated in 1938 by the St. Augustine Historical Society and Institute of Science. Known as the Oglethorpe Monument, it marks

the site of El Pozo, the main battery used by James E. Oglethorpe in his actions against the Castillo. Just to the south of the park, at 121 Arredondo Avenue, was located a frame vernacular building constructed between 1925 and 1927, which served as the temporary Davis Shores administration and sales building. In later years, it was the meeting hall of the Knights of Columbus. The building was allowed to deteriorate and was recently razed.

[Southeast on Arredondo Avenue, northeast on Ribault Street, southeast on Comares Avenue]

2.) 57 COMARES AVENUE

Conch House. In about 1948, Jimmy Ponce Sr. opened the Conch House Marina Resort at this location along the banks of Salt Run. The building was designed to resemble the Capo Beach House, built during the 1870s above the river a little north of the Plaza de la Constitución and reached by a short bridge from the sea wall until it was destroyed by fire in 1914. The Conch House has a two-hundred-slip marina and a popular restaurant and cocktail lounge.

[Southeast on Comares Avenue, southeast on Anastasia Boulevard, east on White Street to Magnolia Avenue]

3.) 37 EAST WHITE STREET

Busam House. In 1908, Shepharin and Mary Busam moved to Anastasia Island and delivered its mail. In this five-sided building constructed between 1924 and 1930, they ran a store and filling station. Later, it was converted to a residence.

[Cross Magnolia Drive]

4.) 37 MAGNOLIA DRIVE

Cozy Inn. During the 1920s, this masonry structure was an inn operated by Mary H. Heston, Anastasia Island's postmaster. It was later converted to a residence and its main entrance was moved to its north side along White Street.

[Cross White Street]

5.) 35 MAGNOLIA DRIVE

Coquina Inn. This house was constructed between 1910 and 1917 of coquina, making it one of the earliest homes on the island made from locally quarried material. It has a basement, an uncommon feature in the area, plus ornamental ceramic decoration on the front of the house.

[East on White Street]

6.) 46 EAST WHITE STREET

Betsworth House. Captain William Betsworth of Baltimore built this structure as a two-and-a-half-story home in the late 1890s and called it the Betsworth Castle. It has a masonry first floor and a wraparound porch. After his death, his widow referred to the home as the Oriole Cottage and sold it in 1904. It was added to the White family compound in 1913, and later was rented as apartments. It was reduced to one story and the porch was partially enclosed.

[East on White Street, north on Lighthouse Avenue]

7.) 10 LIGHTHOUSE AVENUE

Shands House. Mary Eliza Shands had this frame vernacular house built between 1887 and 1894. After belonging to two other owners, it was sold to Chester and Winifred Erwin Littlefield in 1920. Within four years, they enlarged the house from one to two stories. In 1930, a three-story Victorian tower was added on the north end.

8.) 8 LIGHTHOUSE AVENUE

Bean House. In 1886, this home was built for Moses R. Bean, who died in 1896. His widow and daughter remained in the cottage until 1899 and then sold it to Lauriston S. Smith of the Smith and Woodson Drug Store. The home was built in a Victorian style with jigsaw woodwork, which remains in the gable despite numerous remodelings.

9.) 7 LIGHTHOUSE AVENUE

Ingraham Cottage. Between 1907 and 1910, this frame vernacular home was built by James E. Ingraham, the vice-president of the Florida East Coast Railway who resided at 32 Sevilla Street. The Lighthouse Avenue home served as the family's beach house until 1943.

10.) 5 LIGHTHOUSE AVENUE

Smith Cottage. Between 1895 and 1899, this frame vernacular house was built by Oscar B. Smith as a one-story wood frame cottage. From 1914 to 1918, it was the winter home of inventor Robert L. Gibson, and then it was the home of his widow, Anna, until 1945. Other owners included Thomas M. Carnegie Jr., a nephew of Andrew Carnegie. Various modifications over the years transformed the home into a larger structure with few of the original Victorian details.

[South on Lighthouse Avenue, west on White Street, south on Ponce de León Avenue]

11.) 5 PONCE DE LEÓN AVENUE

Russell House. This two-story frame vernacular home was built in 1910 for William J. Russell, the chief electrician of the U.S. Wireless Station that was located on Carver Street. He sold it to Felix Fire who in turn

sold it to George Reddington. After 1930, a three-story tower was added.

12.) 15 PONCE DE LEÓN AVENUE

Howes House. Between 1885 and 1893, Orange Howes built a home on this lot. Today, it is three and a half stories tall with a masonry ground floor, novelty siding on the second floor and board and batten siding on the third floor. It is possible that the masonry first floor was erected between 1910 and 1925 and the upper floors are a combination of at least two older homes. Howes served as the island's postmaster and ran a skating rink on Maria Sanchez Creek. The home was added to the White family compound in 1913.

[North on Lighthouse Avenue]

13.) 60 LIGHTHOUSE AVENUE

White Mansion. Utley J. and Sarah White purchased lots in the Lighthouse Park area, including the Octagon House, the Betsworth House and the Howes House, to create a family compound. In 1912, this two-and-a-half-story, brick and stucco home was constructed with marble front steps, and the compound was surrounded by a concrete block wall. Daughter Wilma conveyed the property in 1953 to the Preachers' Relief Fund of the Florida Conference of the Methodist Church. The home was later converted to apartments.

14.) 62 LIGHTHOUSE AVENUE

Octagon House. This lot was one of the first two purchased in what was being developed as "the new city of Anastasia," which then became the neighborhood of Lighthouse Park. The eight-sided home was built by Rollin N. Clapp in 1886, following a national trend of octagonal homes that had begun during the 1850s. The second-story open porch had a Chinese Chippendale balustrade and the roof was surmounted by a widow's walk. Wings were added in later years on the north and west sides. Clapp sold the house and lot for $625 in 1905.

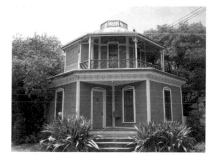

Octagon House
After this eight-sided home was sold by its original owner in 1905, it was used as a beach house rented by a series of people. Two of its notable residents were Mary Antin, who authored *The Promised Land* in 1912, and artist Norman MacLeish. *Photo by Kelly Goodman.*

15.) 74 LIGHTHOUSE AVENUE

Speights House. This two-story wooden house now supported by concrete blocks was built between 1886 and 1894 at 60 Lighthouse Avenue. It was moved to its present site by 1912 to make room for the construction of the White Mansion. It was owned by a farmer, J.T. Speights.

16.) 81 LIGHTHOUSE AVENUE

Lighthouse. Information on the present St. Augustine lighthouse is contained in "The 1870s" section of this book.

[East on Carver Street, south on Red Cox Drive]

17.) 999 ANASTASIA BOULEVARD

Alligator Farm. In 1891, Joseph Campbell opened an alligator farm in Palm Beach, and then another one in Jacksonville. Around the same time, Felix Fire and George Reddington exhibited about forty penned-up alligators at the beach on Anastasia Island, near the end of a tram railway that crossed the island adjacent to Everett C. Whitney's Burning Spring Museum. During 1893, their facility was called the South Beach Alligator Farm and Museum of Marine Curiosities, a name under which they incorporated in 1909.

Alligator Farm
In addition to research, the St. Augustine Alligator Farm became popular for providing entertainment, displaying reptiles in cages and other natural habitats. Here, one of the attraction's guides poses with a large alligator to delight and amaze spectators. *Courtesy of the Florida Photographic Collection.*

In the early 1920s, the farm moved about two miles to the north to its present location at 999 Anastasia Boulevard. In about 1934, Reddington bought out Fire's interest, and in 1937, he sold the business to W.I. Drysdale and F. Charles Usina. They combined the St. Augustine attraction with the Campbell alligator farm in Jacksonville, calling it the St. Augustine Alligator Farm. It was badly damaged by a fire, and they rebuilt and expanded it. The farm was a popular destination for military personnel stationed in Florida during World War II, and by their telling others about it, it became a major tourist destination.

In later years, the St. Augustine Alligator Farm has also become popular with researchers interested in not only alligators, but also the other animals that live in the farm's controlled environment. A nature trail was established in the park during the 1970s. It received

accreditation from the American Association of Zoological Parks and Aquariums in 1989. The facility was added to the Natural Register of Historic Places in 1992. An expansion in 1993 added the Land of Crocodiles, where representatives of each of the world's twenty-three species of crocodilians are on display.

[Southwest on Old Quarry Road]

18.) 400 OLD QUARRY ROAD

A L'aise. This house was constructed during the late 1920s by Gould T. Butler, and it was given a name which in French means "At Ease." It was the home of August Heckscher who made his millions in coal and zinc mining and New York real estate. He bought an orange grove in Florida to help feed the poor of New York and founded the Heckscher Foundation for Children. He also developed Vilano Beach and its casino north of St. Augustine. On the property are a bomb shelter and swimming pool. The wrought-iron front gate attached to the stone pillars was manufactured in Italy. A later owner was Hobson T. Crane who served as the mayor of St. Augustine and owned Zoric Cleaners.

19.) 404 OLD QUARRY ROAD

Day House. This frame vernacular home was built by local architect Gould T. Butler for A.B. Day between 1910 and 1917. It features a three-sided arcade made from palm tree trunks. The foundation is made from coquina concrete block. In addition to being a private residence, it has also served as a kindergarten and a movie set for 1988's *Illegally Yours.*

[Southwest on Old Quarry Road, northwest on Coquina Avenue, north and northwest on Arricola Avenue, south on Arredondo Avenue, southeast, southwest and northwest on Dolphin Drive]

20.) 77 DOLPHIN DRIVE

Baskin House. This was the home of Norton Baskin, the widower of author Marjorie Kinnan Rawlings. In the house is a black-and-white tile floor, plus a staircase that had originally stood in Flagler's mansion, Kirkside.

[Northwest on Dolphin Drive, east on Arricola Avenue, north on Gerado Street, east on Oglethorpe Avenue]

21.) 107 OGLETHORPE BOULEVARD

Milam House. This home was one of the few actually constructed as part of the Davis Shores development during the 1920s, and was to be the home of the project's general manager, Robert R. Milam. The area was hit by a hurricane in 1926, and D.P. Davis suffered financial difficulties. Davis fell off of a cruise ship in the Atlantic, either as an

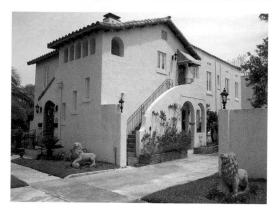

Milam House
This was the largest house planned by D.P. Davis on the marshy north end of Anastasia Island. It is also one of the few that was completed in the original Davis Shores development before Davis disappeared and the project was terminated. *Photo by Kelly Goodman.*

accident or suicide. As a result, the big plans for Davis Shores were never completed.

[West on Oglethorpe Boulevard, north on Gerado Street, west on Arpieka Avenue]

22.) 12 ARPIEKA AVENUE

Apartment Building. This is an apartment house built during the 1925–27 land boom. It was designed by Carlos Schoeppl, the architect for the Vilano Beach Casino, in a Mediterranean Revival style.

[West on Arpieka Avenue, north and northeast on St. Augustine Boulevard, southeast on Arredondo Avenue, north on Montrano Avenue]

23.) 10 MONTRANO AVENUE

Residence. This two-story Mediterranean Revival–style home built between 1925 and 1927 features a three-stepped roof and an attractive metal balcony. It is one of the few remaining original Davis Shores homes.

[North on Montrano Avenue, east on D'Allyon Avenue, southwest on Minorca Avenue]

24.) 307 MINORCA AVENUE

Ryman House. This house was built between 1925 and 1927 as the residence of Harold Ryman. His Ryman-Thompson Real Estate firm marketed the lots at Davis Shores until the project came to a halt in 1926. It is built in a Mediterranean Revival style.

[Southwest on Minorca Avenue, southeast on Arredondo Avenue to the beginning]

Ancient City

Sites North of King Street

Site	Distance	Address
1	0.0	East end of King Street
2	0.1	124 Charlotte Street
3	0.1	24–28 Cathedral Place
4	0.1	36 Cathedral Place
5	0.1	38 Cathedral Place
6	0.1	St. George Street
7	0.1	152–56 St. George Street
8	0.2	143 St. George Street
9	0.2	57 Treasury Street
10	0.4	80–92 Charlotte Street
11	0.4	58 Charlotte Street
12	0.4	56½ Charlotte Street
13	0.4	52 Charlotte Street
14	0.5	26 Toques Place
15	0.5	35 Hypolita Street
16	0.6	97 St. George Street
17	0.6	91 St. George Street
18	0.6	74 St. George Street
19	0.6	72 St. George Street
20	0.6	70 St. George Street
21	0.6	69 St. George Street
22	0.6	65 St. George Street
23	0.6	62 St. George Street
24	0.7	105 St. George Street
25	0.7	121 St. George Street
26	0.8	62A Spanish Street
27	0.8	76 Spanish Street

Site	Distance	Address
28	0.9	59 Hypolita Street
29	1.0	70 Hypolita Street
30	1.0	51 Cordova Street
31	1.0	6 Valencia Street
32	1.0	8 Valencia Street
33	1.0	20 Valencia Street
34	1.1	44 Sevilla Street
35	1.2	48 Sevilla Street
36	1.3	36 Valencia Street
37	1.3	35 Valencia Street
38	1.5	55 Riberia Street
39	1.5	50 Carrera Street
40	1.5	52 Carrera Street
41	1.6	67 & 71 Carrera Street
42	1.8	76–78 Saragossa Street
43	1.8	56 Saragossa Street
44	1.9	16 Riberia Street
45	1.9	16 Mulvey Street
46	2.2	67 Orange Street
47	2.3	63 Orange Street
48	2.3	61 Orange Street
49	2.4	14 Sevilla Street
50	2.4	24 Saragossa Street
51	2.4	28 Saragossa Street
52	2.6	27 Sevilla Street
53	2.6	32 Sevilla Street
54	2.6	33 Sevilla Street
55	2.7	9 Carrera Street
56	2.7	8 Carrera Street
57	2.8	70 Cuna Street
58	2.8	30 Cordova Street
59	2.8	26 Cordova Street
60	2.9	13 Saragossa Street
61	3.0	20 Cordova Street
62	3.1	7 Cordova Street
63	3.1	40 Orange Street
64	3.1	47 Orange Street
65	3.2	31 Orange Street
66	3.2	24 Orange Street
67	3.3	1 South Castillo Drive
68	3.3	14 St. George Street
69	3.3	19½ St. George Street
70	3.4	21 St. George Street
71	3.4	22 St. George Street
72	3.4	27 St. George Street
73	3.4	29 St. George Street

Site	Distance	Address
74	3.4	33 St. George Street
75	3.4	35 St. George Street
76	3.4	37 St. George Street
77	3.4	41 St. George Street
78	3.4	42 St. George Street
79	3.4	43 St. George Street
80	3.4	46 St. George Street
81	3.4	52 St. George Street
82	3.4	53 St. George Street
83	3.4	54 St. George Street
84	3.4	58½ St. George Street
85	3.4	59 St. George Street
86	3.4	60 St. George Street
87	3.5	42 Spanish Street
88	3.5	44 Spanish Street
89	3.5	46 Spanish Street
90	3.6	29 Cuna Street
91	3.6	27 Cuna Street
92	3.6	26 Cuna Street
93	3.6	25 Cuna Street
94	3.6	17 Cuna Street
95	3.6	12 Charlotte Street
96	3.7	26 Charlotte Street
97	3.7	8 Avenida Menendez
98	3.7	12 Avenida Menendez
99	3.8	22 Avenida Menendez
100	3.8	24 Avenida Menendez
101	3.8	32 Avenida Menendez
102	3.8	42 Avenida Menendez
103	3.9	44 Avenida Menendez
104	3.9	46 Avenida Menendez
105	3.9	1 Anderson Circle
	4.0	Plaza de la Constitución

SITES ALONG KING STREET AND TO THE SOUTH

Site	Distance	Address
	4.0	Plaza de la Constitución
106	4.0	1 King Street
107	4.0	11 King Street
108	4.0	17 King Street
109	4.0	31 King Street

Site	Distance	Address
110	4.1	41 King Street
111	4.1	48 King Street
112	4.2	74 King Street
113	4.2	75 King Street
114	4.2	81C King Street
115	4.3	83 King Street
116	4.3	93½ King Street
117	4.3	99 King Street
118	4.4	102 King Street
119	4.4	105 King Street
120	4.5	118–20 King Street
121	4.5	77 Riberia Street
122	4.5	124 King Street
123	4.6	136 King Street
124	4.7	1 Malaga Street
125	4.7	157 King Street
126	4.9	88 Riberia Street
127	5.0	122 Riberia Street
128	5.2	9 Martin Luther King Avenue
129	5.2	89 Cedar Street
130	5.2	87 Cedar Street
131	5.3	83 Cedar Street
132	5.3	79 Cedar Street
133	5.4	12 Granada Street
134	5.4	32 Granada Street
135	5.6	154 Cordova Street
136	5.6	161 Cordova Street
137	5.7	172–80 Cordova Street
138	5.8	282 St. George Street
139	5.8	287 St. George Street
140	5.8	288 St. George Street
141	5.9	297 St. George Street
142	5.9	298 St. George Street
143	5.9	311 St. George Street
144	6.0	322 St. George Street
145	6.3	159 Marine Street
146	6.4	180 Marine Street
147	6.6	4 Tremerton Street
148	6.6	5 Tremerton Street
149	6.7	124 Marine Street
150	6.8	105 Marine Street
151	6.8	104 Marine Street
152	6.8	101 Marine Street
153	6.8	97 Marine Street
154	6.9	86–92 Marine Street
155	6.9	82 Marine Street

Site	Distance	Address
156	7.0	14 St. Francis Street
157	7.0	18 St. Francis Street
158	7.0	22 St. Francis Street
159	7.1	257 Charlotte Street
160	7.1	267 Charlotte Street
161	7.1	271 Charlotte Street
162	7.2	25 St. Francis Street
163	7.2	28 St. Francis Street
164	7.2	31 St. Francis Street
165	7.2	34 St. Francis Street
166	7.2	279 St. George Street
167	7.3	268 St. George Street
168	7.3	262–64 St. George Street
169	7.3	259 St. George Street
170	7.4	256 St. George Street
171	7.4	252 St. George Street
172	7.4	246 St. George Street
173	7.4	241 St. George Street
174	7.5	36 Aviles Street
175	7.6	33 Aviles Street
176	7.6	32 Aviles Street
177	7.7	38 Marine Street
178	7.7	35 Marine Street
179	7.7	15 Bridge Street
180	7.7	7 Bridge Street
181	7.7	46 Marine Street
182	7.7	47 Marine Street
183	7.8	53 Marine Street
184	7.8	56 Marine Street
185	7.8	59 Marine Street
186	7.8	67 Marine Street
187	7.9	174 Avenida Menendez
188	8.0	172 Avenida Menendez
189	8.1	146 Avenida Menendez
190	8.1	142 Avenida Menendez
191	8.2	111 Avenida Menendez
192	8.3	16 Marine Street
193	8.3	22 Marine Street
194	8.3	11 Cadiz Street
195	8.3	21 Aviles Street
196	8.4	20 Aviles Street
197	8.4	232 St. George Street
198	8.4	234 St. George Street
199	8.5	1 Palm Row
200	8.5	3–4 Palm Row
201	8.5	123 Cordova Street

Site	Distance	Address
202	8.6	115 Cordova Street
203	8.6	95–99 Cordova Street
204	8.8	214 St. George Street
205	8.8	215 St. George Street
206	8.8	224 St. George Street
207	8.8	4 Artillery Lane
208	8.9	3 Aviles Street
209	8.9	12 Aviles Street
210	9.0	206 Charlotte Street
	9.0	Plaza de la Constitución

[Begin at the Plaza de la Constitución at the east end of King Street]

1.) BLOCK FORMED BY KING AND CORDOVA STREETS, CATHEDRAL PLACE AND AVENIDA MENENDEZ

The Plaza de la Constitución. Located on this public square are several historical sites:

City Market. The current structure of St. Augustine's market dates to 1824. It replaced a prior coquina building erected during the 1700s. Prior to that, dating back to 1598, the site was used for a city market. The present building served as a guardhouse and marketplace. The floor is constructed of masonry, which supports square pillars of coquina topped by a gabled roof and square cupola. The structure was rebuilt twice during the 1800s following storm and fire damage.

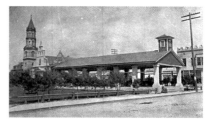

City Market

This structure, the last in a series of markets on the Plaza de la Constitución dating back to 1598, goes by the names of the Old Spanish Market, the Old Market and the Old Slave Market. The last name is probably a misnomer, as there are doubts as to whether slaves were ever traded here. This photo is from 1893, three years after the city market was moved to the city hall. *Courtesy of the Florida Photographic Collection.*

Spanish Public Well. This is a 1975 reconstruction of a first Spanish period well that was partially destroyed during the British colonial period.

Constitution Obelisk. This thirty-foot-tall obelisk was dedicated on February 14, 1814, following the adoption of the liberal Spanish constitution. A royal order required the provincial towns to erect monuments to commemorate the event. Not long afterward, the constitution was revoked and the monuments were ordered taken down, but St. Augustine refused.

World War II Memorial. This monument was presented to the city in 1946 by the Pilot Club. It honors those killed in World War II and later conflicts.

Anderson Fountain. This fountain was erected in 1921.

Confederate War Memorial. This obelisk was commissioned by the Ladies' Memorial Association and was erected in 1872. It was first located on the east side of St. George Street and was moved to the Plaza de la Constitución in 1879.

Varela Monument. This tribute honors Felix Varela Morales, a Cuban-born patriot and priest.

[Cross to the northwest corner of the intersection of Charlotte Street and Cathedral Place]

2.) 124 CHARLOTTE STREET

Bank of America. During the 1920s, the Jefferson Theatre was located here in a four-story building, and after serving as an opera house and vaudeville theatre, it began showing silent films. A small two-manual organ was installed in 1927. In 1955, the property was purchased by the St. Augustine National Bank, which erected a new building on the site. It was remodeled in 1967 and renamed Barnett Bank in 1971. Later it became the Bank of America. The Tropical Trade Winds Lounge

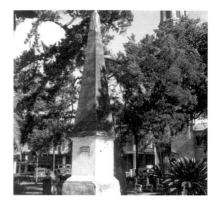

Constitution Monument
The monument bears small tablets designating this area as the "Plaza de la Constitución." When the Spanish government ordered that the monument be taken down, St. Augustine only removed the tablets from it. They were reattached to the monument in 1818. *Courtesy of the Florida Photographic Collection.*

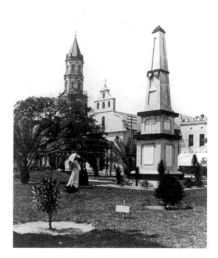

Confederate Monument
Erected in 1872, this is the oldest Confederate Civil War monument in Florida. Other nearby relics of the Civil War include an eight-inch Rodman artillery piece and a ten-inch mortar. This photo was taken in 1891, and the Cathedral Basilica can be seen in the background. *Courtesy of the Florida Photographic Collection.*

Vaill Block
On this site sat the four-story St. Augustine Hotel that was owned by Captain Edward E. Vaill. It was replaced by this tower, the city's only skyscraper. For a time, it was the home of the Exchange Bank. *Courtesy of the Florida Photographic Collection.*

is now also housed in the two-story building on the Charlotte Street side of the site.

[West on Cathedral Place]

3.) 24–28 CATHEDRAL PLACE

Vaill Block. This 1927 Mediterranean Revival–style building was erected by San Marco Construction Company and later was remodeled as a bank by Francis A. Hollingsworth. Today, it includes Wachovia Bank, galleries and gift shops, plus offices and residential condominium units.

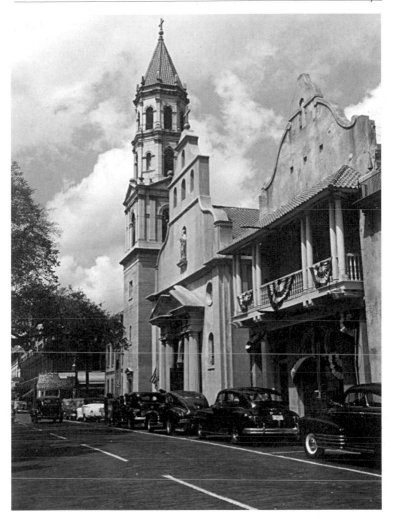

Cathedral Place
This view of Cathedral Place, looking westward, shows the tall bell tower that was added to the Cathedral Basilica in the late 1880s. To its right, the building with the curved parapet was built as a bank. This photo dates to 1947. *Courtesy of the Florida Photographic Collection.*

4.) 36 CATHEDRAL PLACE
(AND 35 TREASURY STREET)

Cathedral Basilica of St. Augustine. The original construction of this structure was completed in 1797. After a fire, it was restored in 1887 and a Spanish Renaissance–style bell tower was added. The architect for the work was James Renwick Jr., who also designed the Castle of the Smithsonian Institution and New York's St. Patrick's Cathedral. Renwick had purchased the old Buena Vista tract on Anastasia Island in 1872 and was approached by civic leaders seeking his architectural skills following the fire. The fanlight over the front entrance is flanked by

Doric columns. The cathedral was covered with stucco during the 1960s and added to the National Register of Historic Places on April 15, 1970.

5.) APPROXIMATELY 38 CATHEDRAL PLACE

Bishop's Residence. Previously located here was the residence of the Catholic bishop, completed during the 1880s. It had a sculpted stone wall on the south and west sides of the lot that was built in 1890 to replace a previous picket fence. St. Augustine had an ordinance making it illegal to sit on the wall. During 1965, that residence was torn down and the wall was moved to a yard at 262 St. George Street.

Bishop's House
For about eight decades, the head of the Catholic diocese headquartered in St. Augustine resided in this building, located next door to the Cathedral Basilica on the site of today's courtyard and statue of Father Pedro Camps. This image is from the 1960s, shortly before the home was razed. *Courtesy of the Florida Photographic Collection.*

[West on Cathedral Place, north on St. George Street]

6.) NORTHWEST CORNER OF ST. GEORGE STREET AND CATHEDRAL PLACE

Tourist Information Booth. During the 1790s, the building on the next lot to the north was the home of John McQueen. The Catholic Church bought both lots in 1856 and erected St. Mary's Convent behind the existing house for the Sisters of Mercy. They arrived in St. Augustine before the Civil War, and were forced into exile during the war. After the war, they returned and were joined by the Sisters of St. Joseph in 1866. Both shared the convent until 1869, when the Sisters

St. Mary's Convent
This three-story building served as a convent during the last half of the nineteenth century. In about 1900, a cigar factory on Hypolita Street burned down, so the bishop allowed its owner to move into the former convent building so he could continue to manufacture cigars. *Courtesy of the Florida Photographic Collection.*

of Mercy left the city. The convent was abandoned when a new St. Joseph's Convent opened at 241 St. George Street. The building was torn down in 1960, and the property was later used for a bank parking lot and tourist information booth.

7.) 152–56 ST. GEORGE STREET

Mission Building. This Moorish Revival–style two-story building was erected between 1885 and 1888. It originally was owned by curiosity dealer E. Mission, and in 1902 Edward B. Genovar opened a barbershop in it. It is also known as the Tarlinsky Building and is the home of the H.W. Davis Clothing & Shoe Store, established in 1894.

8.) 143 ST. GEORGE STREET

Dr. Peck House. This first Spanish period home with coquina walls and a tabby floor was built in about 1715. Between 1741 and 1763, it was the home of Royal Treasurer Juan Esteban

Dr. Peck House
Now the Woman's Exchange Gift Shop, this nearly two-hundred-year-old building has a small second-floor balcony. However, to reach it you have to open a window and two small doors beneath it, and then step through the opening. *Courtesy of the Florida Photographic Collection.*

de Pena, so it is also known as the Treasurer's House. While the British ruled, it became the home of Lieutenant Governor John Moultrie and an east wing was added. In 1784 Governor Patrick Tonyn moved in. It was vacant for part of the second Spanish period (1784–1821), but then became a home for slaves. Dr. Seth Peck of Whitesboro, New York, bought it in 1837 and added a wooden second floor. Here, he entertained guest Sidney Lanier, known as the "Poet Laureate of the South." Dr. Peck's granddaughter, Anna Burt, willed the home to the city and the Woman's Exchange took over its maintenance. It was opened as a museum in 1932, at which time it still retained its L shape. The eastern portion was reconstructed in 1968–70, completing its present U shape.

[North on St. George Street, west on Treasury Street]

9.) 57 TREASURY STREET

Joaneda House. Minorcan farmer Juan Joaneda built a wooden house on this lot in about 1790. By 1807, it had been replaced with a one-story Spanish Colonial–style coquina structure. Joaneda could not pay its builder, so he sold the house. It was restored during the 1970s.

[East on Treasury Street, north on Charlotte Street]

10.) 80–92 CHARLOTTE STREET

Monson Apartments. This apartment complex was built in a Mediterranean Revival style between 1924 and 1930. The first floor is now occupied by a boutique, gallery and real estate office.

11.) 58 CHARLOTTE STREET

Herrera House. This home from the first Spanish period was built for Juan de Muros. After the Spanish returned, it was acquired by Luciano de Herrera, who rented it to a tailor. Herrera's heirs sold it to Don Miguel Ysnardy, the contractor who built the Cathedral Basilica. In 1792, it was acquired by a free black man, Pedro de Cala, who sold it in 1803 to Don Gabriel Guillermo Perpall. It was reconstructed in 1967 and used as an office before it became La Pentola Restaurant.

12.) 56½ CHARLOTTE STREET

Secret Garden Inn. This two-story home was built in about 1920, and by the 1940s it was the home of the Abernethy-Kitchens Typewriter Shop. Residents of the property have included Mrs. Harold Playter (from 1966 until 1979) and professional singer Marie Ward, who was known as the "Songbird of the South." It was converted to the Secret Garden Inn during 1991 and is now an antiques shop.

13.) 52 CHARLOTTE STREET

Inn on Charlotte. This two-story brick house was built in 1918 for attorney Levi Nelson. It was later converted to a bed-and-breakfast.

[North on Charlotte Street, west on Hypolita Street, north on Toques Place]

14.) 26 TOQUES PLACE

Ancient City Antiques. Now an antique shop, this frame vernacular building was erected in 1910 as a carriage house or servants' quarters. When the main house burned down, its family moved into this structure. For a time it was used as a restaurant before serving as an antique shop. It is believed by some to have been haunted in previous years by a ghost who wrote on the bathroom mirror and also by a young boy.

[South on Toques Place, west on Hypolita Street]

15.) 35 HYPOLITA STREET (AND 103 ST. GEORGE STREET)

Casa del Hidalgo. This masonry vernacular structure is a 1965 reconstruction of the original home. It houses shops, a restaurant and a visitor information center.

[West on Hypolita Street, north on St. George Street]

16.) 97 ST. GEORGE STREET

Marin-Hassett House. This is a 1969 reconstruction of a Spanish Colonial home owned by a member of the upper class during the first Spanish period. In 1787, it belonged to Father Thomas Hassett. Near the home is a statue of Queen Isabella of Spain, sculpted by Anna Huntington and placed there in 1965. In the building is the Pink Petunia clothing store.

17.) 91 ST. GEORGE STREET

Santoya House. In 1764, the house on this lot belonged to Miguel Santoya, a Spanish dragoon. During the British colonial period, it was acquired by surgeon George Kemp. The two-room house was made of ripio and was set back from the street, unusual for St. Augustine. Along the street was a high wall with a barred gate. The floor was probably wood or dirt, and the inhabitants slept on pallets that were rolled out at nighttime. The original house was destroyed by 1788, and it was reconstructed in 1966. It now houses a jewelry store.

18.) 74 ST. GEORGE STREET

Acosta House. The original Acosta House was built between 1803 and 1812 by Jorge Acosta (circa 1764–1812) of Corsica. His wife, Margarita Villalonga, was of Minorcan descent. The coquina structure was a private home until the 1880s, and then it became the home of the Woman's Exchange. It was torn down in about 1917. The house was reconstructed in 1976 with funds provided by the Versaggi Brothers Foundation, Inc. It now houses an art gallery.

19.) 72 ST. GEORGE STREET

Villalonga House. This was the home of Bartolomé Villalonga (1789–1825) of Minorca and his wife, Maria Acosta of Corsica. It was built between 1815 and 1820 with a loggia typical of the period and was reconstructed in 1976 but retains its original foundation. It is now a cat boutique shop.

20.) 70 ST. GEORGE STREET

Ortega House. This home, built in about 1740, became the home of Spanish armorer Nicolas de Ortega in 1764. At the time, there was a small outbuilding, probably a kitchen. Ortega lost ownership when the British arrived, but when the Spanish returned, Ortega's heirs successfully litigated and acquired the property. It was reconstructed in 1967 with funds from A.D. Davis, J.E. Davis and Winn Dixie Stores, Inc.

21.) 69 ST. GEORGE STREET

Suarez-McHenry House. This tabby house dates to the first Spanish period. In 1787, it was acquired by William McHenry of Ireland. It was reconstructed by Thompson-Bailey Realty and now houses a restaurant.

22.) 65 ST. GEORGE STREET

Benét House. In 1804, this lot and a wooden house were purchased by Estevan Benét (Don Estaban Benéto) of Minorca, and he replaced the existing structure with a coquina house. One of his children, Pedro Benét, was an original member of the Florida Historical Society beginning in 1856. Pedro operated a store across the street and served on the city council. The house was reconstructed in 1965 and is now an ice cream parlor.

23.) 62 ST. GEORGE STREET

Benét Store. This wood and stone building was owned by Matias Pons until he died in 1817. Under his ownership, the building served as a grocery. It was purchased in 1839 by Pedro Benét, who had been operating a store on the first floor of his home across the street. In 1840, he transferred his liquor license from 65 to 62 St. George Street. After Pedro died in 1870, his son Joseph operated the store until 1887. It was torn down in 1903 and reconstructed in 1967 by the Historic St. Augustine Preservation Board. For a time, it was operated as the Museum Store and is now a gift shop.

[South on St. George Street]

24.) 105 ST. GEORGE STREET

Sánchez-Burt House. This Spanish Colonial–style home was constructed in about 1809. It was the home of Francisco Xavier Sánchez and his wife, Mary Hill, of Charleston. It was restored by the Independent Life Insurance Company and the Herald Life Insurance Company.

25.) 121 ST. GEORGE STREET

The Bunnery. Previously located in this building was the St. George Pharmacy. The St. Augustine Colonial Revival–style store was built between 1917 and 1924.

[North on St. George Street, west on Hypolita Street, south on Spanish Street]

26.) 62A SPANISH STREET

Fornells House. Barracks for Spanish dragoons were previously located on this site. This two-story Spanish Colonial–style coquina home was built by Pedro Fornells between 1800 and 1807 when the property extended back to Cordova Street and had 196 orange trees. The home was restored in 1962 by the St. Augustine Historical Society and now houses a bath accessories store.

27.) 76 SPANISH STREET

Sabate House. This one-and-a-half-story, frame vernacular house tucked in between two taller homes was built by alderman Ramón Sabate in

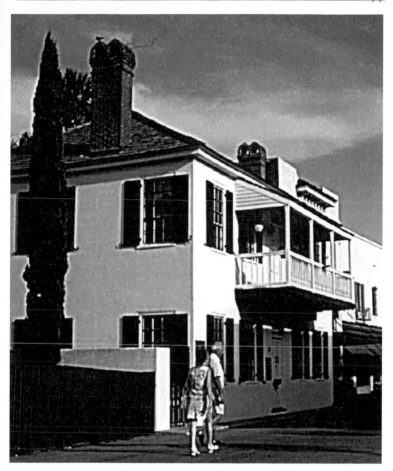

Sánchez-Burt House
Much of the dating of buildings in St. Augustine is based on the well-documented changes of architectural styles over the centuries. This home's hip roof with a pitch of thirty degrees, along with its height that is greater than that of two-story homes of other periods, confirms its construction in about 1809. *Courtesy of the Florida Photographic Collection.*

about 1840 and sits back from the street. It is not the home's original location, as it previously sat at the corner of Spanish and Treasury Streets some time before 1874. It features dormer weatherboard slanted at forty-five degrees, rather than placed horizontally, to be parallel to the roofline.

[North on Spanish Street, west on Hypolita Street]

28.) 59 HYPOLITA STREET

Old Florida Spice Traders. A house built on this lot between 1820 and 1833 was a predecessor of the current two-and-a-half-story structure, erected in about 1850 and altered since. The current structure was designed in

a St. Augustine Colonial Revival style, utilizing Spanish elements that may or may not have actually appeared in original Spanish buildings. During the 1920s, the Tangerine Tea Shoppe was located here.

29.) 70 HYPOLITA STREET

Scarlett O'Hara's Restaurant. This house was built by Mr. Colee for his fiancée in 1879. He drowned while taking a bath in one of the upstairs bathrooms, and some believe the home (especially the second floor near the present restaurant's Ghost Bar) is haunted by his ghost. Allegedly, another ghost can be found near the main bar downstairs. Some also claim that while the second story of the building was being rented as an apartment in 1975, a man was murdered there in the bathtub and the area is haunted by his spirit.

[West on Hypolita Street, south on Cordova Street]

30.) 51 CORDOVA STREET

Villalula House. This Mediterranean Revival–style structure was built between 1880 and 1884. At various times, it was the Worley Realty Company, the Hiawatha Gift Shop and the Pennsylvania Restaurant. It now houses several stores that sell art, books, clothing and gifts.

[South on Cordova Street, west on Valencia Street]

31.) 6 VALENCIA STREET

Casa Amarylla. This two-and-a-half-story, Colonial Revival frame home was built in 1898 with a one-story porch on the south side. It was initially occupied by Dr. Fremont-Smith, Henry Flagler's hotel doctor, but he moved in 1899 to the new Flagler resort in Palm Beach. The structure became known as Casa Amarylla when it was owned by Albert Lewis, the "Pennsylvania Lumber King," for about twenty years beginning in 1900. In 1936, the house was remodeled under the supervision of Francis A. Hollingsworth to be a charitable preschool day-care center, but before it opened it was sold to Vernon A. Lockwood who turned it into the Valencia Apartments, a name it had from 1940 to 1975. The property was later donated to Flagler College and is used as an administration building called Wiley Hall. The horse hitching ring in front dates to about 1900.

32.) 8 VALENCIA STREET

Lewis Outbuilding. This building sat on the grounds of the Albert Lewis estate. The posts supporting the roof extension over the front door are palm tree trunks.

33.) 20 VALENCIA STREET

Union Generals' House. McGuire and McDonald, contractors for Henry Flagler, built this home in 1889 for Osborn Dunlap Seavey, who managed the Ponce de León Hotel. It copied the hotel's color

scheme of gray and red, but lacks the Ponce's Spanish style. In 1899, it became the winter home of John McAllister Schofield, a Civil War Union general whose name appears on Schofield Barracks at Pearl Harbor, Hawaii. He died in 1906, and ten years later the home was acquired by Martin D. Hardin, also a Union general. He died in 1923 and his widow, Amelia, lived in this house until her death in 1939. It was acquired by Flagler College, which in 1987 finished a $500,000 renovation and remodeling of it for use as its business office.

[West on Valencia Street, south on Sevilla Street]

34.) 44 SEVILLA STREET

De Crano House. Built in 1898, located here was the winter home of artist Felix de Crano, known as the Shingles for its exterior covering. De Crano had a studio on Artists' Row along Valencia Street on the second floor of the Ponce de León Hotel, and after his death in 1908, his widow kept the studio open. She willed the home to a local hospital, and it was the last remaining shingle-style house in the city when it was torn down by Flagler College on October 25, 1994.

35.) 48 SEVILLA STREET

Anderson Cottage. This home was built on the Markland estate between 1865 and 1885 as a wooden Victorian cottage along King Street. It was owned by the Andrew Anderson Jr. family, who lived next door and rented this property to a series of tenants. Henry Flagler purchased the eastern end of the Anderson property for the construction of the Ponce de León Hotel and moved the cottage to the northwest to this site. Flagler preferred to move existing buildings rather than tear them down. Later tenants included author Rebecca Ruter Springer and the Andersons themselves when Markland was being remodeled in 1899–1900. In the 1920s, this home was renovated in a Mediterranean Revival style under the supervision of Fred A. Henderich. It now exhibits a shell-dash stucco texture.

[North on Sevilla Street]

36.) 36 VALENCIA STREET

Flagler Memorial Presbyterian Church. This church was built for Henry Flagler by McGuire and McDonald as a memorial to Flagler's oldest daughter, Jennie Louise Benedict. It was dedicated in her memory on March 16, 1890. The year before, she had given birth to Margery, who died within hours in New York. Jennie died about six weeks later aboard a yacht bound for Florida, where she was headed for her health. The copper dome reaches about 150 feet above street level and is topped by a 20-foot cross. The church and the adjacent fellowship hall were built using poured concrete. Flagler donated the Tiffany stained-glass windows during 1902, and they tell the story of the Apostles' Creed. The Aeolian

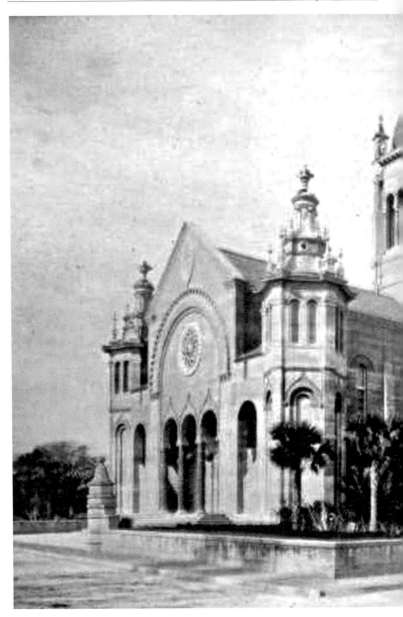

Flagler Memorial Presbyterian Church
This church was built with funds provided by Henry Flagler, and it was designed by his architects, John M. Carrere and Thomas Hastings. They patterned it after Venice's St. Mark's Cathedral and its terra cotta decorations, mahogany paneling and screens. Its style is known as Venetian Renaissance Revival. This is how it appeared in 1894. *Courtesy of the Florida Photographic Collection.*

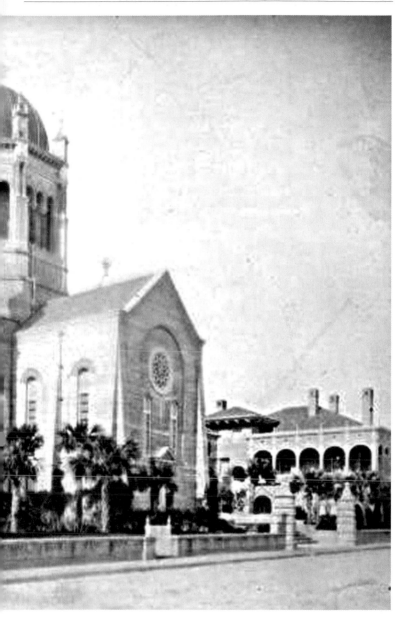

Skinner organ was installed in 1970. In the church are buried Henry Flagler, Jennie Louise Flagler Benedict and Henry's first wife, Mary Harkness Flagler.

[South on Sevilla Street, west on Valencia Street]

37.) 35 VALENCIA STREET

Villa Girasol. This structure began as a small wooden house in about 1905, and architect Francis A. Hollingsworth remodeled it in a Mediterranean Revival style with a chimney showing sections of exposed coquina. Hollingsworth had moved to St. Augustine from Virginia to work for the Florida East Coast Railway, and in 1922 he went into private architectural practice.

[West on Valencia Street, north on Riberia Street]

38.) 55 RIBERIA STREET

Kirkside Apartments. The tall columns in the front of this apartment building were salvaged from Kirkside, the mansion of Henry Flagler, when it was razed in 1950. The capitals were given a much simpler appearance when the present apartments were built in 1951–54.

[North on Riberia Street to Carrera Street]

39.) 50 CARRERA STREET

Crawford House. This two-story, frame vernacular structure built between 1885 and 1894 was the home of John W.R. Crawford, the son of W.L. Crawford, the general manager of the railroad that connected St. Augustine to Jacksonville. Henry Flagler had the house built for W.L. as a gift. John was married to a daughter of Thomas Nast, the political cartoonist who was famous for providing images of Santa Claus, the elephant and donkey of today's major political parties and Uncle Sam.

[West on Carrera Street]

40.) 52 CARRERA STREET

La Posada Hotel. This frame vernacular building was erected between 1885 and 1894 and was operated as the La Posada Hotel into the 1930s. It is now an apartment house.

41.) 67 AND 71 CARRERA STREET

Flagler Employee Homes. These one-and-a-half-story homes, in addition to the home at 75 Carrera Street that has been torn down, were erected between 1885 and 1894 as residences for employees of Henry Flagler.

[West on Carrera Street, north on Ponce de León Boulevard, east on Saragossa Street]

42.) 76–78 SARAGOSSA STREET

Fishwick House. In about 1900, 78 Saragossa Street was the home of contractor William Fishwick. In September of 1980, it was linked to the house next door and became the Herbie Wiles Insurance Office.

[East on Saragossa Street]

43.) 56 SARAGOSSA STREET

Memorial Lutheran Church. During the early 1900s, three buildings in this vicinity were utilized by contractors McGuire and McDonald. They were later used to house the Florida East Coast Railway and Hotel Company carpenter shop. This main building, erected between 1904 and 1910, was remodeled as a sanctuary for the Memorial Lutheran Church. Later, it was converted into a personal residence.

[East on Saragossa Street, north on Riberia Street]

44.) 16 RIBERIA STREET

Montgomery House. This coquina, concrete-block house was claimed to be St. Augustine's largest single-family residence when it was constructed between 1924 and 1927 for J.A. Montgomery.

[North on Riberia Street, east on Orange Street, south on Mulvey Street]

45.) 16 MULVEY STREET

Hulett House. This frame vernacular home was built between 1865 and 1885. It was originally located on Orange Street and was the residence of Philander Hulett. It was moved to its present location to make room for construction of the Ketterlinus School.

[North on Mulvey Street, east on Orange Street]

46.) 67 ORANGE STREET

Ketterlinus Junior High School. Originally, a Mediterranean Revival–style school building was designed by Francis A. Hollingsworth and built in 1925. It has been replaced by a modern construction but retained its original name, that of William Warden's daughter, Elizabeth Warden Ketterlinus, who donated the land.

47.) 63 ORANGE STREET

63 Orange Street B&B. Built in 1884, this wood-frame, Victorian home with eleven-foot ceilings has been restored. It is operated as the 63 Orange Street Bed and Breakfast Inn.

48.) 61 ORANGE STREET

Bruer House. This Queen Anne–style home was built between 1885 and 1894.

[East on Orange Street, south on Sevilla Street]

49.) 14 SEVILLA STREET

Alexander Homestead. This Victorian home was built in 1888. Beginning in 1991, it was restored by Bonnie Alexander as a bed-and-breakfast.

[South on Sevilla Street, west on Saragossa Street]

50.) 24 SARAGOSSA STREET

Milburn House. C.M. Milburn erected this two-story, Mediterranean Revival–style home between 1910 and 1914. It was the home of attorney and judge George W. Jackson during the 1920s and 1930s.

51.) 28 SARAGOSSA STREET

Ritchie House. This is an 1891 Queen Anne–style home that was the residence of H.J. Ritchie. In 1894, he produced a bird's-eye sketch of St. Augustine that has been relied on to determine the existence, location and appearance of its buildings as of that year.

[East on Saragossa Street, south on Sevilla Street]

52.) 27 SEVILLA STREET (AND 30 CARRERA STREET)

Ancient City Baptist Church. In 1895, this yellow brick church was constructed of brown brick in a Romanesque Revival style. It has a three-story tower topped by a conical turret. The congregation had formed on January 20, 1887, and Henry Flagler donated the land in 1894 for the construction of its sanctuary.

Ancient City Baptist Church
When Henry Flagler donated the funds to construct this church, three conditions had to be met. The construction cost could not exceed $10,000—it was completed for less than that amount. The congregation also had to promise that the church would never be mortgaged and that no bell would ever be hung in its tower. *Courtesy of the Florida Photographic Collection.*

53.) 32 SEVILLA STREET

Ingraham House. James E. Ingraham was hired by Henry Flagler to develop land that had been provided by the state in exchange for his construction of the railroad. Ingraham also worked for Henry Sanford and Henry Plant, served as mayor of St. Augustine from 1915 to 1920 and explored the Everglades. In Miami, the Ingraham Building was named in his honor. This building on Sevilla Street was his home, a two-and-a-half-story, Colonial Revival–style house built in 1894 next door to Flagler's mansion. After serving as a residence, the home was donated to the Presbyterian Church. In 1990, it was dedicated as the Mary Lily Flagler Manse, although it was used as offices and classrooms instead of the minister's residence.

[North on Sevilla Street]

54.) 33 SEVILLA STREET

Spades House. In about 1899, this Colonial Revival home was built as a winter residence for Michael H. Spades of Indianapolis. Inside, there are seventeen rooms, and outside, the house is constructed with a flat roof, Ionic columns and a porch.

[North on Sevilla Street, east on Carrera Street]

55.) 9 CARRERA STREET

Coxe House. This is one of a pair of cottages built by McGuire and McDonald to supplement the Ponce de León Hotel in 1888. During the 1890s, it was often rented to Alexander Brinton Coxe of Pennsylvania. The two-and-a-half-story, Queen Anne structure later became the home of the art gallery and art department of Flagler College and was moved forward to make room for the construction of a dormitory. The former house now also houses faculty offices in addition to the college's gallery.

56.) 8 CARRERA STREET

Grace United Methodist Church. Designed by John M. Carrere and Thomas Hastings, this church was built in 1887 in a Spanish Renaissance Revival style. The church was built by Henry Flagler for the

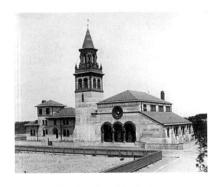

Grace Methodist Church
This photo was taken in 1889, two years after this church was constructed from coquina shells and Portland cement, which was poured in place, rather than forming blocks that would be stacked and bound together with mortar. Exterior ornamentation was done with salmon-colored terra cotta. *Courtesy of the Florida Photographic Collection.*

congregation of the Olivet Methodist Church, whose 1874 wooden building was removed by him to make room for the construction of the Alcazar Hotel. The first pastor of the church was Reverend Charles C. McLean, who had previously served the Olivet congregation. For a time, the assistant was Wilma Davis, the first ordained Methodist woman in Florida. The church was placed on the National Register of Historic Places on November 29, 1979.

[East on Carrera Street, north on Cordova Street]

57.) 70 CUNA STREET

Carriage Way. This Victorian home was built along the Rosario Line in 1883–85 by Edward and Rosalie Masters. It was converted to apartments during the 1940s and was restored to its original configuration in 1984. It is operated as a bed-and-breakfast with rooms named after its previous owners: Masters, Pacetti, Pittman, Bonnie Hill, Burkley, Elizabeth Gould, Eula Clark, St. John Brown and Johnson.

58.) 30 CORDOVA STREET

Lucas House. This building constructed between 1924 and 1930 formerly had a frame second story above its present masonry first floor. The frame portion, removed after 1956, might have been merely moved a few lots to the east.

59.) 26 CORDOVA STREET

Centennial House. Now a bed-and-breakfast, this two-story, frame vernacular home was built between 1899 and 1904 for city councilman J.D. Oliveros.

[North on Cordova Street, west on Saragossa Street]

60.) 13 SARAGOSSA STREET

López House. In 1878, this one-story home was built of wood, and it features a catslide roof. In addition to its being owned by the López family, its owners have included the Oliveros and Pomar families.

[East on Saragossa Street, north on Cordova Street]

61.) 20 CORDOVA STREET

Sueños House. This stuccoed, two-story, Mediterranean Revival–style home was constructed in 1904. Its first occupant was George A. Colee, the 1880s founder of the St. Augustine Transfer Company. Its Mediterranean style, the result of a 1920 remodeling, includes Palladian windows, a red tile roof and arched doorways. In the 1950s and 1960s, it housed Garcia's Funeral Home and the St.

Augustine Association for Retarded Citizens before it was converted to offices. Some believe the building is haunted by a ghost named Randolph.

[North on Cordova Street]

62.) ACROSS FROM 7 CORDOVA STREET

Tolomato Cemetery. Before 1763, the site of today's cemetery was considered part of Tolomato, an early eighteenth-century village of Christian Indians. Franciscan missionaries working with the Native Americans abandoned the site when Florida became part of the British Empire. In 1777, Governor Tonyn gave his permission to Father Pedro Camps to use the former Indian burying ground as a cemetery for Camps's parishioners. The Spanish began burying people there in about 1784. The cemetery closed in 1884, but illegal burials took place in 1886 and 1892, costing the decedents' families fines of twenty-five dollars each.

[North on Cordova Street, west on Orange Street]

Tolomato Cemetery
One individual buried in Tolomato Cemetery was Most Reverend Jean Pierre Augustin Marcellin Verot, who served as the first bishop of St. Augustine. His remains were placed in the mortuary chapel shown in this 1886 photo. Some believe the cemetery to be haunted by the ghosts of children and a shadowy male adult. *Courtesy of the Florida Photographic Collection.*

63.) 40 ORANGE STREET

Orange Street Elementary School. This school, built in 1910 as St. Augustine High & Graded School, was designed in a Neo-Classical style by Francis A. Hollingsworth. On a portion of the property has been found evidence of the old moat that

Orange Street School
This image appears on a postcard printed by Rogero & Pomar of St. Augustine in 1911, the year following the completion of the school's construction. The school closed in 1982, and students were moved to the new W.D. Hartley Elementary School. This building has since been used by the Board of Education. *Courtesy of the Florida Photographic Collection.*

ran parallel to the Cubo Line to help defend the city in case of an attack from the north. The opening of the Orange Street School eliminated the need for Public School #1, which had operated on Aviles Street in an 1857 building.

[East on Orange Street]

64.) 47 ORANGE STREET

Elementary School Annex. This brick annex for the elementary school opened in 1938. It was designed by Fred A. Henderich and built by J.A. Reyes.

Old Drug Store

65.) 31 ORANGE STREET

Speissegger Drug Store. T.W. Speissegger and Sons entered the pharmacy business during the 1870s. The drugstore on this corner was established by them in 1887 and carried medicine, tobacco and toiletries.

This image comes from an old postcard published when the wooden two-story building appeared to be in good condition. Today, the weathered gray walls lean away from Cordova Street, and sightseers may think twice before entering. If they do, however, they are delighted with the artifacts on display inside. *Courtesy of the Florida Photographic Collection.*

The business was continued by the Speissegger sons, R.A. and T. Julius, into the 1960s. The frame vernacular store was then converted into the Old Drug Store Museum.

66.) 24 ORANGE STREET

**Dismukes Clinic.* A dental clinic formerly located here was built and endowed by John T. Dismukes, who moved to St. Augustine from Quincy, Florida, and also established the First National Bank. During the 1960s, the clinic was targeted by civil rights protesters because it had provided free dental care beginning in the 1910s, but only to white children. The structure was built in a Mediterranean Revival style and was constructed between 1917 and 1924.

[East on Orange Street]

67.) 1 SOUTH CASTILLO DRIVE

Castillo de San Marcos. This structure is the oldest fort standing intact in the United States. For more information about the fort, see "The 1660s" section of this book.

[West on Orange Street, south on St. George Street]

68.) 14 ST. GEORGE STREET

Oldest Wooden Schoolhouse. This structure covered with cedar planks is also known as the Genopoly House for its builder and owner Ioannis Gianopoulos, who was involved in the New Smyrna immigration in 1777. He acquired the land and an existing building in 1778, built a wooden home on it by 1783 and replaced it with the present structure after 1788. His family kept the house until 1904. Over the years, in addition to its being a schoolhouse, it was also a novelty shop, a photo shop and a tea room. In 1939, it became the Oldest Wooden Schoolhouse Museum.

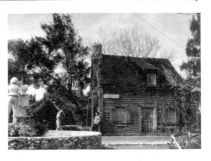

Oldest Wooden Schoolhouse
This one-and-a-half-story home, formerly known as the Oldest Frame House, features a shingle-covered gable roof with a steep pitch of forty-seven degrees and a long catslide, giving it an English appearance that would date it to before 1821. This photo was taken by Francis P. Johnson in 1953. *Courtesy of the Florida Photographic Collection.*

69.) 19½ ST. GEORGE STREET

Old Mill. During the 1930s, Walter B. Fraser built a gristmill here, powered by the water from an artesian well. Above the wheel on the second floor was the mill machinery. The upstairs mill has been removed and replaced by the Mill Top Tavern. Some believe it is haunted.

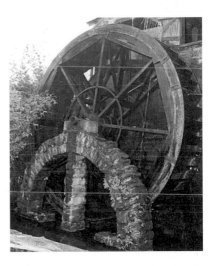

Old Mill
The original water-powered mill was rebuilt in 1947, the year this photo was taken. It was rebuilt a second time in 1996. Upstairs, where the mill operated, the grinding machinery was removed and in its place is today's Mill Top Tavern. *Courtesy of the Florida Photographic Collection.*

70.) 21 ST. GEORGE STREET

Gallegos House. This structure is a 1964 Spanish Colonial–style tabby reconstruction of the home of a Spanish artilleryman. The original home was built in about 1720 and was owned in 1764 by Juan Garcia and Martinez Gallegos. The original two-room masonry structure with a loggia and patio on the south side had been removed by 1788 and was replaced with a wooden house. The rear yard had a garden, chickens and fruit trees.

71.) 22 ST. GEORGE STREET

Riberia House. This house is a 1962 reconstruction of the home of Juan Riberia, erected on a foundation that dates from the first Spanish period. It was built with coquina and covered with plaster and a tabby floor. The home originally had no glass windows, just openings and wooden shutters. Downstairs is a living room and dining room. Upstairs is a sitting room plus a large and a small bedroom. The kitchen was originally located in a separate structure that had no chimney, just holes in the ceiling to let the smoke out. The size of the home indicates that it was built for someone wealthy.

72.) 27 ST. GEORGE STREET

Gomez House. This pine and cypress building is a 1964 Spanish Colonial–style reconstruction of the original, built circa 1764. It was the home of Spanish soldier Lorenzo Gomez and his wife, Catarina Perdomo. The original was built with two rooms and a sleeping loft reached by a ladder.

73.) 29 ST. GEORGE STREET

Triay House. The original home here was built between 1768 and 1790 and was the residence of Minorcan settler Francisco Triay and his wife, Maria. The present building is a 1963 reconstruction of the original, atop the original foundation. It was built with two rooms and a sleeping loft. Later uses have included an art studio and gallery.

74.) 33 ST. GEORGE STREET

Florencia House. This is a Spanish Colonial–style reconstruction from 1964 of the home of Pedro de Florencia.

75.) 35 ST. GEORGE STREET

Gonzalez House. This is a reconstruction of the home of a Spanish cavalryman, Bernardo Gonzalez, who built it in about 1790. The foundation is original. Later uses have included a restaurant.

76.) 37 ST. GEORGE STREET

De Hita House. Also known as the Avero House, this structure is the 1978 reconstructed home of Geronimo de Hita, a Spanish cavalryman. The original construction dates to later than 1736. Adjacent to it is a blacksmith shop built in 1980.

77.) 41 ST. GEORGE STREET

St. Photios Greek Shrine. This structure began as the 1749 home of the Carrera Avero family, who moved to Cuba in 1763. Fourteen years later, Governor Tonyn gave the home to Father Pedro Camps for use as a place of worship for residents of Greek descent. During 1964, there was a renewed interest in St. Augustine to preserve the memory of the early Greek colony. The home was later turned into the St. Photios Shrine to honor the early Greek settlers of St. Augustine and

was added to the National Register of Historic Places on June 13, 1972. Restored in 1979, it was dedicated on February 27, 1982, to the memory of more than four hundred Greek people who had arrived in St. Augustine on June 26, 1768, and then headed south to establish the Turnbull Plantation at New Smyrna. Many of them returned during the following decade to settle in St. Augustine.

78.) 42 ST. GEORGE STREET

Salcedo House. During the first Spanish period, the home on this lot belonged to Joaquin Blanco, a manager of military supplies at the Castillo. During the British colonial period, it was owned by Captain Andreas Rainsford and a kitchen was added. In the second Spanish period, it was acquired by José Salcedo, an artillery captain. The house was reconstructed in 1964 upon the original foundation, which dates to at least 1788, with plaster-covered coquina walls. The roof consists of cedar shake shingles. An outside stairway leads to a private apartment upstairs. Later uses have included a candy shop.

79.) 43 ST. GEORGE STREET

De Mesa-Sánchez House. This tall, two-story home, also known as the Spanish Inn, is a restored building that was originally erected by 1764. Initially, the home built by Antonio de Mesa was only one story, but it was enlarged by Juan Sánchez during the second Spanish period. Formerly, the house had a detached kitchen. The structure was restored during the 1960s.

80.) 46 ST. GEORGE STREET

Arrivas House. It appears that this structure began as a smaller house that was later enlarged in practically all directions. Artifacts found on the site appear to date to the second half of the seventeenth century, so this house is probably older than 1700. The masonry floor is built up in layers—one of tabby from 1650–1700, then three more of tabby from 1700–60, then another of tabby from 1760–80 and then rubble and a layer of concrete from the late nineteenth century. By 1788, the structure was an L-shaped masonry home with a second story and balcony. Additions were rebuilt between 1829 and 1830. This home has wooden floors formed with tongue-and-groove joined boards. It is named for its first known owner, infantry lieutenant Don Raimundo de Arrivas, who lived here from about 1748 to 1764.

81.) 52 ST. GEORGE STREET

Rodríguez-Avero-Sánchez House. Fernando Rodríguez, a Spanish army sergeant, built his home here of wood in 1760 and hired Juan Peréz to add a room constructed of coquina at the northeast corner. Antonia de Avero inherited the property from Rodríguez, but in 1762 she fled to Cuba. When she returned after the British departed from St. Augustine, she attempted to get the house back, but instead it was sold at public auction

to Juan Sánchez in 1791. In 1865, Roscoe Perry married Margarita Capo, and this was their first home. After leaving the army, Perry's first business in St. Augustine was a grocery store. The house was restored in 1958 by Mr. and Mrs. Walter Scott Crawbuck. It formerly housed the Museum of Yesterday's Toys and is now the Casa Rodriguez Gift Shop.

82.) 53 ST. GEORGE STREET

Colonial Spanish Quarter Museum. Also known as the Pellicer–de Burgo House, the building began as a wood-frame duplex built in about 1785 by Francisco Pellicer. Shopkeeper José Peso de Burgo lived in half of it. Later, the present structure on the original foundation was formed by the consolidation of three buildings with addresses of 49, 51 and 53 St. George Street. The other structures housed the Paffe Stationery Store and print shop, an upstairs apartment occupied by the Paffe family and a toy store and card shop. The consolidated building was reconstructed in 1976 by the Historic St. Augustine Preservation Board. According to legend, in 1927 during a hurricane, the property was visited by a nurse who came by to check on Mrs. Paffe, who was ill. The nurse reported that at one point, she saw a woman wearing the habit of the Sisters of St. Joseph kneeling by Mrs. Paffe's bed, who then disappeared. She said that Mrs. Paffe said it was Sister Mary Helen, and Mrs. Paffe began to regain her strength. Days later, the nurse reported that she saw a seventeenth-century Spanish sentry by the bed, and Mrs. Paffe said he had come to take her away. The nurse left the room, and when she returned the sentry was gone and Mrs. Paffe was dead.

83.) 54 ST. GEORGE STREET

Dodge's Oldest House. This one-and-a-half-story house, also known as the Paredes House, was for a time claimed to be the oldest house in St. Augustine, with a construction date of 1565. However, it was determined to date only to about 1803, when it was built by Don Juan Paredes.

84.) 58½ ST. GEORGE STREET

Rodríguez House. This is a reconstruction of the home built circa 1764 for Jose Rodríguez of Spain. The tabby structure with a flat roof consisted of two rooms and a loggia that faced south. The yard was surrounded by a wall and cooking was done outside or on the loggia, so the home had no chimney.

85.) 59 ST. GEORGE STREET

Oliveros House. There were three previous houses on this lot, constructed of wood, tabby and wood, respectively. Then, a two-story coquina home was built in about 1798 by Sebastian de Oliveros, a Corsican mariner and trader. The yard was enclosed by a masonry wall. The house was torn down in 1908 and was reconstructed in 1965 by L.C. Ringhaver and used as a cigar factory. It is now the location of Flagler's Legacy Tours & Gifts.

WALKING TOURS: ANCIENT CITY 93

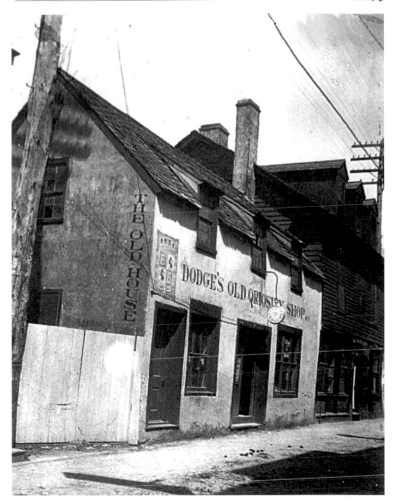

Dodge's Oldest House
Once touted as the oldest house in St. Augustine, allegedly constructed the year of the town's founding, the Dodge House has now been determined to be a little more than two hundred years old. It was known as Dodge's Curiosity Shop when this photo was taken in 1902, and it was restored during the 1970s. *Courtesy of the Florida Photographic Collection.*

86.) 60 ST. GEORGE STREET

Sánchez House. Built by 1764, this two-room, Spanish Colonial–style house was constructed of stone with a tabby floor. It had a tile roof and casement windows and was the home of José Sánchez de Ortigoza of Spain. It was reconstructed in 1964.

[South on St. George Street, west on Cuna Street, south on Spanish Street]

87.) 42 SPANISH STREET

Triay House. This two-story, Spanish Colonial–style home built in about 1806 by Mr. Triay, a Minorcan colonist, has a well that was once surrounded by an octagonal curb made from brick or block. The gable roof on the house shows parapet ends. The house was undergoing restorations in 1950 at the time that Kirkside was torn down, so some of the wood from Flagler's mansion was recycled into this home.

88.) 44 SPANISH STREET

44 Spanish Street Bed & Breakfast. This two-and-a-half-story, wood-frame home was constructed during the early 1920s. It was converted to the Azalea Inn in 2003 and is now known as the 44 Spanish Street Bed and Breakfast.

89.) 46 SPANISH STREET

López House. Constructed between 1820 and 1833, likely by Andre López, this is the second-oldest wooden building in the city. Coquina is utilized in the fireplace and the piers to support the house. It has served as a residence, a retail store, apartments, a boardinghouse and the Monk's Vineyard restaurant.

[North on Spanish Street, east on Cuna Street]

90.) 29 CUNA STREET

Agustin Inn. This structure is a St. Augustine Colonial Revival–style home built in 1903. In 1994 it was converted to a bed-and-breakfast with eighteen guest rooms. Some believe that the ground-floor guest room is haunted by the ghost of a man with white hair and a beard, wearing a white suit.

91.) 27 CUNA STREET

Wells Print Shop. William Wells and his brother, John, started the *East Florida Gazette* during the British colonial period, and then moved to the Bahamas a year later at the start of the second Spanish period. This building, reconstructed in 1969 in a British Colonial style, for years displayed a replica of their printing press, the original of which had been operated at another location. This building now serves as a jewelry store.

92.) 26 CUNA STREET

Cerveau House. This frame vernacular home was built in about 1880 with no windows on the north and west sides in order to keep out the cold of winter and the heat of summer. Originally, the yard included an herb garden, chicken house and pecan, fig and persimmon trees. Now, it has a hand-split shingle roof. Behind the home is a privy dating to the same period. In the main building is the Cuna Street Toy Shop.

93.) 25 CUNA STREET

Buchanti House. In 1777, Italian Josef Buchanti came to St. Augustine from New Smyrna and bought a wooden house at this location. In addition to his home, this property was used by him as a small tavern.

94.) 17 CUNA STREET

Harness Shop. This structure was built in 1965 with the appearance of an eighteenth-century harness shop.

95.) 12 CHARLOTTE STREET

Sims House. This wood-frame building was constructed in 1966 to resemble William Sims's eighteenth-century home and shop. The north wing of the original building served as his residence and is now a candle store.

[East on Cuna Street, south on Charlotte Street]

96.) APPROXIMATELY 26 CHARLOTTE STREET

**Genovar Opera House.* The Genovar family built the Genovar Opera House at this location. After it burned down, B. Genovar built a new one on St. George Street. The original was the only theatre in town large enough to accommodate large touring companies and was destroyed by fire on April 2, 1914. Its 1969 replacement, a British Colonial–style structure built to represent a typical eighteenth-century blacksmith shop, is now a walk-up coffee shop.

[South on Charlotte Street, east on Cuna Street, south on Avenida Menendez]

97.) 8 AVENIDA MENENDEZ

**La Caseta.* Located here was the home of Hugh de Laussat Willoughby from Solitude, New York. He founded the Rhode Island Naval Reserve, played the first round of golf completed in Florida and explored the Everglades. His Moorish-style home, with a name that means "the cottage" in Spanish, burned down in 1895.

98.) 12 AVENIDA MENENDEZ

Acapulco Mexican Restaurant. Previously on this lot was the three-story Bennett Hotel, and across the street were carriage stands. Eateries that have been located here are the King's Forge Restaurant and Lounge and the Matanzas Bay Café.

99.) 22 AVENIDA MENENDEZ

Casa de la Paz. This 1911 home was owned by banker James Duncan Puller and his family, who moved in during 1915. The building has also served as a kindergarten, restaurant and apartments, and it became a

bed-and-breakfast in 1986. According to legend, it is haunted by the ghost of a woman who stayed with the Pullers. Her husband went out fishing and was lost in a storm, and she has been reported to say, "Is it time to leave yet?"

100.) 24 AVENIDA MENENDEZ

Casablanca Inn. This home built in 1914 was designed by Gould T. Butler in a Mediterranean Revival style and for a time was known as the Matanzas Hotel. During Prohibition in the 1920s, it was operated as the Bayfront Boarding House by an elderly widow who served bootleg whiskey to her guests, including federal agents. According to legend, she would go to the widow's walk atop her house and swing a lantern to signal boats when it was not safe to bring their whiskey ashore. Today some report that they still see the lantern light at night, and there have been sightings of her ghost in the home. She is buried in the Huguenot Cemetery. The building is now operated as a bed-and-breakfast.

101.) 32 AVENIDA MENENDEZ

Monson House Hotel. The third in the series of Monson lodgings was built in the late 1920s and was razed during the early 1960s. In its place was built the Monson Motor Lodge, a key site during the 1964 civil rights rallies and demonstrations. Dr. Martin Luther King Jr. was arrested at the lodge during a sit-in, and black protestors had muriatic acid poured into the water when they refused to get out of the motel's "whites only" swimming pool. The motel was torn down in 2002. In 2005, the Hilton St. Augustine Historic Bayfront opened on the site and consists of seventy-two hotel rooms in nineteen buildings designed by architect Gerald Dixon.

102.) 42 AVENIDA MENENDEZ

Vedder House. The wall at this corner was part of a home owned in 1763 by Lieutenant Antonio Rodríguez Afrian. For a time, the home was used as the Vedder Museum. It also served as the home of merchant John Leslie. The house was destroyed by the 1914 fire, but it was rebuilt with the Colonial-era foundation. One of the remaining walls was incorporated into the Monson House Hotel.

103.) 44 AVENIDA MENENDEZ (also 110 Charlotte Street)

Espinosa-Sánchez House. At least a portion of this home, also known as the Peréz-Snow House, was constructed during the first Spanish period (1565–1763) as a one-story residence for Don Diego Espinosa. In 1764, it was owned by Don Juan de Mata Peréz, and by 1788 it was the home of Don Bernadino Sánchez. During the late 1790s, a second story of coquina was added. After the Civil War, it showed an additional half-story with dormer windows. It was reduced to one

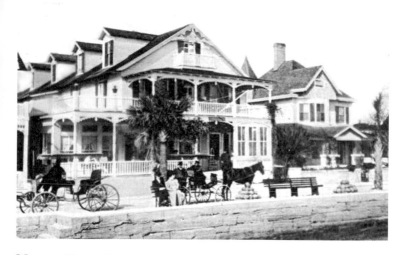

Monson House Hotel
The original Monson House along the bayfront burned down on April 2, 1914. It was rebuilt as a three-story hotel, which lasted until 1926, before it burned down again. This image is of the original structure as it appeared on a postcard printed by M. Marx of Jacksonville in 1909. *Courtesy of the Florida Photographic Collection.*

story by owner Daniel Edgar and was used for storage, wood and coal, serving as an outbuilding for a much larger house built on the water end of the lot. A wooden second floor was added by 1884. At least the first-floor masonry walls survived an 1887 fire that began in the paint room of a store owned by Charles F. Hamblen. Then in 1911 a new second story was built and covered with shingles and a balcony over Charlotte Street was added. The second floor was rented as apartments, but that portion was destroyed by a fire in 1914. The first-story walls were saved and used to construct a garage with attached living quarters by owners Elbridge and Fanny Snow. The building was restored in 1965 for use as an accountant's office.

104.) 46 AVENIDA MENENDEZ

Drysdale House. Also known as the Carr Cottage, this structure

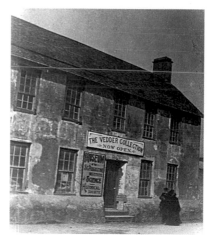

Vedder House
This old two-story home was purchased by the St. Augustine Historical Society and Institute of Science in 1899 and turned into their first "House of History." It was called the Vedder House for Nicolas Vedder, whose collection of ancient maps and relics constituted most of the museum's displays. *Courtesy of the Florida Photographic Collection.*

was the home of Burroughs E. Carr, a merchant and hotel owner. It is a nineteenth-century reconstruction of a home originally built with tabby in colonial times. During the British colonial period, the home was unoccupied, and then it was used as a storage shed before it returned to use as a residence in 1789. The house was destroyed in the 1887 fire and was rebuilt the following year out of concrete. The building has served as Harry's Restaurant since 1997, but it was previously known as Catalina's Gardens for a girl named Catalina de Porras, who was born in 1753 and lived in the original structure until 1763, when the family moved to Havana. It was the Puerta Verde Restaurant beginning in 1976 and the Chart House from 1985 until 1993. Some believe it is haunted by the ghost of Catalina or a woman named Bridgett.

105.) 1 ANDERSON CIRCLE

American Legion. In the late nineteenth century, on this site was the home of Ansel B. Phillips and his wife, Maria Solana. The tall, white, frame structure was later the home of Charles F. Hamblen. Between 1899 and 1904, it was replaced by the present Mediterranean Revival–style masonry building. It was used as a hotel, tea room and D.P. Davis's administration building for his Davis Shores development. After Davis died, it became the home of the Hamblen Club, an organization for young working men. During World War II, it became the headquarters of the local American Legion Post. The flagpole in front of the building was a gift from Dr. Andrew Anderson Jr. and was dedicated in 1921.

[South on Avenida Menendez to the Plaza de la Constitución on the north side of King Street]

106.) 1 KING STREET

Plaza Hotel. This masonry vernacular building constructed in 1888 has had several tenants during its existence. In the 1920s, it was the Surprise Department Store. In the 1940s, the Gilbert Hotel and the C.F. Hamblen Hardware Store were located here. During the 1950s and 1960s, it was the Plaza Hotel.

[West on King Street]

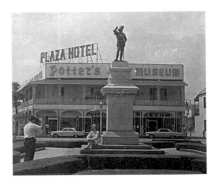

Plaza Hotel

This photo taken in August of 1965 shows two St. Augustine landmarks. The statue of Ponce de León was unveiled in 1923 by Dr. Andrew Anderson Jr. It is a replica of a statue that stands in San Juan, Puerto Rico. Behind it across King Street is the Plaza Hotel building, which for a time also housed Potter's Wax Museum. *Courtesy of the Florida Photographic Collection.*

107.) 11 KING STREET

Wakeman House. On this site stood the home of Seth Wakeman, built while Florida was a U.S. territory. The present commercial structure, built in 1965, is known as the Florida Heritage House.

108.) 17 KING STREET

Potter's Wax Museum. This attraction was founded by George L. Potter in 1949, making it the oldest wax museum in the United States. On display are amazingly realistic wax figures of well-known individuals from history, entertainment, politics and other public realms. The building also houses Potter's Museum Gift Shop.

109.) 31 KING STREET

Woolworth's. This masonry vernacular building was constructed in 1955. For much of its existence, it was the home of the Woolworth dime store. The store was the site of several important demonstrations during the civil rights movement of the 1960s, beginning with St. Augustine's first lunch counter sit-in on March 6, 1960, staged by six Florida Memorial College students. Today, it is the home of Atlantis Resort Wear & Gifts.

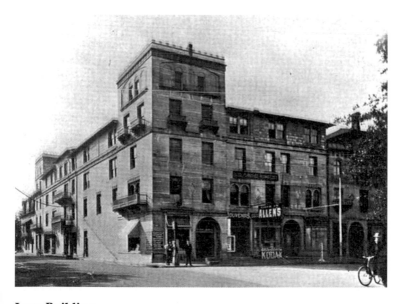

Lyon Building
When the fourth floor of the Lyon Building burned in 1938, most of the building was closed to the public. During 1989, the Jaycees used the second floor as a Halloween haunted house, marking the first time in a half-century that the public was allowed above the first floor. *Courtesy of the Florida Photographic Collection.*

110.) 41 KING STREET (ALSO 206 ST. GEORGE STREET)

Lyon Building. Previously on this corner was the three-story, wood-frame home of Benjamin Putnam, which became Mrs. Gardner's Boarding House in 1869 and was torn down in 1887. The current building with Moorish Revival elements was built with poured concrete during 1886–87. It was designed by S. Bangs Mance to have some similarities with the nearby hotel. It began with five-story towers, three and a half of which were full stories, and a mansard roof, but the roof section was later transformed into a full fourth story in 1899. It was owned by Walter Lyon and used as a grocery and general merchandise store. Other occupants have included the Lyon Company, Kernan's Ponce de León Pharmacy, the YMCA and the St. Augustine Gas and Electric Company. It also later housed the Lyon Hotel. The building has since served as the home of restaurants, bars and shops.

111.) 48 KING STREET

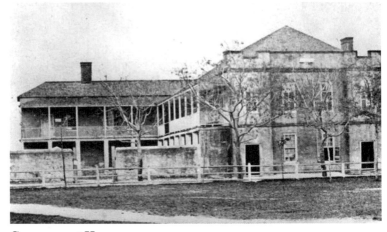

Government House

This structure, rebuilt in 1833, was substantially remodeled in 1873 and soon after appeared as it does in this photo. It was remodeled again in 1930 to accommodate the expanding post office and customs office. On the grounds is the Post Office Fountain, erected in 1899. *Courtesy of the Florida Photographic Collection.*

Government House. In 1604, the home of Governor Gonzalo Canzo was built here. In about 1680, the Governor's (or Government) House was rebuilt and was one of just three buildings that belonged to the government. The Government House was a two-story, wooden home erected over a stone foundation with a shingle roof. Between 1696 and 1702, the walls were rebuilt with coquina, but it was destroyed during the Siege of 1702. The present structure was built in 1706–13 and was substantially restored in 1759. In 1823, it was the site of the first territorial legislative council, before the capital was moved to Tallahassee. The structure was reconstructed in 1833 under the supervision of architect

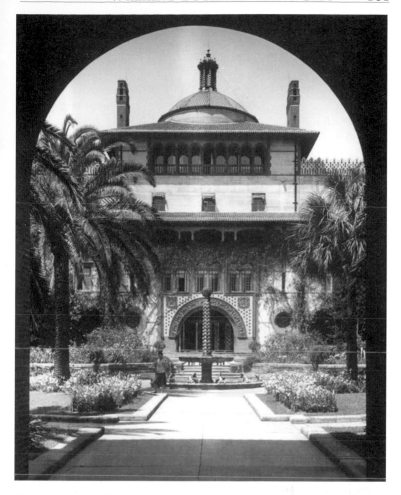

Ponce de León Hotel
The hotel, whose entrance court is shown in this 1930 photo, closed in 1967. It was remodeled, and in 1968 became the home of Flagler College, founded by Flagler Systems Chairman Lawrence Lewis Jr. Remodeling and restoration cost $30 million. The former hotel was added to the National Register in 1975. *Courtesy of the Florida Photographic Collection.*

Robert Mills. The result was a sixteen-room building that housed the courtroom (until 1891), federal offices and the post office. In 1936 it was modified by architects Mellen Clark Greely and Clyde Harris to have the King Street entrance resemble that of the Castillo. The building was acquired by the state in 1966 to stand as a public monument and was turned over to the Historic St. Augustine Preservation Board to use as a museum, theater and office. Although some of the stonework dates to colonial days, most of the present building structure only dates back to the 1930s. Near the building is the William Wing Loring Memorial, a pillar presented in 1920 by the Daughters of the Confederacy to honor Loring for his gallantry during the Second Seminole War and the Civil

War. Loring had lived in a coquina house on St. George Street across from the Spanish treasury beginning in 1833.

112.) 74 KING STREET

Flagler College. Henry Flagler built this as the Ponce de León Hotel, which opened in 1888. It was designed in a Spanish Renaissance Revival style by Bernard Maybeck and architects John M. Carrere and Thomas Hastings and was built by contractors McGuire and McDonald. The interior was designed by Louis Comfort Tiffany and was decorated with murals by George W. Maynard. It was the first major building in the country constructed by pouring concrete into frames to form the walls and floors. When Flagler died, his funeral was held in the front hall of the hotel, and some believe that the building is haunted by his ghost or that of his wife, who hanged herself on the fourth floor. Some also believe that it is haunted by one of Flagler's mistresses who went insane after being addicted to heroin. Another ghost that has been reported is that of a woman in a blue skirt, a hotel guest who broke her neck falling down the stairs.

113.) 75 KING STREET

Lightner Museum. This structure was originally the Alcazar Hotel, built by Henry Flagler in 1888 to serve a clientele that was less affluent than the guests of the Ponce de León Hotel across the street. The three-hundred-guest-room complex sat on a foundation that covered an area of 250 feet by 450 feet. Initially, the hotel was supposed to be a shopping arcade with guest rooms upstairs. After a time, a dining room was added and some of the shops were converted into a hotel lobby. It was designed by architects Carrere and Hastings and constructed by contractors McGuire and McDonald. The hotel closed in 1931. In 1947, Otto C. Lightner bought the hotel for $150,000, and in it he placed his extensive collection of Victoriana, including musical instruments, pottery, stained glass, crystal bowls, paintings and just about everything else he could gather on his world travels. He donated the former hotel to the city to be operated by a board consisting of the mayor and four others. Lightner died in 1950. A portion of the Alcazar houses the St. Augustine City Hall, which was dedicated on April 27, 1973. The former hotel was added to the National Register of Historic Places on February 24, 1971. In the courtyard is a statue of Don Pedro Menéndez de Avilés, erected in 1972. It was a gift from Avilés, Spain, and the garden was dedicated as the Parque de Menendez in 1979. It includes the picturesque Coats Bridge, built in 1948.

114.) 81C KING STREET

Museum of Weapons & Early American History. On display here are muskets, rifles, swords, pistols, Indian knives and projectile points, other weapons and shipwreck artifacts. There is an emphasis on the Civil War era. The museum was opened by Donna Lee in 1984, after

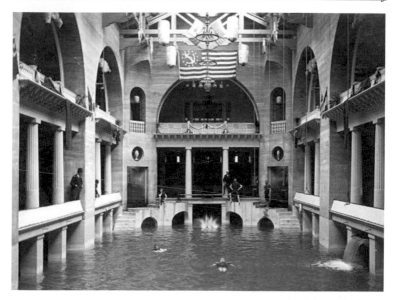

Alcazar Hotel

A popular attraction inside the casino portion of Henry Flagler's Alcazar Hotel was its swimming pool, fed by eighty-degree water produced by an artesian well drilled fourteen hundred feet down. The Lightner Museum now occupies the site of the former pool, along with most of the rest of the former hotel, with displays of more than twenty thousand items. *Courtesy of the Florida Photographic Collection.*

she partnered with Edward F. Walton during the 1960s to accumulate a large collection of weapons and other antiques.

115.) 83 KING STREET

Villa Zorayda. This home was built by Franklin Waldo Smith, a Boston hardware merchant who built replicas of famous buildings. For his St. Augustine home, he used as a model the Alhambra Palace of Spain and designed it as a one-tenth-size replica of the original palace. In 1883, he constructed his design with poured concrete and named it for a character in Washington Irving's *Tales of the Alhambra.* In 1913, the home was acquired by Abraham S. Mussallem, and it was converted into a nightclub and casino in 1922. The casino lasted only until 1925, when the state outlawed gambling.

116.) 93½ KING STREET

López House. This house was built in 1903 by William Fishwick and K. McKinnon in a Queen Anne style, including a curving porch and a tower. This home of Xavier López was considered for demolition in 1979 to provide a parking lot for the post office. In response, a preservation organization known as the Friends of St. Augustine Architecture was formed, and they were able to keep the building intact. However, it had to be moved from its original location and was turned to face a different direction.

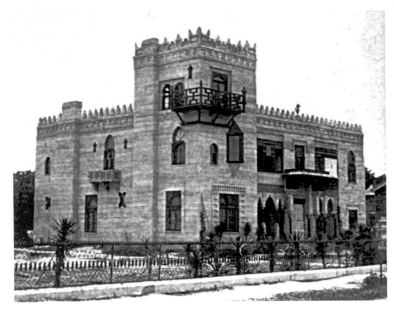

Villa Zorayda
This poured concrete structure became a tourist attraction known as the Zorayda Castle in 1936 and included exhibits relating to Moorish architecture and society. It was added to the National Register of Historic Places in 1993. *Courtesy of the Florida Photographic Collection.*

117.) 99 KING STREET

Post Office. This building was erected in 1967, replacing a 1914 home that was moved to 9 Martin Luther King Avenue.

118.) 102 KING STREET

Markland. In October of 1839, Dr. Andrew Anderson Sr. and his wife, Clarissa Fairbanks, set the cornerstone of this magnificent home, which they called Markland Hall. Within a month, Dr. Anderson died from yellow fever and Clarissa continued the construction, which lasted until 1842. She reduced the house to half its original planned size. It has walls of exposed coquina, sheltered from the weather by large porches, and the house was surrounded by an orange grove. Andrew Anderson Jr. was born the year the house was started. He became a doctor and mayor of St. Augustine and was Henry Flagler's closest friend. Anderson hired architect Charles A. Gifford to enlarge the home, a project that was completed in 1901. On the grounds is a billiard house from about 1900 with a front porch supported by several palm tree trunks used as posts.

119.) 105 KING STREET

Masonic Lodge. Ashlar Lodge No. 98 was chartered on January 18, 1888. In the late 1880s, the headquarters of the local Masons was located on the east side of Charlotte Street between Hypolita Street and Bryan Lane.

Markland
In 1939, this large home was sold to road contractor H.E. Wolfe, and then it was sold again in 1968 to Flagler College. It was initially used as the college president's home, and then as classrooms and offices. It was added to the National Register of Historic Places on December 6, 1978. *Photo by Kelly Goodman.*

120.) 118–20 KING STREET

First United Methodist Church. This church was founded in 1845 as the First Methodist Episcopal Church. The present sanctuary was built in about 1911 of brick covered with stucco. It features Gothic arches, a parapet resembling that of a castle and decorative pilasters. Because of its original orange color, it was nicknamed the Pumpkin Church. A sealed room at the top of the bell tower is said to be haunted.

[West on King Street, north on Riberia Street]

121.) 77 RIBERIA STREET

Youth Center. Long before this structure became the youth center for the First United Methodist Church, this former residence was used for other charitable purposes. When it was new in 1916, Mary Neil Darrow donated it to the humanitarian King's Daughters organization. From 1924 until 1973, that organization owned the building, and it housed the County Welfare Federation.

[South on Riberia Street, west on King Street]

122.) 124 KING STREET

Catholic Daughters' House. This frame home built between 1904 and 1910 served as the headquarters of the Business and Professional Women's

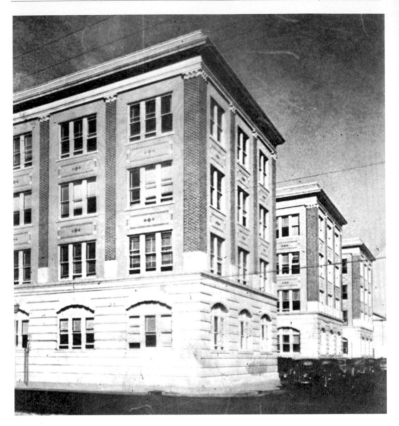

Railway Headquarters
This trio of connected four-story office buildings was constructed for the railroad in 1923–24 to be used as its executive offices. This photo was taken during the 1930s, when the railroad station was located nearby on Malaga Street, just north of King Street. *Courtesy of the Florida Photographic Collection.*

Forum before it became the home of St. Augustine Court No. 23 of the Catholic Daughters of America.

123.) 136 KING STREET
Pellicer House. This two-story home was built in the early 1910s for retired banker X.L. Pellicer. The home served as apartments for a time, and then was converted back to a single residence.

124.) 1 MALAGA STREET
Railway Headquarters. Francis A. Hollingsworth designed this series of multi-story buildings connected by a one-story walkway for the Florida East Coast Railway. The railroad depot has been located along Malaga Street at least since 1905, and the adjacent Railroad Park built in 1885–94 was once the center of the railroad yard.

[Cross to the south side of King Street]

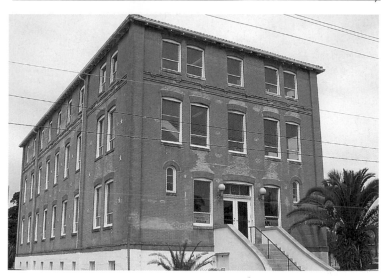

Cigar Factory
This large cigar factory was built in 1908 for the Board of Trade in an attempt to lure a cigar company to St. Augustine. That company, however, went bankrupt and the building became the home of another cigar manufacturer that lasted from 1920 until 1929. The building was taken over by a bank, which itself failed. *Photo by Kelly Goodman.*

125.) 157 KING STREET

San Sebastian Winery. This 18,000-square-foot wine production facility offers tours of the wine-making process. Previously, it was one of the buildings used by the Florida East Coast Railway. Built in 1924, it was remodeled as a winery in 1996.

[South and east on Sebastian Harbor Drive]

126.) 88 RIBERIA STREET

Cigar Factory. St. Augustine once had a small cigar industry, beginning with Bartolo and Frank Genovar, who had a business on Charlotte Street in about 1900. Eugene Pomar also had a small cigar factory. This three-story, brick cigar factory was built in about 1908 by the Board of Trade in an attempt to lure to St. Augustine the Martinez, Solla and Carcaba Cigar Company. The company planned to move here and receive the factory as a gift if it could produce eight million cigars within five years, but instead it went bankrupt. William Carcaba died in an accident, followed soon after by the death of Augustine Solla. Mr. Martinez moved to Jacksonville to enter into business there. The Pamies & Arango Cigar Company did move from Tampa and agreed to produce seven million cigars within ten years. The company reached that goal but suffered financial problems and moved out in 1929. The cigar factory was remodeled as an office building.

[South on Riberia Street]

127.) 122 RIBERIA STREET

Ice Plant. This masonry vernacular building was erected between 1917 and 1924.

[East on Cedar Street, north on Martin Luther King Avenue]

128.) 9 MARTIN LUTHER KING AVENUE

**Foster House.* One of the two St. Augustine homes that exhibited the Carpenter Gothic architectural style was located here until recent years. An empty lot was purchased in 1852 by Godfrey and Catherine Foster, and on it they constructed a home facing King Street in 1855. Around it was a six-acre grove containing four hundred orange trees, rose bushes, grapevines and fig trees. During the 1900s, the house was moved to this site to provide room for a parking lot along King Street. One of the occupants of this house was Andrew P. Foster, who grew up to become an army general. Another was Ward Foster, a partner in Foster and Reynolds, which published the *Standard Guide to St. Augustine* in about 1900. The Foster House was razed in about 2000 to make room for modern apartments.

[South on Martin Luther King Avenue, east on Cedar Street]

129.) 89 CEDAR STREET

At Journey's End. Now a bed-and-breakfast, this late nineteenth-century Victorian home was built between 1899 and 1904 as a single-family home.

130.) 87 CEDAR STREET

Peace & Plenty Inn. This home was built in 1894 by Conrad Decker, who emigrated from Germany to Boston and often came to St. Augustine with his wife, Sophie, for the January through March season. He ran the train line to the beach and built the first Bridge of Lions to accommodate this line. This home was restored in 1996–2001 and is now operated as a bed-and-breakfast.

131.) 83 CEDAR STREET

Penny Farthing Inn. This bed-and-breakfast began as a personal residence constructed in 1897.

132.) 79 CEDAR STREET

The Cedar House. This Victorian home was built in 1893 by carpenter Carl Decher. After decades as a single-family residence and a boardinghouse, it was restored as a bed-and-breakfast operated by Jack and Mylene Martin.

[East on Cedar Street, north on Granada Street]

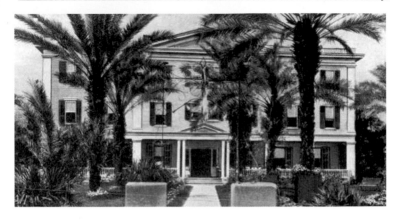

Colored Home

After this facility operated as a retirement home for black individuals, it became known as the Buckingham Hotel and was operating by that name when this photo was taken in about 1916. Later on the building housed the Grenada Hotel, also known as the Alhambra Hotel. *Courtesy of the Florida Photographic Collection.*

133.) 12 GRANADA STREET

Colored Home. The Colored Home, a retirement home for black residents previously located on this site, was endowed in 1871 by a bequest of Buckingham Smith, who had served as a state senator and a secretary to the Spanish Embassy. It was a two-and-a-half-story structure with a mansard roof, donated by Dr. Isaac Bronson, which opened in 1873. After the building was torn down following a fire on September 24, 1954, all that remained was a portion of a wall dating to about 1895. On the site is now the Flagler College Gymnasium.

[South on Granada Street]

134.) 32 GRANADA STREET

Alcazar Cottage. This frame vernacular structure was one of the outbuildings of the Alcazar Hotel when it was erected between 1893 and 1899.

[South on Granada Street, east on Bridge Street, south on Cordova Street]

135.) 154 CORDOVA STREET

Cordova Apartments. Before this Mediterranean Revival–style building was converted into apartments, it was the home of the *St. Augustine Record* newspaper. The first portion was built in 1906 and designed by Francis A. Hollingsworth, who also designed an addition on the south side and remodeled and expanded the original building during the 1920s. A second expansion took place during the 1980s. In 2001, the newspaper moved to a new 61,324-square-foot building designed by the Austin Company on a sixteen-acre site five miles from downtown.

136.) 161 CORDOVA STREET

Congregation Sons of Israel. This congregation was funded in the late nineteenth century by Jacob Tarlinsky, and services were held until 1923 in a private home on Bridge Street. Most members were from Eastern Europe, seeking freedom from persecution. The synagogue was designed by Francis A. Hollingsworth in a Mediterranean Baroque style and opened in 1923. Originally, it was an Orthodox congregation, so the building provided for the women to sit in the balcony. The congregation is now Conservative and is led by a resident rabbi.

137.) 172–80 CORDOVA STREET

Lakeside Condominiums. The older portion of this Colonial Revival–style complex was built between 1885 and 1893.

[South on Cordova Street, east on St. Francis Street, south on St. George Street]

138.) 282 ST. GEORGE STREET

Stickney House. This Mediterranean Revival–style home was built in about 1873 and served as the residence of Judge John B. Stickney. Following its use as the Keewatin School, a boarding school for boys, it was the temporary home of Flagler Hospital from 1916 until 1921 while it was owned by J.W. Estes. The home was remodeled during the 1920s by architect Fred A. Henderich.

139.) 287 ST. GEORGE STREET

Estes House. This home uses palm tree trunks as columns to support the front porch roof. It is a bungalow constructed between 1910 and 1917 and was the home of George L. Estes.

140.) 288 ST. GEORGE STREET

Estes House. This frame vernacular house was built between 1904 and 1910 for Edgar Estes.

141.) 297 ST. GEORGE STREET

Henderich House. This home was designed by Fred A. Henderich for one of his clients in 1925. Later, he bought the house to serve as his own residence. Henderich had come to St. Augustine to work for the Florida East Coast Hotel Company in 1905, then went into private practice and designed several of the homes at the southern end of St. George Street. His non-residential projects include the Visitors Center, Flagler Hospital, Hastings High School, Florida Normal School, Excelsior School and the bandstand in the plaza. He was an early proponent of the Mediterranean Revival style in this state.

Congregation Sons of Israel
This synagogue has an elaborately decorated white façade and simple brick walls for the sides and rear. Within the brickwork are small stained-glass windows that were installed during 1957. *Photo by Kelly Goodman.*

142.) 298 ST. GEORGE STREET

Baldwin House. This frame vernacular home was built in 1910 by Fred Walton for Simeon Baldwin, who served as Connecticut's chief supreme court justice and then its governor. He also ran for president, served as the president of the American Bar Association and taught at Yale Law School. He was involved with an agricultural project in Lincolnville known as Yale Farms. During the 1920s, this house became the residence of author Edith Taylor Pope.

143.) 311 ST. GEORGE STREET

Steinecke House. This was the home of professional baseball player Bill Steinecke, whose Major League career as a player consisted of four at-bats for the Pittsburgh Pirates during a four-game span in September of 1931. He retired to St. Augustine after a career as a coach and died here in 1986. The fanlight windows on the porch of this frame vernacular home from the mid-1910s are thought to have originally been a part of Henry Flagler's Kirkside mansion.

144.) 322 ST. GEORGE STREET

Meserve House. This low bungalow is one of a cluster that surrounds Maria Sanchez Lake. It was built in about 1915 and features open gable work, overhanging eaves and a pergola. Its first resident's parents lived in the 1890s Victorian house next door at 320. Other residents over the years have included Superintendent of Schools Robert Meserve, *St. Augustine Evening Record* editor Herbert Felkel and real estate investor John B. Mulvey.

[South on St. George Street, east on Charlotte Place, south on Charlotte Street, east on South Street, south on Marine Street]

145.) 159 MARINE STREET

**Flagler Hospital.* To replace the original Alicia Hospital building that burned down in 1916, the Mediterranean Revival–style Flagler Hospital was built here in 1921. Flagler Hospital moved from this location in 1989 and merged with St. Augustine General Hospital along U.S. 1 to produce a single 316-bed facility on a campus of seventy-five acres. On the 1921 site are now condominiums built in 2001.

146.) 180 MARINE STREET

Powder House Lot. Near this St. Johns County building are the remains of a concrete-block building foundation. The structure formerly situated atop it was a powder house erected by the Spanish between 1797 and 1807. The powder house was torn down after 1860, and its foundation was excavated in 1970 by Richard H. Steinbach of the Historic St. Augustine Preservation Board. The site was added to the National Register in 1972. A portion of the lot is now the home of the Coastal Community Center.

[North on Marine Street, east on South Street, north on Tremerton Street]

147.) 4 TREMERTON STREET

Bay Breeze Cottage. This property, located near the Seminole village of La Punta, was owned in the 1790s by Jose Ximénez and in the 1820s by Joseph Smith. Built in about 1900, this two-and-a-half-story Victorian house was occupied by Thomas Adams from 1904 until 1912. He served as the deputy collector of customs and as the assistant manager of the Ancient City Wagon Works. The house was restored as the Bay Breeze Cottage in 1995.

148.) 5 TREMERTON STREET

Pilgrim House. In 1926, this home designed by Fred A. Henderich in a Mediterranean Revival style was completed along the waterfront adjacent to Flagler Hospital. Shoe store owner A.E. Pilgrim and his family moved in one week before the area was hit by a major hurricane.

The house was later owned by Owen D. Young, General Electric's chairman of the board and founder of RCA.

[North on Tremerton Street, west on Tremerton Place, north on Marine Street]

149.) 124 MARINE STREET

Murder House. This stucco-covered, flat-roofed home was built between 1925 and 1927 and acquired its nickname in January of 1974. Its then resident, Athalia Ponsell, a former model and political activist, married former St. Augustine Mayor James Lindsley. Next door at 126 Marine Street lived Alan Stanford, whom Ponsell attempted to have fired from his position of county manager. On January 23, Ponsell was found hacked to death on her front steps. Stanford was arrested, tried and acquitted, and the murder went unsolved.

150.) 105 MARINE STREET

U.S. Military Hospital. This frame vernacular structure was built in 1867 and served as a military hospital. Later, it became the Val Rica Apartments and then Villas on the Bay.

151.) 104 MARINE STREET

National Cemetery. Included in this military cemetery are three large pyramids marking the graves of casualties of the Second Seminole War. On December 28, 1835, a contingent led by Major Francis L. Dade was walking from Fort Brooke (Tampa) to Fort King (Ocala) and engaged in battle with Seminoles near Bushnell in Sumter County. Only 4 survived, and the other 104 bodies remained on the battlefield for approximately seven weeks, until they were found by another party of soldiers who buried them there. On August 15, 1842, they were reinterred here in the National Cemetery. The Indian scouts who had served in the war are buried under plain white marble markers.

152.) 101 MARINE STREET

Sánchez House. This frame vernacular home was built in 1904–05 and was the residence of Alfred W. Sánchez.

153.) 97 MARINE STREET

King's Bakery. This Spanish Colonial–style structure was erected during the British colonial period (1763–84) across from the Marine Street barracks so the troops stationed there could have fresh bread. In 1934, it was converted to garages and offices for National Guard personnel.

154.) 86–92 MARINE STREET

Officers' Quarters. These three large Victorian homes were built in 1882–83 for the officers serving at the St. Francis Barracks.

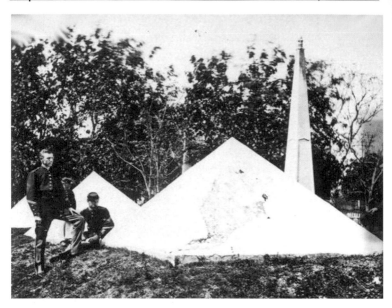

National Cemetery
Beneath these three coquina pyramids are the remains of 1,468 soldiers who died during the Second Seminole War, including 104 soldiers who died in the 1835 Dade Massacre. *Courtesy of the Florida Photographic Collection.*

155.) 82 MARINE STREET

St. Francis Barracks. Since 1921, this former army barracks complex with sections dating back to the sixteenth century has been the home of the Military Department of the State of Florida.

[North on Marine Street, west on St. Francis Street]

156.) 14 ST. FRANCIS STREET

Oldest House. It appears that the original thatched wooden structure at this site was built in 1650, burned down perhaps twice and was rebuilt not long after the 1702 destruction of the city. In 1727, it became the home of artillery soldier Tomas González y Hernández and his bride, Maria Francisca Guevara y Dominguez. At the time, it was a one-story coquina home with two rooms and a flat roof. A wooden second story with glass windows was added by Joseph and Mary Evans Peavett, who bought the home in 1775. In 1786, widowed Mary married John Hudson, and they moved out in 1790. Geronimo Alvarez moved from a home on Marine Street, and the Alvarez family occupied it from 1790 until 1882, when it was sold to William B. Duke. He sold it two years later to Mary E. Carver. Her husband, dentist Charles P. Carver, covered the coquina walls and ceiling with wood paneling that came from the old Presbyterian church. A two-story circular tower and roof dormers were added. In 1892, the home began to be advertised as the "Oldest House in the Oldest City in the U.S.," and the curious paid a

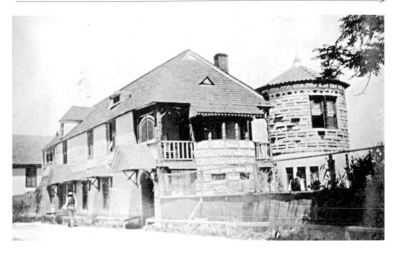

Oldest House
This 1895 photo of the González-Alvarez House shows a two-story circular tower. It was added in the late nineteenth century and then removed (along with a west end apartment and garage) during 1959–60 when the home's appearance was restored to that of an earlier period. *Courtesy of the Florida Photographic Collection.*

fee to tour the interior. In 1898, it was purchased by attorney James W. Henderson and his wife, and they added a two-story addition on the west end of the home, providing a garage downstairs and an apartment upstairs. They sold it to the owners of the Alligator Farm in 1911, and they sold the home to the St. Augustine Historical Society in 1918. During 1959–60, the house was returned to an earlier appearance. Greenish paint was exposed and determined to be the second story's original color. On the lot is also a 1938 reproduction of an eighteenth-century kitchen. Some believe that the house is haunted, and report that clothing is rearranged and lights are seen at night, despite there being no electricity in the building.

157.) 18 ST. FRANCIS STREET

Webb Memorial Museum. This masonry vernacular structure was built in 1924 and houses the Webb Memorial Museum. It is named for Dr. Dewitt Webb, who served as the president of the St. Augustine Historical Society. On the building is a Great Floridian plaque honoring Emily Lloyd Wilson, whose research on the city performed from 1919 to 1953 formed the basis for the historical society's library.

158.) 22 ST. FRANCIS STREET

Tovar House. Spanish infantryman Don José Tovar lived on this corner in 1763. The original site and size of his house remained unchanged during the British colonial period, when John Johnson, a Scottish merchant, lived here. After the Spanish returned in 1784, José Coruna, a Canary Islander, and his family, along with Tomas Caraballo, an assistant surgeon, occupied the house. Geronimo Alvarez, who lived

next door in the González-Alvarez House, purchased the property in 1791. It remained in his family until 1871. A later occupant was Union Civil War General Martin D. Hardin.

[West on St. Francis Street, north on Charlotte Street]

159.) 257 CHARLOTTE STREET

Herrera House. This Spanish Colonial–style house built before 1821 was the home of Manuel de Herrera. It was reconstructed in 1955 with one and a half stories.

[South on Charlotte Street]

160.) 267 CHARLOTTE STREET

Alexander-Garrido House. This house, reconstructed in 1966, features *canales*, spouts that pierce the parapet to drain rainwater from the flat roof. It exhibits a typical Spanish Colonial style.

161.) 271 CHARLOTTE STREET

Alexander-O'Donavan-O'Reilly House. In 1883, the St. Augustine Historical Society was established. Its library was located here in this eighteenth-century home reconstructed in 1964 in a Spanish Colonial style.

[South on Charlotte Street, west on St. Francis Street]

162.) 25 ST. FRANCIS STREET

Checchi House. During the 1980s, it was proposed that this Queen Anne–style house be torn down and replaced by a new construction. State officials prevented that action, saving the original home, which was built between 1885 and 1893.

163.) 28 ST. FRANCIS STREET

Wilson House. This house was built between 1833 and 1838 and was acquired in 1872 by winter resident John L. Wilson. Between 1885 and 1893, it was enlarged from a single story to two and a half stories, and the original wooden first story was covered by a concrete block veneer. The Wilson family owned the house until 1923, and two years later it was acquired by Dr. Charles Bagwell, who had a private medical practice and ran a clinic at the Florida School for the Deaf and Blind.

164.) 31 ST. FRANCIS STREET

Fernández-Llambias House. It appears that this home began as a smaller structure that was later enlarged in practically all directions. Its well was enclosed in a circular masonry curb, covered by a lid made of boards including a removable square central section with a handle. The "X" pattern balustrade along the balcony was constructed not long after 1821. Built before 1763, the home was owned by Nicholas

Tovar House

This former home of Don José Tovar is owned and maintained by the St. Augustine Historical Society. It serves as the Museum of Florida's Army, with displays from the days of the Spanish conquest and settlement through today's Florida Air and Army National Guard. *Courtesy of the Florida Photographic Collection.*

Turnbull, the son of Dr. Andrew Turnbull of New Smyrna. During the British colonial period, the second floor and hip roof were added. It was purchased by Juan Andreu Sr. in 1795, and next was owned by Peter and Joseph Manucy. In 1854, it was bought by Joseph and Catalina Usina Llambias.

165.) 34 ST. FRANCIS STREET

Wilson House. This is one of ten homes constructed on the estate of John L. Wilson, replacing an earlier home of prominent free black man Antonio Proctor. It was built in 1889 in a Victorian Italianate style and features paired cornice brackets and a projecting bay. It was an experiment in home construction, using a concrete block veneer over a wood frame. Other examples of this combination later succumbed to Florida's moisture and termites. This building, in addition to being a residence, has also served as a newspaper office, a gift shop, an antique shop and an apartment building. Wilson donated the Cathedral Basilica's belfry clock and a house to serve as the city library. He also was the president of the Colored Industrial School.

[West on St. Francis Street, north on St. George Street]

166.) 279 ST. GEORGE STREET

St. Francis Inn. This bed-and-breakfast formerly known as the Gaspar Garcia House was constructed in 1791. In 1838, it was purchased by

Fernández-Llambias House
In the mid-nineteenth century, this home was acquired by the Llambias family and was remodeled to appear as it does in this 1952 photo. Two years later, architect Stuart Barnette returned the structure to its 1821 appearance. It was placed on the National Register in 1970. *Courtesy of the Florida Photographic Collection.*

Colonel Thomas Henry Dummett, and by 1845 it was owned by Sara and Anna Dummett who turned it into an inn. Sara married Civil War General William J. Hardee. He sold the inn to John Wilson, who added a third story. It was remodeled in 1930 and renamed the St. Francis Inn during 1848. Some believe it is haunted by the ghost of Lily, a black maid who fell in love with the son of General Hardee, who hanged himself when their relationship was forbidden. The small structure behind the main house formerly served as a slave cabin. Across St. George Street is a parking lot that was formerly the site of the Alencia (or Valencia) Hotel, which was built in the 1890s by J.A. McGuire. It was demolished in the 1960s and all that remains is an original wall of poured concrete.

167.) 268 ST. GEORGE STREET

Upham Cottage. This wooden house was built in 1892–93 and modified by additions later that decade. Further modifications included the construction of masonry Moorish arches. The house began as a twelve-room winter cottage constructed for Colonel John J. Upham, who had fought Native Americans on the Plains and saw action at the Battle of Gettysburg. It is basically an octagon with lots of Queen Anne ornamentation. Its builder, John T. Lander, disappeared in January of 1893 after giving instructions to his workers. His body was found the following month on the beach on Anastasia Island, apparently as the

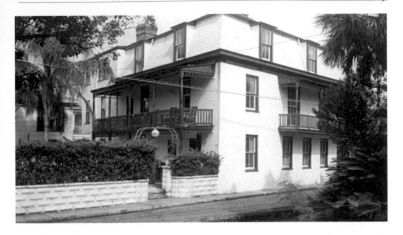

St. Francis Inn
Some believe this bed-and-breakfast is haunted by the ghost of Lily, a black maid who fell in love with the white son of General William J. Hardee, who owned the house. According to legend, the son hanged himself when their relationship was forbidden and Lily continues to inhabit the site. *Courtesy of the Florida Photographic Collection.*

result of an accidental drowning. The assumption was that he slipped off a bridge on the way to North Beach and then floated out to sea and south to Anastasia. John Upham died in 1898 and his widow kept the home until 1915. During the 1950s, it was converted to apartments and then back to a single-family residence during the 1970s. Some believe it is haunted by a ghost in the attic named Claire who plays the harpsichord. According to legend, she was the wife of a ship's captain who locked her in the attic when he traveled, and she died there while he was away.

168.) 262–64 ST. GEORGE STREET

Presbyterian Church. The Presbyterian congregation formed with thirteen original members on June 10, 1824, and a coquina church was built in 1830. The first pastor was Dr. William McWhir. During the 1840s its pastor was Reverend R.K. Sewall. The church had a tower that collapsed during a heavy rain in 1860. During the Civil War, the Union army took its pews. When Henry Flagler had the Flagler Memorial Presbyterian Church built in 1890 in memory of his daughter, he gave the congregation that new structure and its grounds in exchange for this property. A portion of the old Presbyterian church was incorporated into eight pillars at the Flagler Memorial Church. On the former church grounds was built the present frame vernacular home in about 1915.

169.) 259 ST. GEORGE STREET

Cathedral Parish School. This school was established by the St. Augustine Catholic parish in 1916 and was led by the Sisters of St. Joseph. Today, over four hundred children attend in kindergarten through eighth grade.

170.) 256 ST. GEORGE STREET

De Medici House. Built between 1851 and 1853, this is a frame vernacular home with two and a half stories and an open front porch with chamfered posts. It was owned by Emanuel J. de Medici and then was acquired by Eugene J. and May Barnes in 1901. The home was remodeled in about 1910 to provide a Colonial Revival appearance, reducing the porch from two stories to one. During the 1910s, the house was moved farther back from its original location nearer St. George Street.

171.) 252 ST. GEORGE STREET

Bronson Cottage. This home was designed in 1875 by Alexander Jackson Davis to be the winter home of Robert D. and Isabel Donaldson Bronson. It is a Gothic Revival cottage, which was owned by the Bronsons until 1905. It was later used by St. Joseph Academy as a fine arts building. A three-tiered fountain in front of the home was moved in 1966 to the park in front of the Lightner Museum. This house was sold in 1988 and returned to use as a private residence.

172.) 246 ST. GEORGE STREET

Old St. Augustine Village. This city block contains nine historic structures erected between 1790 and 1910, and it is operated as a living museum. The properties were owned by Kenneth W. Dow of Michigan, who in 1940 purchased one of the homes to serve as his permanent residence. Within a decade, he had acquired all nine structures, renting out some of them to others. He and his wife, Mary Mohan Dow, were advocates of historic preservation and donated the block of homes to the Museum of Arts and Sciences of Daytona Beach in 1989. In the courtyards of the buildings are gallery exhibits that memorialize and interpret the history of St. Augustine. Some believe that Old St. Augustine Village, an area that has been continuously occupied since the 1500s, is the most haunted area of the city. The buildings located here are:

Star General Store. Built between 1899 and 1904, this structure began as a home. It then served as a doll and toy store, a kindergarten and a millinery shop. In 1921, it was converted into a pair of apartments for two members of the de Medici family, who operated businesses in St. Augustine beginning in the 1880s.

Canova House. This home at 42 Bridge Street was constructed with coquina walls and tabby floors in about 1840 by the Antonio Canova family. The Emanuel de Medici family operated it as a boardinghouse near the end of the nineteenth century. The house features details in a Greek Revival style.

Carpenter's House. This wooden home was built between 1899 and 1904 by a local carpenter. Since much of it was constructed out of materials

that were left over from other homes and projects, some features of the house appear mismatched. Also, the house leans on its foundation, likely the result of a hurricane and flood that hit St. Augustine during the 1940s.

Prince Murat House. This coquina home at 250 St. George Street was built some time between 1790 and 1815. During 1824, the home was owned by the Canova family, and it was rented to Achille Murat. This was the first of the properties acquired by Kenneth W. Dow, who purchased it to serve as his home in 1940.

Dow House. This home was built by the Canova family just to the north of the Prince Murat House in about 1839, and then was moved to another portion of the block, fronting Bridge Street, by Mary Hayden in about 1905. In its place, fronting St. George Street, she had a large Colonial Revival house constructed. When that home was acquired by Dow in 1941 from Sarah McKinnon, it was with the agreement that she could continue living in it for the rest of her life. She died at the age of 102.

Howells House. Built between 1904 and 1910, this Colonial Revival house was the winter 1916 home of William Dean Howells, an author who wrote about the Prince Murat House. This structure has served as the library, administrative office and volunteer center for the Old St. Augustine Village.

Spear House. When this home was built between 1899 and 1904, it had only one story and a two-story tower at its southwest corner. By 1910, the second story was added. By 1920, it was operated as an apartment house and continued as such until recent renovations converted it into the village's visitor center.

Rose House. This Colonial Revival–style home built in about 1910 is named, not for a person, but for the Rose Museum that was operated in it. Rose collector and author Jean Gordon exhibited roses here for a decade beginning in 1956. Today, the exhibits include antiques instead of roses, which were collected by Kenneth Dow on his world travels.

Worcester House. This two-and-a-half-story, wooden home was built between 1904 and 1910, and was the home of local grocer John L. Henry. It passed to his heirs and was rented out to others. The house was divided into two apartments, one of which was lived in during the 1950s by Susan Worcester, the aunt of Kenneth W. Dow.

173.) 241 ST. GEORGE STREET

St. Joseph's Convent. The wall around this property was part of the Cavedo House, built before 1763 as a one-story masonry home with

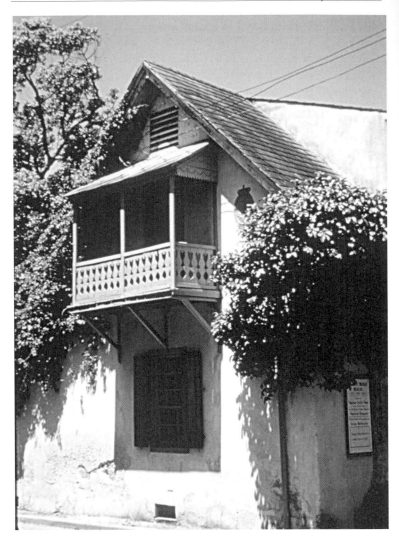

Prince Murat House
This home is so named because it was briefly the rented residence of Prince Achille Murat, the nephew of Napoleon Bonaparte. It was furnished by later owner Kenneth Dow with antiques associated with the Murat family. *Courtesy of the Florida Photographic Collection.*

a flat roof. It served as the home of Juan Cavedo and as his family's tailor shop. In 1879, the Sisters of St. Joseph moved from their convent in the former O'Reilly House to a three-story coquina building on this site. The house was torn down between 1904 and 1910 and replaced with the present convent building showing a Gothic Revival style.

[South on St. George Street, east on Bridge Street, north on Aviles Street]

174.) 36 AVILES STREET

Toledo House. Research has determined that this house, owned for much of the 1800s by free black individuals, was built between 1801 and 1817. John Whitney, a relative of inventor Eli Whitney, claimed that it was much older, and the structure came to be known as Whitney's Oldest House. John Whitney also claimed to have discovered the first fountain of youth and his son ran an alligator farm. The home is known as the Toledo House for owner Don Toledo, and also as the Papy House for Gaspar Papy, a Greek colonist who arrived in the city from New Smyrna in 1777.

175.) 33 AVILES STREET

Fontane House. This home, built up to the street line, dates back at least to 1835. By the late 1880s, it was described as a "negro tenement," and by 1904 it was the home of D.J. Trapps, a mattress maker and upholsterer. It was called the Ben Bow Tavern during the 1920s and later was the Fireside Artcrafters and the Blue Gate Gift Shop. For a time beginning in the 1950s, it was divided into efficiency apartments, and then it was returned to a single residence during the 1980s. At that time, the exterior was stripped of its stucco to reveal the original wooden boards.

176.) 32 AVILES STREET

O'Reilly House. This tall, two-story home built of coquina block and covered with stucco dates to the second Spanish period and has a yard enclosed by a masonry wall. Its roof's forty-degree pitch is typical of pre-1760 construction. Over the years it has been enlarged and modified several times. It was the home of Michael (Miguel) O'Reilly, who arrived in St. Augustine during the 1780s and served as a chaplain of troops as well as a Catholic pastor. When he died, his will provided that the money raised from the sale of oranges growing on the property was to be used for the religious training of women. The will also stated that ownership of the home was to pass to the Catholic Church, which used it for a rectory, convent and school. The Sisters of St. Joseph occupied it and then moved from the house in 1879. In 1954 it was restored to its pre-1800 appearance, and it is now operated as the Father Miguel O'Reilly House Museum. Across the street is a round coquina well that dates to 1613. Excavation of the area revealed charred artifacts, perhaps from the 1668 burning of the city, and evidence that the well was filled in during 1670. The well was restored in what is known as Old Town Park, established in 2004 across Aviles Street from the museum.

[South on Aviles Street, east on Bridge Street, north on Marine Street]

Toledo House

John Whitney, a St. Augustine developer of the nineteenth century and former mayor in New Jersey, claimed that this was the oldest house in the city with a construction date of 1516. Archaeological evidence indicates that he was wrong by about three centuries. *Courtesy of the Florida Photographic Collection.*

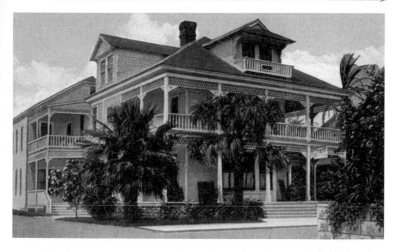

Kenwood Inn
This stately structure is shown on an old postcard as the Hotel Kenwood and has also been known as Mr. T's Boarding House. It is believed by some that the inn, now operated as a bed-and-breakfast, is haunted by happy, peaceful ghosts named Raymond and Lavender. *Courtesy of the Florida Photographic Collection.*

177.) 38 MARINE STREET
Kenwood Inn. This structure was built as an inn in 1865, and it was enlarged with a side addition in 1885 and a rear wing in 1910. It was acquired during the late 1980s by Mark and Kerriane Constant and is operated as a bed-and-breakfast.

178.) 35 MARINE STREET
Rodríguez House. Portions of this home, also known as the Free Black House, were constructed in colonial days, perhaps as far back as the first Spanish period. In 1811, the house was traded for a slave and her child. By 1821, it was owned by Chloe Ferguson, a free black woman, whose family occupied it until the Civil War. It was then lived in by Hager Carr, another free black woman, until she died in about 1900. In the early part of the twentieth century, this house was used as quarters for the butler, gardener and chauffeur who served the occupants of a mansion constructed next door.

[South on Marine Street to Bridge Street]

179.) 15 BRIDGE STREET
Carcaba House. In about 1900, this wall surrounding the yard of cigar manufacturer P.F. Carcaba was three feet tall and made of poured concrete. It was later increased to a height of about six feet.

180.) 7 BRIDGE STREET
Sánchez House. On this lot, a wooden house was built in 1788 by José Rosy. It was sold by his daughter, Francisca Rosy Dulcet, to George

Long Jr. in 1804. Long built the present Spanish Colonial coquina house during the early 1800s, and it served as the home of the mother of Jacksonville's first mayor. It was owned by Jose Simeon Sánchez and his family beginning in 1835, and they called it Bleak House after the Charles Dickens novel. It was substantially restored by William and Beulah Lewis beginning in the late 1930s. In the mid-1970s, the house was owned by siblings Richard J. and Doris M. Quinn.

[West on Bridge Street, south on Marine Street]

181.) 46 MARINE STREET

Bay State Cottage. This frame vernacular structure was built between 1865 and 1885. In the early 1900s, it was operated as a year-round boardinghouse by Mrs. H.G. French. Twenty-five people could stay here for $1.50 per day, each. A bath and sanitary plumbing were major amenities. It has also been known as the Duddington Apartments.

182.) 47 MARINE STREET

Marin House. This lot was owned by Francisco Marin, who constructed the two-story stone house during the 1790s and willed it to his son in 1799. The Marin family retained the property until 1876. Subsequent owners have made several wooden additions to the home.

183.) 53 MARINE STREET

Puello House. This Mediterranean Revival–style home was built between 1812 and 1821. It has been completely restored as a private residence.

184.) 56 MARINE STREET

González-Jones House. This two-story, Spanish Colonial–style home was originally built before 1763. It has been completely restored as a private residence.

185.) 59 MARINE STREET

Gibbs House. This property was owned by Kingsley B. Gibbs, who had this wood-frame home built with coquina piers in 1839. During 1866, his son Henry Gibbs operated it as a boardinghouse, and four years later it belonged to Seminole War veteran Captain Daniel Mickler. It was expanded in 1930 with an apartment wing on the eastern end.

186.) 67 MARINE STREET

Pinkham House. This house was constructed between 1840 and 1854 and sits on a foundation of piers made of coquina, which was also used to construct the chimney. It has been the home of William S.M. Pinkham and William W. Dewhurst, both former mayors of the city. The home is covered with wood siding, generally running horizontally. The exception is on the dormer, where the siding slants at an angle of forty-five degrees appearing parallel to the roofline.

[South on Marine Street, east on St. Francis Street, north on Avenida Menendez]

187.) 174 AVENIDA MENENDEZ

Brooks Villa. This home was constructed in 1891 in a Moorish Revival style for brothers Charles S. and Tracy Brooks. Between 1910 and 1917, the one-story porch on the south side was added. It was sold in 1924 to Frederick M. Sackett, a senator from Kentucky who later served as an ambassador to Germany. During the 1960s, it was occupied by Dr. Maurice Leahy, president of the international Oriel Society, and the home took on the nickname of the Oriel House.

188.) 172 AVENIDA MENENDEZ

Rovíra-Hernández House. The exterior wood on this home dates to at least two historical periods. The wider boards on the left section are typical of construction from before the Civil War, likely from 1800–08. The narrower boards on the right side are from the 1880s or later.

189.) 146 AVENIDA MENENDEZ

Westcott House. During the late 1880s, this two-and-a half-story, wood-frame home was built for Dr. John Westcott, a developer of the Intracoastal Waterway and the St. Johns Railroad. The home, on piers to protect it from flooding and allow cooling air to circulate, has front porches on the two main stories plus a porch on the bay that projects from the south side. Victorian details include intricate scrollwork brackets. It was converted to a bed-and-breakfast in 1983.

190.) 142 AVENIDA MENENDEZ

Bayfront Marin House. On this lot in 1788 sat a two-story, wood-frame home owned by Francisco Marin. It was later owned by Captain Henry Belknap, who moved a cottage from the lot to the north and attached it to the back of the house. The present structure dates from 1885–93. It later became apartments known as the Villas de Marin and was converted to a bed-and-breakfast in 2003.

191.) 111 AVENIDA MENENDEZ

City Dock Building. This structure was built between 1924 and 1930 in a Mediterranean Revival style.

[South on Marine Street]

192.) 16 MARINE STREET
(ALSO 118 AVENIDA MENENDEZ)

Worth House. This tall, two-story building was originally built in 1791 by Don Miguel Ysnardy across the street. He used coquina blocks of varying and irregular sizes, perhaps recycled from prior structures. In 1799, it became a hotel known as the Union Hotel, and later as

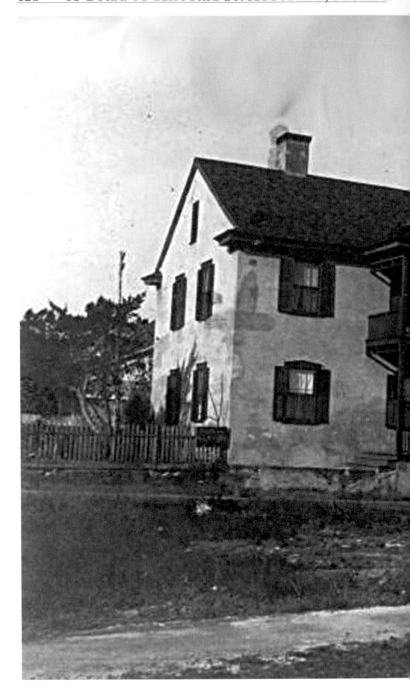

Worth House

After standing for 170 years across the street, this building was reassembled by George Potter on its present site in 1961. This photo shows its appearance in 1902. As the still-popular O.C. White's Restaurant, it was damaged by fire on November 13, 1992. It was restored and reopened, despite many believing it is haunted. *Courtesy of the Florida Photographic Collection.*

Livingston's Hotel and Bridier's Hotel. In the mid-nineteenth century, it was purchased by Margaret S. Worth, who lived in it until she died in 1869. In the early 1900s, it became the home of the Elks Lodge. George Potter bought it in 1948 and later reconstructed it in a Spanish Colonial style on its current location.

193.) 22 MARINE STREET

St. Augustine Art Association. Located here is the home and gallery of the St. Augustine Art Association, which was founded in 1931 as the St. Augustine Arts Club. It was renamed the Arts Club of St. Augustine in 1934 and the St. Augustine Art Association in 1948. The organization and support of local businessmen and the newspaper transformed St. Augustine into a major winter art colony. After occupying space in a portion of the Alcazar Hotel building, later the Lightner Museum, the association acquired this land from the Muller family and constructed the present Art Center in 1953–54.

[North on Marine Street, west on Cadiz Street]

194.) 11 CADIZ STREET

Victorian House. This two-story, wood-frame home was built in about 1895 by Albert Rogero. Rooms were rented out until the 1940s, when the Meyers family turned it into a private residence.

[West on Cadiz Street, north on Aviles Street]

195.) 21 AVILES STREET
(ALSO 20 CHARLOTTE STREET)

Solana House. A home was constructed here in about 1763 for Don Manuel Lorenzo Solana, one of the eight Spanish soldiers allowed to remain in the city when the British took over in 1763. By 1764, a tabby house was on the premises, and it was replaced with a wooden house by 1788. The present home probably dates to 1803–20, and it is built of coquina blocks. After the Civil War it was acquired by Dr. Oliver Bronson, a doctor from New York who became St. Augustine's largest taxpayer and helped establish the Buckingham Smith Benevolent Association to assist black residents. The house was next owned by Charles Hamblen of Maine, who sold hardware and building materials. After 1900, it was used as a meeting site for local labor unions and then was a real estate office during the 1920s. It later housed various stores selling curios, sheet music and antiques. Then in 1983, it was transformed into a bed-and-breakfast. A recent modification to the home was the enclosure of the front arches. The Solana family is one of the city's oldest documented bloodlines, going back to the marriage of Vincent Solana and Maria Visente in 1594.

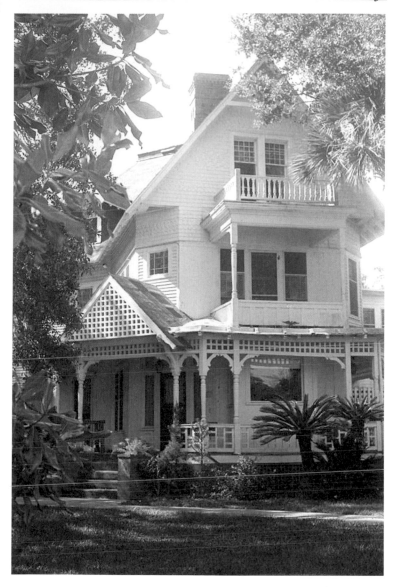

Victorian House
This structure is appropriately called the Victorian House. The porch in this 1984 photo shows Victorian details such as brackets, latticework and turned spindles. The house was restored in 1983 and it, as well as the adjacent carriage house, is operated as a bed-and-breakfast, which its owners named the Victorian House. *Courtesy of the Florida Photographic Collection.*

196.) 20 AVILES STREET

Ximénez-Fatio House. This tall, two-story home built by Andres Ximénez in about 1798 had a six-panel front door, popular during the eighteenth century in the British colonies. Its wooden stairway to the second floor is on the exterior of the home, located at the angle formed

Ximénez-Fatio House
After serving as a real estate office beginning in the 1920s, this home was acquired by the Colonial Dames of America in 1939. They restored its 1848 appearance and have maintained it as a representation of early Florida tourism. It was added to the National Register in 1973. This photo dates to 1946. *Courtesy of the Florida Photographic Collection.*

by the L-shaped porch, and forms a landing approximately halfway to the top. Its first owner used the home as a store to sell groceries, liquor and schoolbooks. The U-shaped house underwent substantial renovations under the ownership of Margaret Cook between 1830 and 1848, including the addition of a wood-frame second story on the warehouse portion of the west wing. Before and after the Civil War, the home served as a boardinghouse for up to twenty-four individuals, run by Elizabeth C. Whitehurst from 1826 until 1838, and Louisa Fatio from 1850 until 1875.

[South on Aviles Street, west on Cadiz Street, south on St. George Street]

197.) 232 ST. GEORGE STREET

Gingerbread House. This home was built between 1857 and 1859 in a Carpenter Gothic style with ornamental woodwork that reminds one of icicles hanging from the edge of a roof. After the Civil War, it was owned by attorney and justice of the peace J. Downing Stanbury, and it remained in the hands of his widow until the 1920s. After she died,

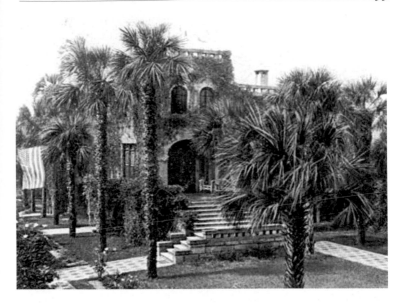

Villa Flora

This photo from about 1906 shows the striking three-story tower resembling that of the Villa Zorayda. Shortly before this photograph was taken, Villa Flora was acquired by roller coaster inventor Alanson Wood. His widow later operated it as a small hotel and the Wander In gift shop. *Courtesy of the Florida Photographic Collection.*

the house was acquired by Robert Gibson, the inventor of radio parts. In the early 1940s, Mr. and Mrs. Henry Gibson operated it as the Magnolia Inn.

198.) 234 ST. GEORGE STREET

Villa Flora. In 1898, this two-story home with a three-story tower was constructed of yellow brick, built over a coquina basement. It was the winter home of Baptist minister O.A. Weenolsen from Minneapolis and one of the first houses in St. Augustine to use yellow-brown brick instead of red brick. It served as the Villa Flora Grill restaurant in the 1930s, and in 1940 was sold to the Sisters of St. Joseph. In recent years, it has served as a kindergarten and was converted in 1973 to a residence for girls training to become nuns.

[North on St. George Street, west on Palm Row]

199.) 1 PALM ROW

Ammidown House. In the front yard of this house was discovered one of the oldest European wells in North America, with pottery fragments dating to the sixteenth century. The 1904 home was occupied for a time by the developer of the street, Henry Philip Ammidown. In 1917, it became the Beckley School for Boys and Girls and then later became the Palm Row School and Kindergarten. It also housed a drugstore owned, in part, by Claude C. Speer who lived at 5 Palm Row.

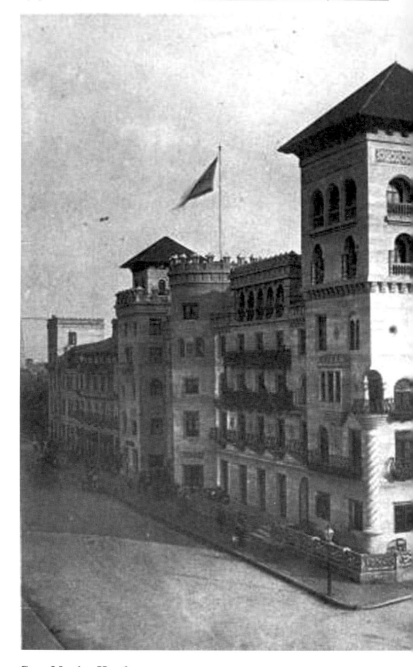

Casa Monica Hotel
After serving as the St. Johns County Courthouse for nearly three decades, the former hotel was restored in 1999 to its original appearance as shown in this 1891 photo, and it is operated once again as the Casa Monica. Some believe the building is haunted by a man in a gray and black striped suit and a 1920s-style hat. *Courtesy of the Florida Photographic Collection.*

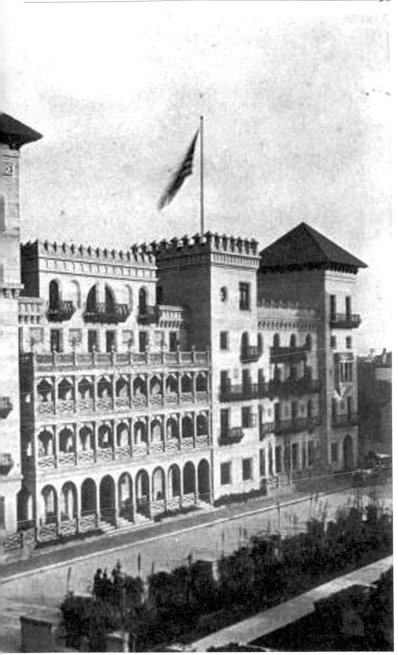

200.) 3–4 PALM ROW

Grout House. This home, as well as four others along this street, were built in 1904 by S. Clarke Edminster for Henry Philip Ammidown. A sixth home was added in 1906, but the remaining planned six were never built. The six white cottages each had corbelled brick chimneys, shutters, brackets cut with jigsaws and bargeboards. A twenty-foot-wide brick street lined with palm trees connected the houses. Grout House was the home of Emma L. Grout, who in September of 1920 became the first registered female voter in the city. The house began as a single residence but was later transformed into a duplex, and during the 1930s it was a beauty shop. Afterward, it became professional offices.

[West on Palm Row, north on Cordova Street]

201.) 123 CORDOVA STREET
(ALSO 7 PALM ROW)

Palm Row House. Although this house has an address on Cordova Street, it is the sixth house built as part of Palm Row. It dates to 1906. When owned by the Ammidown family, this was a rental property with R. Fuller Callaway of the Callaway Clothing Company as one of its earliest occupants. A later occupant was Minerva E. Muir of Muir's Chinese Shop.

202.) 115 CORDOVA STREET

Old City House. This St. Augustine Colonial Revival–style home dating back to 1873 is operated as the Old City House Inn and Restaurant. On the property once stood a portion of the defensive Rosario Line, and the coquina front of the house may have been salvaged from the ruins of a Rosario sentry post. Some believe the property is guarded by the ghost of a Spanish soldier who died when his own musket misfired. This house served as the stable for the Holmes Ammidown mansion, which stood on the site of the bed-and-breakfast's parking lot and burned down in 1929.

[North on Cordova Street]

203.) 95–99 CORDOVA STREET

Casa Monica Hotel. This castle-like hotel includes 138 rooms and was built by architect Franklin Waldo Smith. When it opened on January 17, 1888, it was named the Casa Monica. In 1889, Henry Flagler bought it for $325,000 and renamed it the Cordova. For a time until July of 1947, it was linked to the Alcazar across the street by a covered walkway above the road. Briefly during the 1920s, it was operated as a low-cost hotel. The Cordova closed in 1932, and a portion of the building was converted into county offices, including the St. Johns County Courthouse from 1968 until 1997.

[North on Cordova Street, east on King Street, south on St. George Street]

204.) 214 ST. GEORGE STREET

Horruytinér-Lindsley House. This tall, two-story home with a one-story ell, also known as the Lindsley House, has wooden floors joined in a tongue-and-groove manner. It survived the 1702 fire, and owner Lorenzo Horruytinér asked the government for four hundred pesos to repair the fire damage. Its yard was at least partially enclosed by a tabby wall, and the section along its south line is the only wall of its kind still standing in St. Augustine. At the end of the first Spanish period, the home was owned by Don Diego Horruytinér y Puego, a member of a prominent family that included two governors. During most of the period of British rule (1764–84), this was the home of Dr. Robert Catherwood, who had a reputation as being a poor surgeon. In 1783, he was suspended from public office because of his speculation in captured slaves and his charging of exorbitant fees for justice. Later, this building, with a spacious loggia, was the home of the Woman's Exchange, whose fundraising efforts included the sale of needlework and jelly, and the rental of rooms to single women. Dr. Horace E. Lindsley bought the house in 1896, and it remained in his family until 1977. Some people believe the home is haunted by the ghosts of a calico cat and a man wearing a blue, seventeenth-century soldier's uniform.

205.) 215 ST. GEORGE STREET

Trinity Episcopal Church. The original portion of this church building was begun in 1830 and was completed in a Gothic style in time for its first service on June 30, 1831. The one-story structure was constructed of coquina, some of which still remains in the baptistery and the east and north walls of the north transept. The stonework was supervised by Reuben Wing Loring. The church, originally thirty-six feet wide and fifty feet long, was enlarged in about 1850 with the addition of a vestry room in the rear and was remodeled in 1893 and 1902–03. During the second remodeling, handled by New York architects Smelling and Potter, the building was converted into a traditional cross shape and reoriented to face St. George Street, and its first Tiffany stained-glass window was added. Additional modifications in 1917 and 1954 gave the church its present open courtyard and arched arcade. Before the construction of the church, this lot was occupied by a structure that served as the Spanish bishop's home, an Anglican church during the British colonial period and a statehouse.

206.) 224 ST. GEORGE STREET

Moeller House. Also known as the Juan Aguillar-Seguí House and the Paredes-Seguí-Macmillan House, this Spanish Colonial–style home's first floor dates to 1764. The upstairs was added in 1823 and the entire home was restored during the 1960s. The owner of this two-story house also owned the home at 214 St. George Street, and in 1993 led a fight to keep a multilevel parking garage from being built between the two.

[North on St. George Street, east on Artillery Lane]

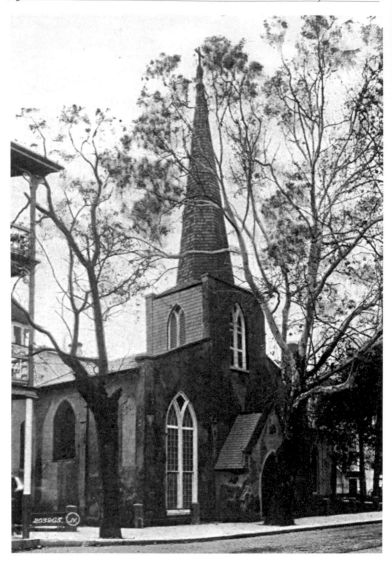

Trinity Episcopal Church
Trinity Episcopal claims to be the oldest Protestant church in Florida, having been founded in 1821. The sanctuary was formally consecrated by Bishop Nathaniel Bowen of South Carolina on June 5, 1834. *Courtesy of the Florida Photographic Collection.*

207.) 4 ARTILLERY LANE

Oldest Store Museum. During the late 1880s, this structure was the store of Charles Ferdinand Hamblen, in which he sold medicine, tobacco, clothing, groceries and household appliances. In the building were also a harness maker, blacksmith, gunsmith, dentist and optometrist. By 1888, Hamblen dropped groceries in favor of hardware. In 1908, it was the third-largest store of its type in the state. As Hamblen's Hardware, the store moved to 111 King. This building was erected between 1910

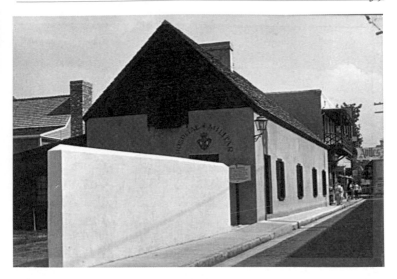

Spanish Military Hospital
During the British colonial period, William Watson purchased a stable located on this lot and remodeled it for his residence. He later tore it down and replaced it with the present structure, which served as his home, which the Spanish turned into a military hospital during the second Spanish period. *Courtesy of the Florida Photographic Collection.*

and 1917 as Hamblen's warehouse and garage for servicing vehicles, and later housed a museum of the hardware business. It has now been substantially remodeled and converted into residences.

[East on Artillery Lane, north on Aviles Street]

208.) 3 AVILES STREET
Spanish Military Hospital. From 1784 until approximately 1821, this site was used by the Hospital of Our Lady of Guadalupe, also known as the Spanish Military Hospital. In 1965–66, the building was reconstructed on the original foundation with the same Spanish Colonial style and was turned into a museum of medical tools from that era. Some believe it is haunted by the ghost of a one-legged man and many others who may have died in the hospital. According to a popular story, a portion of Aviles Street collapsed during the 1970s, so the city decided to repair or replace pipes beneath the street. When workers opened the area in front of the former hospital, they found hundreds of human skeletons, some complete and some partial. This building now serves as a tour office.

[South on Aviles Street]

209.) 12 AVILES STREET
Seguí-Kirby Smith House. This homesite has been occupied continuously since the late 1500s. The tall, two-story home has been there since

the late 1700s. In 1786, the house was acquired by Bernardo Seguí, a member of a prominent Minorcan family. He was a prosperous merchant and served as the baker to a Spanish garrison and a Spanish militia official. He acquired the Buena Esperanza property, a small mission built to serve Native Americans living along Maria Sanchez Creek, which he developed into an orange grove. In about 1823, the home was rented by Judge Joseph Lee Smith, and in May of 1824 it was the birthplace of Edmund Kirby Smith (sometimes written as Kirby-Smith). Edmund grew up to graduate from West Point, serve as the youngest lieutenant general in the Confederate army and be the last Confederate Civil War general to surrender. General Smith and his sister sold the house in 1887, and it was transformed into a boardinghouse and offices. The small building to the left of the main house served as a dining room and kitchen. In 1895 John L. and Frances Wilson purchased the property and donated it to the city to serve as a free public library. During World War II, the library's president was noted author Marjorie Kinnan Rawlings. In addition to books, the building later housed the *St. Augustine Daily Press* newspaper office, a courtroom and the Daughters of the American Revolution. In 1995, it became the home of the St. Augustine Historical Society.

[South on Aviles Street, east on Artillery Lane, north on Charlotte Street]

210.) 206 CHARLOTTE STREET
Watson House. In 1766, William Watson of Scotland arrived and began acquiring old buildings, fixing them up and selling them. Watson built this house and lived in it until he left St. Augustine in 1784. This two-story, wood-frame home has a foundation measuring twenty by thirty-two feet. It was reconstructed with a British Colonial style in 1965.

[North on Charlotte Street to end at the Plaza de la Constitución]

Lincolnville

Site	Distance	Address
1	0.3	115 Bridge Street
2	0.4	89 Bridge Street
3	0.4	84 Bridge Street
4	0.5	79 Bridge Street
5	0.5	74 Bridge Street
6	0.5	69 Washington Street
7	0.5	70 Washington Street
8	0.6	83 Washington Street
9	0.6	87 Washington Street
10	0.6	92 Washington Street
11	0.6	93 Washington Street
12	0.7	100 Washington Street
13	0.8	100 M.L. King Avenue
14	0.8	102 M.L. King Avenue
15	1.0	119 & 121 Kings Ferry Way
16	1.1	37 Lovett Street
17	1.3	156 M.L. King Avenue
18	1.3	160 M.L. King Avenue
19	1.5	94 South Street
20	1.7	175 Oneida Street
21	1.7	187 Oneida Street
22	2.0	163 Twine Street
23	2.3	222 Riberia Street
24	2.6	86 M.L. King Avenue
25	2.7	85 M.L. King Avenue
26	2.7	82 M.L. King Avenue
27	2.8	91 St. Francis Street
	3.0	Bridge Street

[From the parking lot at the intersection of Granada and Bridge Streets, go west on Bridge Street]

1.) 115 BRIDGE STREET

Yallaha Grove House. This one-and-a-half-story home consists of a wooden section built in about 1845 and a coquina section that is probably older. Both sections sit atop a coquina foundation. The home was owned by the family of P.B. Dumas, who lived there from 1869 until 1893, and then was substantially remodeled by William A. Forrester, a contractor who purchased it in 1955. A number of later modifications were undone to return the house to its 1876 appearance, as it had been depicted in a pair of sketches made by E.R. Townsend. For a time, it was used as a welfare and food stamp office, with living quarters upstairs.

[East on Bridge Street]

2.) 89 BRIDGE STREET

Macon House. This two-story Victorian home was built between 1871 and 1885 with a two-story open porch. One of the early occupants of the home was Carrie Macon, the owner of a hair salon located at 161½ St. George Street.

3.) 84 BRIDGE STREET

Trinity United Methodist Church. This congregation was founded in 1821. It erected a sanctuary at this site in 1870, and it was rebuilt out of masonry with its present appearance in 1913. Adjacent to the sanctuary is the Trinity Methodist House, a bungalow constructed during the 1920s.

4.) 79 BRIDGE STREET

Rudcarlie Building. In this 1950 masonry vernacular structure was the dental office of Dr. Robert Hayling, the NAACP representative who was instrumental in focusing national attention on segregated St. Augustine in 1963–64. He was a local hero of the civil rights movement.

5.) 74 BRIDGE STREET

**The Iceberg.* Located here in the early twentieth century was a soda fountain and drugstore. It was reputed to serve St. Augustine's best ice cream.

[South on Washington Street]

6.) 69 WASHINGTON STREET

St. Mary's Baptist Church. This congregation was established on May 25, 1875, as an affiliate of First Baptist Church. After meeting in a church built at another location in 1920, this sanctuary was erected in 1937.

7.) 70 WASHINGTON STREET

Soup Kitchen. This frame vernacular home was restored and used as a soup kitchen during the 1990s. It is now operated as the St. Francis House by the St. Augustine Society Inc. It was built between 1885 and 1893.

8.) 83 WASHINGTON STREET

**Lincolnville Bar.* Originally located here was a one-story, masonry building erected between 1904 and 1910. Over the years it was the meeting place of the Iroquois Social Club, a store, poolroom and tavern. An ornate liquor shelf and tile floor were distinguishing characteristics of the interior. The old structure was replaced by the Butler, Edwards, Hadley Building in 1997, housing the St. Paul AMEC Development Center.

9.) 87 WASHINGTON STREET

Butler House. This home of Frank B. Butler was built in about 1906. Beginning in 1914, Butler owned the Palace Grocery, located a little north on Washington Street at the corner of Bridge Street. In the same building, he had an office for his College Park Realty Company, which developed the College Park subdivision. The store was remodeled during the 1970s and for a time was used as a law office.

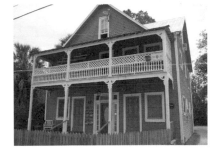

Butler House
This was the residence of Frank Butler, who in addition to operating a grocery store was also a realtor and a developer. He developed Butler Beach along the Atlantic Coast south of St. Augustine because black individuals were not allowed on "white" beaches. Butler Beach was the site of civil rights demonstrations in the 1960s. *Photo by Kelly Goodman.*

10.) 92 WASHINGTON STREET

Odd Fellows Hall. This three-story structure was built in 1908 with a two-story open porch. It has been a meeting hall since it opened and has also housed the medical office of Dr. Thomas G. Freeland, a grocery store and a movie theater. Modifications included the removal of the porch.

11.) 93 WASHINGTON STREET

**Temperance Hall.* A one-story frame home at this location was built between 1865 and 1885 and after serving as a community meeting hall was rented by funeral director E. Aldrich Johnson. During the 1920s, it acquired its name of Temperance Hall, and ironically later became a bar. It was later torn down.

12.) 100 WASHINGTON STREET

Elks Rest. This building was constructed in 1958 for the Fountain of Youth Lodge 649 of the BPOE. During the 1960s, it served as a training and strategy center for the St. Augustine civil rights movement.

[South on Washington Street, west on Park Place to Martin Luther King Avenue]

13.) 100 MARTIN LUTHER KING AVENUE

Echo House. During 1926, this one-story, Mediterranean Revival–style home was built as part of a complex of three buildings. The Echo House was started here in 1973 with the help of a donation by Clarissa Anderson Gibbs in memory of her father, Dr. Andrew Anderson Jr. The project included plans to provide Lincolnville with a library, alcoholism counseling, meeting space and an arts and crafts outlet.

[South on Martin Luther King Avenue]

14.) 102 MARTIN LUTHER KING AVENUE

Excelsior Museum and Cultural Center. Formerly Excelsior High School, this Mediterranean Revival–style structure was built in 1924 and was the first high school in St. Augustine for black students. In 2004, the Board of County Commissioners authorized the expenditure of nearly $350,000 to renovate the local museum housed here.

[South on Martin Luther King Avenue, west on Kings Ferry Way]

15.) 119 AND 121 KINGS FERRY WAY

Shotgun Houses. These homes, built in about 1910, each have a long hallway leading from the front door and three rooms along one of its sides. They are said to be "shotgun houses" because a shotgun could be fired through the front doorway and not hit any walls before the buckshot went out the back doorway. They are trimmed with gingerbread and were likely the homes of working-class families.

[East on Kings Ferry Way, south on Martin Luther King Avenue]

16.) 37 LOVETT STREET

St. Cyprian's Episcopal Church. St. Cyprian's was established as a mission in 1896. This visually interesting, shingle-covered church was built in 1902 in a Victorian style with diamond-shaped and stained-glass windows and a gable tower.

17.) 156 MARTIN LUTHER KING AVENUE

Price House. This home's claim to fame is that Dr. Martin Luther King Jr. spent the night here in 1964 while he was visiting the city for civil rights demonstrations.

18.) 160 MARTIN LUTHER KING AVENUE

Civil Rights House. When he was a youth, L.L. Fabisinski lived in this Victorian house built between 1885 and 1894. By 1954 he was serving as a judge in Pensacola. During that year, the U.S. Supreme Court handed down its *Brown vs. Board of Education* decision, which declared the segregation of public schools unequal, and therefore illegal. Florida formed the Fabisinski Committee, headed by the judge, in an attempt to stall integration as long as possible. Later, this was the home of Dr. Robert Hayling, a black dentist who had led civil rights demonstrations to bring about the integration that the Fabisinski Committee was trying to delay. The home, originally owned by George Old of the St. Augustine Gas Company, is Victorian in style with a somewhat Moorish Revival influence.

[North on Martin Luther King Avenue, east on South Street]

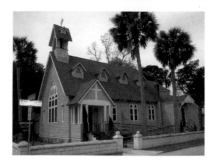

St. Cyprian's Episcopal Church
At the corner of Martin Luther King Avenue and Lovett Street is this large wooden church with a distinctive tower. Much of the credit for raising the funds necessary for its 1902 construction is attributed to winter visitor Emma White. *Photo by Kelly Goodman.*

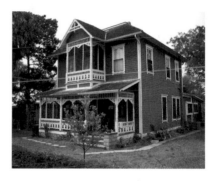

Civil Rights House
At different times, this was the home of two prominent figures in the civil rights movement of the 1960s. It was the home of a judge who headed a committee that attempted to delay integration as long as possible, and later it was the home of a local activist who fought for equal rights. *Photo by Kelly Goodman.*

19.) 94 SOUTH STREET

Slave Cabin. This coquina building is a garage or storage building serving the larger house nearby. However, this building started out itself as a house, providing living quarters for slaves.

[East on South Street, south on Oneida Street]

20.) 175 ONEIDA STREET

Three Oaks. In 1890, this two-and-a-half-story, wood-frame house was built for George Atwood Jr., the vice-president of the St. Augustine Improvement Company. That company manufactured the concrete

block veneer that covers the wood and holds the decorative stones placed on the exterior. The original gabled roof was replaced by a hipped roof in 1910. The home was modified several times, including a substantial renovation following a fire during the 1960s. After 1979, new owners changed the name of the home to Casa Guadalupe and added a porch and awnings.

Slave Cabin
This small outbuilding was built prior to the construction of nearby larger homes. Before the Civil War, it was the home of slaves who worked on the nearby Buena Esperanza plantation. *Photo by Kelly Goodman.*

21.) 187 ONEIDA STREET

Villa Rosa. This home was built in 1895 for Heth Canfield, president of the St. Augustine Improvement Company. As such, he directed the dredging of the southern portion of Maria Sanchez Creek, resulting in today's Maria Sanchez Lake. The house had an open tower that rose above the two main stories. The exterior was covered with wooden shingles. It was sold in 1901 to Alfred Jerome Weston as a winter home. In 1935, Weston sold it to the Episcopal Sisters of Resurrection for use as a convent. In the 1940s, it became Resthaven, an Episcopal rest home. During the late 1960s, the home was purchased by Alfons Bernhard and John Bernworth, who also owned Three Oaks.

[South on Oneida Street, west on Cerro Street, north on Twine Street]

22.) 163 TWINE STREET

Twine House. This was the home of Henry L. Twine, president of the local chapter of the NAACP and a three-time member of the St. Augustine City Commission. He was also the city's first black vice mayor. His wife, Katherine Twine, was nicknamed as the "Rosa Parks of St. Augustine" and was frequently arrested a result of her participation in civil rights demonstrations in the 1960s.

[North on Twine Street, west on South Street, north on Riberia Street]

23.) 222 RIBERIA STREET

Bethel Missionary Baptist Church. This congregation was organized on November 8, 1939, and this stucco-covered church building was erected in 1943 while Reverend William Banks was the pastor.

[North on Riberia Street, east on DeHaven Street to Martin Luther King Avenue]

24.) 86 MARTIN LUTHER KING AVENUE

St. Benedict School. This school, originally called St. Cecilia, was built in 1898 and is the oldest surviving brick schoolhouse in St. Augustine. Its Victorian architecture is shown in its tower and its original wraparound porch. The school was donated by a wealthy Philadelphia heiress, Mother Katharine Drexel, who founded the Sisters of the Blessed Sacrament for blacks and Native Americans. Drexel also established more than sixty private religious schools throughout the country and was named a saint on October 1, 2000. The school was operated by the Sisters of St. Joseph, a teaching order that came to St. Augustine in 1866. St. Benedict School closed in 1964 upon the integration of local Catholic schools. The school building was used as the headquarters of the Northeast Florida Community Action Agency during the late 1970s and early 1980s. Upon the completion of the current renovation, there are plans for the three-room schoolhouse to house a museum.

25.) 85 MARTIN LUTHER KING AVENUE

St. Paul AME. Church. This congregation was organized in 1873 by Reverend Richard James. Its first building was a small structure located near Maria Sanchez Creek. From 1888 until 1903, the congregation worshipped in a stone church building on School Street. In 1904, Reverend E.F. Williams arranged for the purchase of the present lot, which included a two-story frame building along St. Benedict Street. Reverend Williams designed the present brick church and supervised its construction. Its baptismal font was donated to the church in memory of Dr. D.W. Roberts, who died of influenza as a result of treating patients during World War I. The educational building was erected in 1958.

26.) 82 MARTIN LUTHER KING AVENUE

St. Benedict the Moor Catholic Church. Prior to the Civil War, this land was part of the Yallaha orange grove plantation. Stella Dumas transferred ownership of it to the Catholic Church in 1890. Construction of the Mediterranean Revival–style church began on September 19, 1909, and was completed in 1911. It was designed by architects Robinson and Reidy of Savannah, who also designed the Orange Street School. Black Catholics in St. Augustine had founded the St. Benedict Benevolent Society before the Civil War and incorporated it in 1872. Next door is a red brick rectory building completed in 1915, and it was the home of the Josephite Fathers. The rectory was visited by Dr. Martin Luther King Jr. in 1964. This building is one of the state's oldest black Catholic churches.

[North on Martin Luther King Avenue, east on St. Francis Street]

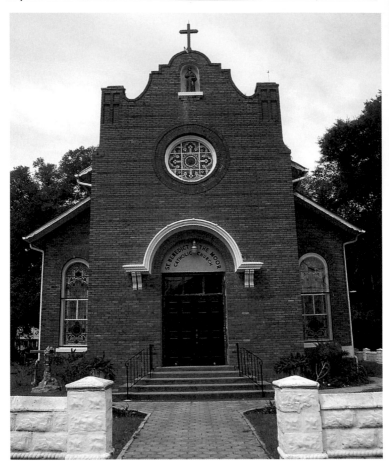

St. Benedict the Moor Church
The name of this Catholic church comes from a Sicilian friar of the sixteenth century. He was known as the "Holy Negro" because of his charitable work, and he was canonized as a saint in 1807. *Photo by Kelly Goodman.*

27.) 91 ST. FRANCIS STREET

First Baptist Church. This church was organized in 1872 by Hannah Jordan, and its first pastor was Reverend Father C. Felder. A sanctuary had been built at this site by 1884, but it burned down in 1915 and was replaced by the current building the following year. Dr. Martin Luther King Jr. attended rallies here in 1964. The parsonage at 81 St. Francis Street was built between 1917 and 1924. During the 1960s, this church served as a meeting place for civil rights activists, earning it the nickname of the "Cradle of the Civil Rights Movement" in St. Augustine.

[East on St. Francis Street, north on Oneida Street, east on Bridge Street to the beginning]

North City

Site	Distance	Address
1	0.0	27 Ocean Avenue
2	0.3	11 Magnolia Avenue
3	0.5	167 San Marco Avenue
4	0.7	16 May Street
5	0.9	24 Nelmar Avenue
6	1.3	207 San Marco Avenue
7	1.8	63 Bay View Drive
8	1.9	54 Bay View Drive
9	1.9	52 Bay View Drive
10	2.1	16 Bay View Drive
11	2.2	7 Waldo Street
12	2.6	190 San Marco Avenue
13	2.7	184 San Marco Avenue
14	2.7	180 San Marco Avenue
15	3.1	10 Sebastian Avenue
16	3.5	33 Old Mission Avenue
17	3.7	102 San Marco Avenue
18	3.8	15½ Bernard Street
19	3.8	28½ Bernard Street
20	4.2	17 Cincinnati Avenue
21	4.3	24 Cincinnati Avenue
22	4.4	50 San Marco Avenue
23	4.4	47 San Marco Avenue
24	4.4	39 San Marco Avenue
25	4.5	19 San Marco Avenue
26	4.5	10 Castillo Drive
27	4.6	San Marco Avenue
28	4.7	15 Shenandoah Street
29	4.9	21 Water Street
30	4.9	22 Water Street
31	4.9	23 Water Street
32	5.1	19 Joiner Street

Site	Distance	Address
33	5.1	14 Joiner Street
34	5.2	33 Water Street
35	5.2	38 Water Street
36	5.3	42 Water Street
37	5.3	47 Water Street
38	5.3	51 Water Street
39	5.4	70 Water Street
40	5.4	80 Water Street
41	5.5	84 Water Street
	5.9	Ocean Avenue

[Begin at the Mission of Nombre de Dios]

1.) 27 OCEAN AVENUE

Mission of Nombre de Dios and Shrine of Our Lady of La Leche. The chapel of the Mission of Nombre de Dios ("Name of God") is a reconstructed 1915 building, replacing a series of chapels that were burned or otherwise destroyed over the centuries. The series began with a 1587 mission church, which was replaced by a stone church in 1678. The stone church was burned in 1728 in an attack on the city by John Palmer. Another church was built in 1874 by Bishop Verot, replacing a church previously used as a hospital by the British that had been allowed to deteriorate. The 1874 chapel lost a roof and two exterior walls in an 1878 storm. The

La Leche Shrine
The present 1915 chapel was donated by the widow of General Martin D. Hardin, who had served as an aide to General Robert E. Lee prior to the Civil War. Hardin retired from the military and practiced law in St. Augustine. *Courtesy of the Florida Photographic Collection.*

early parish church located here was called Nuestra Señora de la Leche y buen parto ("Our Nursing Mother of Happy Delivery") and included a statue of Mary and her infant. The tall cross designed by Eugene F. Kennedy Jr. was erected in 1966 at the point where Menéndez first came ashore. At seventy tons and 208 feet in height, it is the tallest cross in the Western Hemisphere. It is reached by a footbridge and path that passes by a bronze statue of Francisco López de Mendoza Grajales, the fleet chaplain who sailed with Menéndez. Near that spot is an eleven-foot-tall statue of Father Grajales sculpted by Ivan Mestrovic, as well as a cemetery that was first used for Catholic

burials in 1856, with its most active period being between 1874 and 1891. Six nuns who came to St. Augustine to teach in 1866 are buried within a walled section of the cemetery. On the grounds is the Prince of Peace Catholic Church, constructed in 1965 to commemorate the four hundredth anniversary of the Mission of Nombre de Dios. It is made largely of coquina and the walls of the church are composed of solid blocks of stone, rather than a mixture of coquina dust and cement seen in other buildings. The church was dedicated by Franjo Cardinal Seper on April 17, 1966.

[North on San Marco Avenue, east on Myrtle Avenue, north on Magnolia Avenue to Williams Street]

2.) 11 MAGNOLIA AVENUE

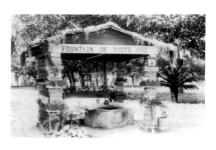

Fountain of Youth. This tourist attraction located on the site of an Indian burial ground was developed by Dr. Luella Day McConnell and later by entrepreneur Walter B. Fraser, who also promoted the Oldest Wooden Schoolhouse. Fraser served as St. Augustine's mayor from 1934 until 1942. On display is a spring that was welled up in 1875, located in the cypress and coquina Spring House. The attraction also includes a pewter reproduction of a salt cellar, an area believed

Fountain of Youth

The owners of this early tourist attraction claim that Ponce de León and his men came ashore at this location in 1513, found the Fountain of Youth and placed twenty-three stones in the ground in the shape of a cross, which was found intact in the early 1800s. This image appears on a 1907 postcard. *Courtesy of the Florida Photographic Collection.*

to be the Indian village of Seloy, a native burial ground and other exhibits relating to Native Americans and Spanish occupation of the area.

[West on Williams Street, north on San Marco Avenue]

3.) 167 SAN MARCO AVENUE

Old Jail. The major building on this site is the former St. Johns County Jail, constructed in 1891 in a Romanesque Revival style with some Queen Anne Victorian elements. It was built by the Pauly Jail Building and Manufacturing Company of St. Louis, which later built Alcatraz Prison in San Francisco. It lacked indoor plumbing until 1914, had open barred windows and up to four inmates shared each cell. This jail housed up to seventy-two prisoners at a time until it closed in 1953, and it is the oldest surviving county government building in St. Johns County. The jail is believed by some to be haunted by a number of ghosts, including possibly Sheriff Perry. Another alleged ghost on the

premises is that of Dexter, who was a prisoner in the jail after being arrested for stealing jewelry at the Ponce de León Hotel. He reportedly has been seen wearing a plaid suit and holding a small round hat. Also on the grounds is the Mary Peck House. The old jail was added to the National Register of Historic Places on August 27, 1987.

[North on San Marco Avenue, east on May Street]

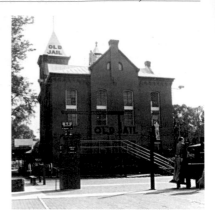

Old Jail
St. Augustine's jail originally was located on Cordova Street, adjacent to the Ponce de León Hotel. Henry Flagler didn't want a jail next door to his wealthy clientele, so he donated $10,000 to have this one built in 1891 north of the Castillo. *Courtesy of the Florida Photographic Collection.*

4.) 16 MAY STREET

The Pink Castle. St. Augustine's most famous resident sculptor was C. Adrian Pillars, and this home built in the early 1920s served as his home and studio. Two of his statues are on display in the U.S. Capitol, those of Dr. John Gorrie and General Edmund Kirby Smith of St. Augustine. Other prominent works are the World War I memorial flagpole in Anderson Circle and the Winged Victory statue that was placed in Riverside Park in Jacksonville. Pillars moved to Sarasota in 1932. This home received its name while it was painted bright pink and is now a more subdued tone of beige.

[East on May Street, north on Magnolia Avenue, west on Nelmar Avenue]

5.) 24 NELMAR AVENUE

Los Robles. This Mediterranean Revival–style home was designed in the mid-1920s by Wallace Neff for Ruth Hopkins Shackford Pickering of Duluth, Minnesota. Neff, of Pasadena, California, gave the home a Southwestern appearance. Walls slope inward and corners are soft, reminding one of adobe homes. The name of the home is Spanish for "The Oaks," so named because it was built in a grove of live oaks.

[West on Nelmar Avenue, north on San Marco Avenue]

6.) 207 SAN MARCO AVENUE

Florida School for the Deaf and Blind. Prior to its use as a school campus, a portion of this land was acquired in 1807 by Juan Genopoly, who used it for growing garden crops. He also acquired nearby acreage from his father-in-law and a portion of the Domingo Seguí Grant, and on

that land raised corn and dairy cattle. Those lands were sold in 1868 and constituted portions of two residential subdivisions as well as the school grounds. In 1883, additional land was donated by Captain Edward E. Vaill for the construction of a school. During 1884–85, the original four wooden buildings were erected on the campus, which then covered four acres. An additional thirty-five acres were dredged from the Matanzas River in 1956. One of the school's most famous students was jazz great Ray

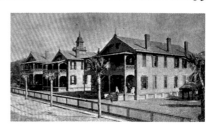

Florida School for the Deaf and Blind

Many believe that Gregg Hall Dormitory on this campus is haunted by the ghost of a blond teenage boy. He has been seen hanging from the shower rod in the east wing's girls' bathroom with his neck cut nearly through. He then gets down and walks away. This photo of the school was taken in about 1897. *Courtesy of the Florida Photographic Collection.*

Charles. The campus now includes the Lucille M. Moore Hall designed by Jefferson D. Powell, built in 1948, the TV Media Center (1915), the Hospital (1917), the F. Charles Usina Athletic Field (dedicated in 1967), McLane Hall (1936), Bloxham Cottage (1924), Wartman Cottage (1922), Rhyme Hall (1930) and Gregg Hall Dormitory (1952).

[North on San Marco Avenue, east on Macaris Street, north on Rainey Avenue, east on Bay View Drive]

7.) 63 BAY VIEW DRIVE

Hopwood House. This 1920s Colonial Revival–style home with a fan decoration over the front door was the winter residence of Judge Robert F. Hopwood of Uniontown, Pennsylvania. He was a Sunday school superintendent for the Methodist Church and a member of the U.S. House of Representatives, who voted for every bill that would support the temperance movement.

[West on Bay View Drive]

8.) 54 BAY VIEW DRIVE

Medoff House. This 1920s bungalow was the home of Harry J. Medoff. It exhibits some Colonial elements such as the columns supporting the entrance porch. An interesting feature of the home is the eyebrow dormer above the similarly curved porch roof.

9.) 52 BAY VIEW DRIVE

Lynn House. This home was built during the 1920s land boom in the Fullerwood neighborhood of the North City. It was designed by Francis A. Hollingsworth in a Mediterranean Revival style and was originally owned by J.H. Lynn Jr.

10.) 16 BAY VIEW DRIVE

McDowell Baptist Church This frame vernacular sanctuary was built between 1917 and 1924. In 2006, the front stained-glass doors were dedicated in memory of Eula Mae Hasty Wilson. Other portions of the building have been dedicated in memory of William "Papa/WJ" Wilson and Cameron Dow Gates.

[West on Bay View Drive, north on San Marco Avenue, west on Waldo Street]

11.) 7 WALDO STREET

Holy Trinity Greek Orthodox Church of St. Augustine. This building was the home of a Greek Orthodox mission beginning in 1995, the year the Hellenic Society purchased it. The mission became a parish six years later. The church later moved to 2940 County Road 214, and the building was remodeled as the offices of Matthews Design Group Inc.

[East on Waldo Street, south on San Marco Avenue]

12.) 190 SAN MARCO AVENUE

National Guard Armory. This facility is named for Lieutenant General Mark W. Lance, who served as the adjutant general of Florida from 1947 until 1962.

13.) 184 SAN MARCO AVENUE

Waterworks. Constructed in 1880s, this brick structure served as St. Augustine's first railroad train station. It was acquired by Henry Flagler, who used it as the city waterworks until it was superceded by a more modern facility west of downtown in 1927. Beginning in 1965, the St. Augustine Garden Club rented the facility and maintained its interior. By 2005, the badly deteriorated building was condemned.

14.) 180 SAN MARCO AVENUE

J & S Carousel. Built in 1927, this was known as the C.W. Parker Carousel. In 1987, Ringling Brothers circus performer Gerard Soules found it in a barn in Mystique, Michigan, and bought it for $25,000. It was placed in operation at the zoo in Fort Wayne, Indiana. When Gerard died in 1992, it was inherited by his brother, James Soules, who restored it with the assistance of Carl Theel of Theel Manufacturing in Leavenworth, Kansas. Theel also died in 1992. James Soules installed the carousel here in Davenport Park in 1994. Some believe it to be haunted and have reported hearing children's laughter when no one is around. Others have reported seeing the image of a man, perhaps the ghost of Carl Theel.

[South on San Marco Avenue, west on Sebastian Avenue]

15.) 10 SEBASTIAN AVENUE

Cathedral Parish School. This school is the early education center for the parish centered in the Cathedral Basilica.

[East on Sebastian Avenue, south on San Marco Avenue, west on Old Mission Avenue]

16.) 33 OLD MISSION AVENUE

Walker House. This was the home of Horace Walker, a driller of artesian oil wells from Pennsylvania who came to St. Augustine to drill water wells for Henry Flagler. Later, he started an alligator farm. The home is a small Moorish Revival–style building with large arches and an unusual masonry fence. Also known as the Castillo Sebastian, it bears the date of July 1886, its time of completion.

[East on Old Mission Avenue, south on San Marco Avenue]

Cathedral Parish School
Before this attractive building became the parish elementary school, it was the home of St. Agnes Catholic Church. The frame vernacular structure was constructed in 1906. *Photo by Kelly Goodman.*

17.) 102 SAN MARCO AVENUE

Raintree Restaurant. This lot and the surrounding area were developed by Bernard Masters between 1879 and 1885. Masters purchased the property at auction in 1877, built a home for himself and his wife and raised five daughters in it. On the same tract, Masters built this building and another identical structure. In 1897, the future restaurant belonged to Bernard's daughter, Hattie, who married A.J. Collins. The home operated as a boardinghouse in the late 1940s and then as the Corner House Restaurant. In 1981, it became the Raintree Restaurant.

[South on San Marco Avenue, west on Bernard Street]

18.) 15½ BERNARD STREET

North City Baptist Church. This church was organized in 1886 by Reverend S. Saunders. Its original sanctuary was rebuilt here by Reverend R. Mabre starting in 1928 and was finished by Reverend C.J. Watkins in 1933. It stands one and a half stories and is constructed of blocks of coquina.

19.) 28½ BERNARD STREET
Hurst Chapel AME Church. This one-story wooden church was built between 1909 and 1910. It has also been known as the Colored Methodist Church.

[East on Bernard Street, south on San Marco Avenue, west on Cincinnati Avenue]

20.) 17 CINCINNATI AVENUE
Allen House. This house was built in 1910 by B.E. Pacetti, who manufactured the rusticated concrete blocks that he called artificial stone. It was the home of Fred M. Allen, the city editor of the *St. Augustine Evening Record.*

21.) 24 CINCINNATI AVENUE
Capo House. In 1914, this home was built by Fred Capo, a blacksmith for the Florida East Coast Railway. He made each concrete block with local coquina shells, which give them a golden hue. He and his wife, Lottie, died in the house, which some believe to be haunted by an old lady who is stuck on the first floor because she is unable to climb the stairs to get to her bedroom.

[East on Cincinnati Avenue, south on San Marco Avenue]

22.) 50 SAN MARCO AVENUE
**Moeller Brothers Bakery.* The Moeller brothers founded a bakery during the 1880s. Initially, they sold their baked goods from a horse-drawn wagon, and then moved to a store at this location. The bakery remained in business here until 1960. The building now houses a convenience store.

23.) 47 SAN MARCO AVENUE
Seguí House. This home was built in 1910 in a Colonial Revival style. It was erected by Minorcan Charles Seguí and remained in his family for almost eighty years. It was transformed into the lodging known as the Seguí House Inn in 1991 and is now operated as the Painted Lady Bed & Breakfast. Some believe it to be haunted.

24.) 39 SAN MARCO AVENUE
Harris House. This was the home of photographer W.J. Harris, who served as curator of the St. Augustine Historical Society. It was built in approximately 1860. A recent owner, Hollie Criswell, operated her Herbal Creations store in it with a tranquil garden outside. Some believe the house is haunted by the ghosts of a cat and of an elderly woman.

25.) 19 SAN MARCO AVENUE

Castle Warden. In 1887, this Moorish Revival home with an elaborate interior was constructed for William G. Warden of Philadelphia, who was a partner of Henry Flagler and John D. Rockefeller in the Standard Oil Company. Warden also served as the financial director of the St. Augustine Improvement Company and the president of the St. Augustine Gas and Electric Company. While Warden resided here during the winter season, it was a popular social center. It was the largest poured concrete

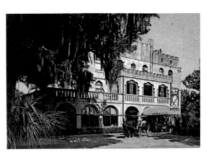

Castle Warden
Since 1950, this building resembling a castle has been the home of Ripley's Believe It or Not Museum. Some believe it to be haunted by the ghosts of two women who perished in a fire in April of 1944, which damaged the third floor and the penthouse suite. *Courtesy of the Florida Photographic Collection.*

structure in the city intended to be used as a residence. The house was acquired by hotelier Norton Sanford Baskin in 1941, the year he married author Marjorie Kinnan Rawlings, and he remodeled it as the Castle Warden Hotel. Baskin and Rawlings had an apartment on the top floor, and other authors and notable individuals stayed here while it was a hotel.

[South on San Marco Avenue to the next building past Castillo Drive]

26.) 10 CASTILLO DRIVE

Civic Center. Architect Fred A. Henderich designed this building in a Mediterranean Revival style, and it was completed as a WPA project in 1938 to serve as the St. Augustine Civic Center. It is now the St. Augustine Visitor Information Center. On the grounds is the large stone sphere known as the Zero Milestone Marker dedicated on April 2, 1929, to mark the beginning of the Old Spanish Trail, which extended to San Diego, California. Rather than being an actual trail used by the early Spaniards to travel from the Atlantic to the Pacific, it was a theme-based motoring route set up along existing roads including U.S. 90 in Florida.

[South on Castillo Drive]

27.) SAN MARCO AVENUE

Huguenot Cemetery. See the material relating to this cemetery contained in "The 1820s" section of this book.

[North on Castillo Drive, east on Shenandoah Street]

28.) 15 SHENANDOAH STREET

Castle Garden. This structure was built in 1887 as a stable, was later modified to be a residence and was converted to a bed-and-breakfast in 1990. It shows some Moorish elements and gable battlements similar to those of the adjacent Castle Warden. The name of the street is a misspelling of the name of General Peter Skenandoah Smith, who had moved to St. Augustine in 1838.

[East on Shenandoah Street, south on Water Street]

29.) 21 WATER STREET

Miramar. This two-story home constructed in 1905 of a combination of brick and wood was designed by Fred A. Henderich, who was known mostly for his St. Augustine bungalows. It was the home of General Walter N.P. Darrow, a director of the St. Augustine National Bank, and initially utilized several palm tree trunks as posts. They were replaced by other building materials in subsequent remodelings.

30.) 22 WATER STREET

Starke House. Built in about 1861, this was the home of army veteran Captain John W. Starke. During much of the Civil War, it served as a hospital, and then in 1873 it became the home of Starke's niece, Lucy Abbott. Over the years, the gabled roof was replaced by a hipped roof, an east wing was added with a pair of two-story porches and a three-story tower was removed. In 1953, it became the home of Frank Tart, St. Augustine's mayor from 1944 to 1945.

[North on Water Street]

31.) 23 WATER STREET

Cleland Mansion. This Queen Anne–style home was built in 1839 for John C. Cleland, the local district attorney. He established the North City Wharf Company, a steam sawmill and the North City Hotel. The home was initially known as the Beach Cottage and was a two-story, wood-frame building with a one-story porch, facing south. It was approximately the size of today's living room before the house was expanded to enclose the original structure. Several owners made additions to the home, including William Deering of the Deering Harvester Company, who bought the property in 1895.

[North on Water Street, west on Joiner Street]

32.) 19 JOINER STREET

Cleland House. This small frame vernacular home dating to about 1843 was built by partners John C. Cleland and William H. Simmons. The street is named for real estate developer Joshua Joyner.

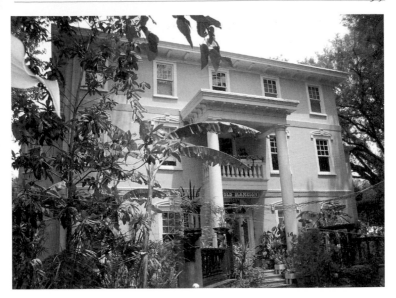

Old Mansion Inn
This stately old mansion was converted into apartments in 1966 and later was turned back into a single-family home. Some believe that it is haunted by the ghosts of real estate developer Lucy Abbott and a man in a sea captain's uniform. *Photo by Kelly Goodman.*

33.) 14 JOINER STREET
Old Mansion Inn. This three-story home was built in 1872 by Lucy Abbott of South Carolina, the last of about nine she built in the area. It has served as a boardinghouse, school, convalescent home, guesthouse, restaurant, studio, art gallery, apartments and offices. It was occupied by a family from 1922 until 1966, and in 1980 it was purchased by its current owners and refurbished as a bed-and-breakfast. Architecturally, it had a Second Empire style until 1921, at which time it was remodeled under the supervision of architect Fred A. Henderich as a Colonial Revival home by removing the mansard roof and replacing the open porch with a two-story portico.

[East on Joiner Street, north on Water Street]

34.) 33 WATER STREET
Perry House. In 1885, this two-story, wooden, Colonial Revival–style house was constructed for Union veteran Roscoe Perry, who had served in St. Augustine during the Civil War. He returned afterward and married Margarita Capo. A later owner was Dr. Adams Clark Walkup.

35.) 38 WATER STREET
Bagwell House. This Colonial Revival style–home, for a time the residence of Dr. Charles C. Bagwell, was built in approximately 1911.

36.) 42 WATER STREET

Abbott House. This is one of approximately nine homes constructed by Lucy Abbott, who moved from Charleston in 1860 and acquired a substantial amount of land. The houses were built between 1861 and 1894 and feature wood siding, porches and wood scroll trim. This house was built between 1872 and 1885.

37.) 47 WATER STREET

Boiling House. This frame vernacular structure began as a warehouse built between 1885 and 1894 by Henry A. Boiling. It was cut in half, moved back from the riverfront and remodeled.

38.) 51 WATER STREET

Rodenbaugh House. This home was built in 1924 for Harry N. Rodenbaugh, the vice-president of the Florida East Coast Railway. It is Mediterranean Revival in style and is constructed of brick and stucco. It is also known as the Sackett House.

39.) 70 WATER STREET

Hoffman House. This home was designed by Francis A. Hollingsworth in 1935 and covered with wood shingles. It was the home of J.W. Hoffman, who led the Model Land Company owned by Henry Flagler. During the 1940s, it was the home of Meredith Nicholson, the author of the 1905 book, *The House of a Thousand Candles*.

40.) 80 WATER STREET

Dismukes House. This Queen Anne–style house was built by contractor John B. Canfield in about 1890 for Confederate veteran John T. Dismukes, who founded the First National Bank of St. Augustine. It has turned wooden balusters, dental moldings and a tower and is the oldest St. Augustine house constructed of brick. After Dismukes, the house was occupied by Dr. J.N. Fogarty, who served as the Florida East Coast Railway's chief surgeon and as mayor of Key West and St. Augustine. Another owner was Judge George W. Jackson.

41.) 84 WATER STREET

Spanish Church. On the site of this 1890s home formerly sat a church, Nuestra Señora de la Leche. It was used to minister to the local Native Americans, and became a hospital while the British occupied the city.

[South on Water Street, west on Pine Street, north on San Marco Avenue to the beginning]

West St. Augustine

Site	Distance	Address
1	0.2	North end Depot Street
2	0.4	230 King Street
3	0.5	8–10 Madison Street
4	0.9	56 Spring Street
5	1.1	98 Evergreen Avenue
6	1.1	Evergreen Avenue
7	1.4	135 Rodriguez Street
8	1.5	271 King Street
9	1.6	254 King Street
10	2.2	41 Whitney Street
11	2.5	24 Anderson Street
12	2.9	16 Isabel Street
13	3.2	212 King Street
14	3.2	3, 5 & 7 Arenta Street
15	3.2	8 Arenta Street
	3.4	Depot Street

[From downtown, go west on King Street across the San Sebastian River, south on U.S. 1 and west on Everett Street to reach a starting point (you can park along the curb). Go east on Everett Street, north on U.S. 1 and west on King Street to Depot Street]

1.) NORTH END OF DEPOT STREET
Railroad Depot. The first railroad depot west of the San Sebastian River was built here in 1858. It served the St. Johns Railway, which received its charter on December 31, 1858. Access to the railroad right of way is now blocked by a masonry wall, and there is no evidence of the former depot.

[West on King Street to Leonardi Street]

2.) 230 KING STREET

Weidman Store. At this site in 1876, Alexander Weidman opened a grocery store. The one-story wood building with a hip roof was the first store in what was becoming known as the settlement of New Augustine. It has been replaced with a modern commercial structure.

[West on King Street to Madison Street]

3.) 8–10 MADISON STREET

New Augustine School. A two-story wooden building at the south end of this street served as the New Augustine School from 1905 to 1925. Because of the school, Madison Street was also known as School Street. The school was torn down after 2004.

[East on King Street, north on Palmer Street, west on Evergreen Avenue, north on Masters Drive, west on Julia Street, south to Spring Street]

4.) 56 SPRING STREET

Van House. This home, featuring curved Victorian porch brackets, is part of Ravenswood, a post–Civil War development with lots large enough to include orange groves. The property was initially offered for sale only to Northerners because the seller felt that Southerners were slovenly. Occupants of this home included John Van who worked on the Florida East Coast Railway, his wife Mattie and daughter Johnnie Mae Van. Both females were schoolteachers.

[South on Spring Street to Evergreen Avenue]

5.) 98 EVERGREEN AVENUE

Zion Baptist Church. This congregation was founded in 1886 by Reverend Charles Baker, and during his tenure its first sanctuary was erected. It was replaced by another structure in 1921, during the leadership of Reverend M.B. Britton Sr., and the masonry vernacular sanctuary was rebuilt again in 1948 while Reverend Edward Martin was the pastor.

[West on Evergreen Avenue]

6.) EVERGREEN AVENUE

Congregation Sons of Israel Cemetery. This Jewish cemetery was established for the St. Augustine congregation that now has its synagogue at 161 Cordova Street. This is the site where two Jewish peddlers were buried after they were killed by Native Americans during the 1840s. The oldest marked graves go back to 1911.

[West on Evergreen Avenue, south on Rodriguez Street]

7.) 135 RODRIGUEZ STREET

New St. James Baptist Church. St. James Baptist Church was organized on April 3, 1898, by Reverend S.S. Saunders and Deacon F.E. Mitchell. Its first sanctuary was rebuilt in 1914 by Reverends E.L. Harrell and V.A.B. Demps. It was renamed as St. James Missionary Baptist Church in 1966, renovated in 1985 and was rebuilt as New St. James Baptist Church in 1995.

[South on Rodriguez Street, east on King Street]

8.) 271 KING STREET

Shiloh Baptist Church. Reverend Whittaker organized Shiloh Baptist Church in 1929. A sanctuary was built at this site in 1937 under the leadership of Reverend E.F. Hankerson. G.H. Leapheart donated the land and L. Royster designed the building, which was rebuilt in 1992.

[East on King Street]

9.) 254 KING STREET

Water Treatment Plant. The older of this pair of brick structures dates to 1927, when the building took over for the previous water treatment plant located on San Marco Avenue.

[West on King Street, south on Whitney Street]

10.) 41 WHITNEY STREET

Davis House. This two-story, frame vernacular house was built during the 1890s for county commissioner Lawrence O. Davis. The front lot is bounded by a coquina block wall, perhaps dating back to the original construction of the house.

[South on Whitney Street, east on Anderson Street]

11.) 24 ANDERSON STREET

Vista del Rio. Kentuckian Major William Aiken began construction of this mansion in 1883 and planted rare plants and other crops on the surrounding thirteen acres. Initially, the frame home had wooden siding, but that has been covered by stucco. It is two and a half stories and the original two-story porch was reduced to a small entrance portico. A later owner of the house was Brigadier General Clifford R. Foster, Florida's adjutant general during the mid-1920s.

[West on Anderson Street, north on Dixie Highway, west on Isabel Street]

12.) 16 ISABEL STREET

Evelyn Hamblen Center. This structure was built in 1925 and was originally known as the West Augustine Grammar School. It was later called the

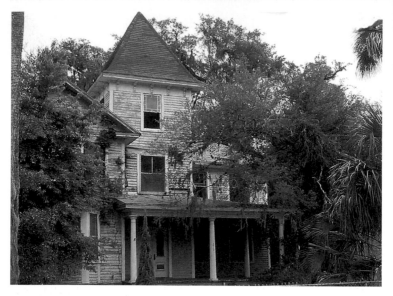

Clark-Worley House
Dr. Samuel Worley's Sanatorium, formerly located on the lot to the east of the present home, was torn down during the 1940s. The house was then converted into apartments. Unless a major renovation is soon undertaken, the house will likely suffer the same fate of the sanatorium and be turned into a vacant lot. *Photo by Kelly Goodman.*

West Augustine Elementary School, and it was renamed after teacher Evelyn Hamblen in 1957. It served as a school until 1990. Also known as the West Augustine School, the building exhibits a Mediterranean Revival style. It was designed by Francis A. Hollingsworth to replace the one-room building that had stood on Madison Street.

[East on Isabel Street, north on Dixie Highway and Leonardi Street, east on King Street]

13.) 212 KING STREET
Clark-Worley House. This two-story, Queen Anne–style house was built in 1882 for railroad man Francis Melvin Clark. After 1904, Dr. Samuel Gaines Worley bought it and added additional Queen Anne elements including a three-story tower. On the lot to the east, Worley operated the Worley Sanatorium with his son from 1914 until 1923.

[East on King Street, south on Arenta Street]

14.) 3, 5 AND 7 ARENTA STREET
Minnehaha, Hiawatha and Wahneta. These three frame vernacular homes with Native American names were built between 1904 and 1908.

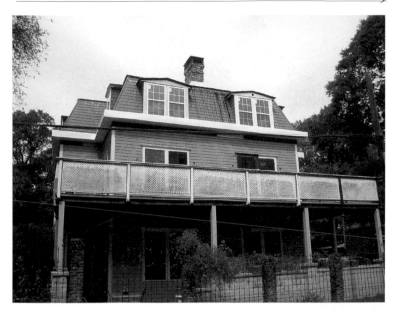

McLean House
This house is considered to have a Second Empire style, also known as a General Grant style, and features a double-pitched mansard roof. It is St. Augustine's last remaining original roof of this type. *Photo by Kelly Goodman.*

15.) 8 ARENTA STREET

McLean House. This home was built in 1886 for Reverend Charles C. McLean as a rental duplex. McLean was the pastor of Grace Methodist Church, and he was the man responsible for the division of the Florida Conference of the Methodist Episcopal Church along racial lines. During the twentieth century, occupants included the Barbour family and novelist June Moore Ferrell, who set the plot of her 1979 book *The House* in this structure. This is the city's last original mansard roof of this type.

[South on Arenta Street, east on Everett Street to the beginning]

Appendix A

NAME CHANGES TO SELECTED ST. AUGUSTINE STREETS

Present Name	Former Name(s)
Abbott Street	Washington Street
Anderson Circle	Hamblen Circle
Arenta Street	Worley Street
Artillery Lane	Fare Lane, Cross Street of the Hospital
Avenida Menendez	Bay Street
Aviles Street	Hospital Street
Bravo Lane	Edmiston Lane, Bosquet Lane
Bridge Street	Cunningham Lane, St. Joseph Street
Cadiz Street	Green Street, Garden Lane, Grogg Lane
Castillo Drive	Bay Street, Calle de la Marina, La Playa
Charlotte Place	Hernandez Place
Charlotte Street	La Calle de Los Mercaderes
Cordova Street	Tolomato Street, La Cienega
Cuna Street	Lane de la Saya, Las Naguask, Baker's Lane, Cradle Street, Partners Lane
DeHaven Street	St. John Street
Fort Alley	Hog Lane
Granada Street	Bronson Street
Hypolita Street	Calle Real, St. Patrick Street, Partner's Lane
King Street	Government House Lane (east of San Sebastian River), Picolata Road (to the west)
Kings Ferry Way	Ferry Way
Lovett Street	Cyprian Street

Marine Street	Broad Street, Street of the Barracks, St. Joseph Street, Juno Street, Sacrament Street
Martin Luther King Avenue	Central Avenue
Osceola Street	Orange Street
Park Place	Venancio Place, St. Francis Place
San Marco Avenue	Mil y Quinientas, Shell Road, Public Road to Jacksonville
Sevilla Street	Oleander Street
Spanish Street	St. Hypolita Street, Dragoon Street, Street of the Dragoon Barracks
St. Francis Street	Convent Lane, Barracks Street, Royal Road
Treasury Street	Paniagua Lane
Tremerton Place	Hernandez Place
Valencia Street	Alameda Street
Water Street	Cleland Street

Appendix B

HISTORIC SITES INDEXED BY STREET ADDRESSES

For each entry below, the first number is the post office street address; the letters refer to the historical walking tour (**A**nastasia **I**sland, **A**ncient **C**ity, **Li**ncolnville, **N**orth **C**ity and **W**est St. **A**ugustine); and the final item is the site number (numbered consecutively for each tour).

Anastasia Boulevard
999 AI 17

Anderson Circle
1 AC 105

Anderson Street
24 WA 11

Arenta Street
3 WA 14
5 WA 14
7 WA 14
8 WA 15

Arpieka Avenue
12 AI 22

Artillery Lane
4 AC 207

Avenida Menendez
8 AC 97
12 AC 98
22 AC 99
24 AC 100
32 AC 101
42 AC 102
44 AC 103
46 AC 104
111 AC 191
118 AC 192
142 AC 190
146 AC 189
172 AC 188
174 AC 187

Aviles Street
3 AC 208
12 AC 209
20 AC 196
21 AC 195
32 AC 176
33 AC 175
36 AC 174

Bay View Drive

16	NC	10
52	NC	9
54	NC	8
63	NC	7

Bernard Street

15½	NC	18
28½	NC	19

Bridge Street

7	AC	180
15	AC	179
74	Li	5
79	Li	4
84	Li	3
89	Li	2
115	Li	1

Cadiz Street

11	AC	194

Carrera Street

8	AC	56
9	AC	55
30	AC	52
50	AC	39
52	AC	40
67	AC	41
71	AC	41

Castillo Drive

1S	AC	67
10	NC	26

Cathedral Place

24–28	AC	3
36	AC	4
38	AC	5

Cedar Street

79	AC	132
83	AC	131
87	AC	130
89	AC	129

Charlotte Street

12	AC	95
20	AC	195
26	AC	96
52	AC	13
56½	AC	12
58	AC	11
80–92	AC	10
110	AC	103
124	AC	2
206	AC	210
257	AC	159
267	AC	160
271	AC	161

Cincinnati Avenue

17	NC	20
24	NC	21

Comares Avenue

57	AI	2

Cordova Street

7	AC	62
20	AC	61
26	AC	59
30	AC	58
95–99	AC	203
115	AC	202
123	AC	201
154	AC	135
161	AC	136
172–80	AC	137

Cuna Street

17	AC	94
25	AC	93
26	AC	92
27	AC	91
29	AC	90
70	AC	57

Depot Street

N end	WA	1

Dolphin Drive

77	AI	20

Evergreen Avenue

98	WA	5
—	WA	6

Granada Street

12	AC	133
32	AC	134

Hypolita Street

35	AC	15
59	AC	28
70	AC	29

Isabel Street

16	WA	12

Joiner Street

14	NC	33
19	NC	32

King Street

E end	AC	1
1	AC	106
11	AC	107
17	AC	108
31	AC	109
41	AC	110
48	AC	111
74	AC	112
75	AC	113
81C	AC	114
83	AC	115
93½	AC	116
99	AC	117
102	AC	118
105	AC	119
120	AC	120
124	AC	122
136	AC	123
157	AC	125
212	WA	13
230	WA	2
254	WA	9
271	WA	8

Kings Ferry Way

119	Li	15
121	Li	15

Lighthouse Avenue

5	AI	10
7	AI	9
8	AI	8
10	AI	7
60	AI	13
62	AI	14
74	AI	15
81	AI	16

Lovett Street

37	Li	16

Madison Street

8–10	WA	3

Magnolia Avenue

11	NC	2

Magnolia Drive

35	AI	5
37	AI	4

Malaga Street

1	AC	124

Marine Street

16	AC	192
22	AC	193
35	AC	178
38	AC	177
46	AC	181
47	AC	182
53	AC	183
56	AC	184
59	AC	185
67	AC	186
82	AC	155
86–92	AC	154
97	AC	153
101	AC	152
104	AC	151
105	AC	150

124	AC	149
159	AC	145
180	AC	146

Martin Luther King Avenue

9	AC	128
82	Li	26
85	Li	25
86	Li	24
100	Li	12
102	Li	14
156	Li	17
160	Li	18

May Street

16	NC	4

Minorca Avenue

307	AI	24

Montrano Avenue

10	AI	23

Mulvey Street

16	AC	45

Nelmar Avenue

24	NC	5

Ocean Avenue

27	NC	1

Oglethorpe Boulevard

—	AI	1
107	AI	21

Old Mission Avenue

33	NC	16

Old Quarry Road

400	AI	18
404	AI	19

Oneida Street

175	Li	20
187	Li	21

Orange Street

61	AC	48
63	AC	47
67	AC	46

Palm Row

1	AC	199
3-4	AC	200
7	AC	201

Ponce de León Avenue

5	AI	11
15	AI	12

Riberia Street

16	AC	44
24	AC	66
31	AC	65
40	AC	63
47	AC	64
55	AC	38
77	AC	121
88	AC	126
122	AC	127
222	Li	23

Rodriguez Street

135	WA	7

St. Francis Street

14	AC	156
18	AC	157
22	AC	158
25	AC	162
28	AC	163
31	AC	164
34	AC	165
91	Li	27

San Marco Avenue

—	NC	27
19	NC	25
39	NC	24
47	NC	23
50	NC	22
102	NC	17
167	NC	3

Toques Place
26	AC	14

Treasury Street
35	AC	4
57	AC	9
143	AC	8

Tremerton Street
4	AC	147
5	AC	148

Twine Street
163	Li	22

Valencia Street
6	AC	31
8	AC	32
20	AC	33
35	AC	37
36	AC	36

Waldo Street
7	NC	11

Washington Street
69	Li	6
70	Li	7

83	Li	8
87	Li	9
92	Li	10
93	Li	11
100	Li	12

Water Street
21	NC	29
22	NC	30
23	NC	31
33	NC	34
38	NC	35
42	NC	36
47	NC	37
51	NC	38
70	NC	39
80	NC	41

White Street
37E	AI	3
46E	AI	6

Whitney Street
41	WA	10

Bibliography

Adams, William R., and Carl Shriver. *The St. Augustine Alligator Farm: A Centennial History*. St. Augustine, FL: Southern Heritage Press, 1993.

Adams, William R., Daniel L. Schafer, Robert Steinbach and Paul L. Weaver. *The King's Road: Florida's First Highway*. St. Augustine, FL: Historic Property Associates, Inc., 1997.

Adams, William R., and Paul L. Weaver. *Historic Places of St. Augustine and St. Johns County: A Visitor's Guide*. St. Augustine, FL: Southern Heritage Press, 1993.

Arana, Luis Rafael, and Albert C. Manucy. *The Building of Castillo de San Marcos*. Washington, D.C.: Eastern National Park & Monument Association, 1977.

Arnade, Charles W. *The Siege of St. Augustine in 1702*. Gainesville: University of Florida Press, 1959.

Baker, Robert J., ed. *Historic Catholic Sites of St. Augustine: A Walking Tour*. St. Augustine, FL: Cathedral-Basilica Bell Tower Religious Shop, 1988.

Bloomfield, Max. *Bloomfield's Illustrated Historical Guide, Embracing an Account of the Antiquities of St. Augustine, Florida*. St. Augustine, FL: Max Bloomfield, 1885.

Brooke, Steven. *The Majesty of St. Augustine*. Gretna, LA: Pelican Publishing Company, Inc., 2005.

Brown, Warren J. *Florida's Aviation History: The First One Hundred Years*. Largo, FL: Aero-Medical Consultants, Inc., 1994.

Carlson, Charlie. *Weird Florida: Your Travel Guide to Florida's Local Legends and Best Kept Secrets*. New York: Barnes & Noble Books, 2005.

The Cathedral-Basilica of St. Augustine and Its History. St. Augustine, FL: Cathedral-Basilica Bell Tower Religious Shop, 1987.

Daughters of the American Revolution. *The Pioneer Churches of Florida*. Chuluota, FL: Mickler's, 1976.

Deagan, Kathleen A. *Archaeology at the National Greek Orthodox Shrine, St. Augustine, Florida: Microchange in Eighteenth-Century Spanish Colonial Material Culture*. Gainesville: University Presses of Florida, 1976.

Deagan, Kathleen, and Darcie McMahon. *Fort Mose: Colonial America's Black Fortress of Freedom.* Gainesville: University Press of Florida, 1995.

DeCoste, Fredrik. *True Tales of Old St. Augustine.* St. Petersburg, FL: Great Outdoors Publishing Company, 1966.

Dewhurst, William W. *The History of Saint Augustine, Florida.* Rutland, VT: Academy Books, 1969 reprint of the 1885 edition.

Doggett, Carita. *Dr. Andrew Turnbull and the New Smyrna Colony of Florida.* St. Petersburg, FL: Great Outdoors Publishing Company, 1967.

Dunn, Hampton. *Historic Florida Courthouses.* Gloucester Point, VA: Hallmark Publishing Company, Inc., 1998.

Edwards, Virginia. *Stories of Old St. Augustine.* St. Augustine, FL: C.F. Hamblen, Inc., 1973.

Fairbanks, George Rainsford. *The History and Antiquities of the City of St. Augustine, Florida: A Facsimile Reproduction of the 1858 Edition, With an Introduction and Index by Michael V. Gannon.* Gainesville: University Presses of Florida, 1975.

Flagler Hospital: "A Gift for Life." St. Augustine, FL: Townet Press, 2001.

Florida Department of Military Affairs. *St. Augustine National Cemetery Index and Biographical Guide.* St. Augustine, FL: State Arsenal, 1990.

———. *St. Francis Barracks History 1578–1962, Post Commanders 1878–1900.* St. Augustine, FL: State Arsenal, 1988.

———. *Tovar House Museum Project.* St. Augustine, FL: State Arsenal, 1991.

Florida East Coast Railway. *List of Hotels and General Information Concerning the Famous Winter Resort Section of America.* Buffalo, NY: Florida East Coast Railway, 1905.

———. *The Story of a Pioneer: A Brief History of the Florida East Coast Railway and Its Part in the Remarkable Development of the Florida East Coast.* St. Augustine, FL: Florida East Coast Railway, 1946.

Fretwell, Jacqueline K., and Susan R. Parker, eds. *Clash Between Cultures: Spanish East Florida, 1784–1821.* St. Augustine, FL: St. Augustine Historical Society, 1988.

Gannon, Michael V. *The Cross in the Sand: The Early Catholic Church in Florida 1513–1870.* Gainesville: University of Florida Press, 1965.

Garrow, David J., ed. *St. Augustine, Florida, 1963–1964: Mass Protest and Racial Violence.* Brooklyn, NY: Carlson Publishing, Inc., 1989.

Graham, Thomas. *Awakening of St. Augustine: The Anderson Family and the Oldest City, 1821–1924.* St. Augustine, FL: St. Augustine Historical Society, 1978.

———. *Flagler's Magnificent Hotel Ponce de León.* St. Augustine, FL: Thomas Graham, 1975.

———. *Flagler's St. Augustine Hotels: The Ponce de León, the Alcazar and the Casa Monica.* Sarasota, FL: Pineapple Press, Inc., 2004.

Griffin, Patricia C. *Mullet on the Beach: The Minorcans of Florida 1768–1788.* Jacksonville, FL: St. Augustine Historical Society, 1991.

Hall, Maggi Smith. *Flavors of St. Augustine: An Historic Cookbook.* Lake Buena Vista, FL: Tailored Tours Publications, Inc., 1999.

Harman, Joyce Elizabeth. *Trade and Privateering in Spanish Florida, 1732–1763.* St. Augustine, FL: St. Augustine Historical Society, 1969.

Harvey, Karen G. *America's First City: St. Augustine's Historic Neighborhoods.* Lake Buena Vista, FL: Tailored Tours Publications, Inc., 1997.

———. *Daring Daughters: St. Augustine's Feisty Females 1565–2000.* Virginia Beach, VA: Donning Company, 2002.

———. *Legends and Tales: Anecdotal Histories of St. Augustine, Florida.* Charleston, SC: The History Press, 2005.

———. *St. Augustine and St. Johns County: A Pictorial History.* Virginia Beach, VA: Donning Co., 1979.

Hirsch, Beverly, ed. *The Evelyn Hamblen Center Historical Scrapbook.* St. Augustine, FL: St. Johns County School District, 1999.

Jenkins, Greg. *Florida's Ghostly Legends and Haunted Folklore, Volume 2: North Florida and St. Augustine.* Sarasota, FL: Pineapple Press, Inc., 2005.

Johnston, Sidney P. *Historic Properties Survey: St. Johns County, Florida.* Jacksonville, FL: Environmental Services, Inc., 2001.

Kapitzke, Robert L. *Religion, Power and Politics in Colonial St. Augustine.* Gainesville: University Press of Florida, 2001.

Kite-Powell, Rodney. "In Search of David Paul Davis." Master's thesis, University of South Florida, 2003.

Lapham, Dave. *Ancient City Hauntings: More Ghosts of St. Augustine.* Sarasota, FL: Pineapple Press, Inc., 2004.

———. *Ghosts of St. Augustine.* Sarasota, FL: Pineapple Press, Inc., 1997.

Lawson, Edward W. *The Saint Augustine Historical Society and Its "Oldest House," a Documented Study of Fabricated History.* St. Augustine, FL: Edward W. Lawson, 1957.

Mann, F.A. *Story of the Huguenots: The French in Florida History.* Ormond Beach, FL: Camelot Publishing Company, 2003 reprint of the 1912 edition.

Manucy, Albert, ed. *The History of Castillo de San Marcos & Fort Matanzas: From Contemporary Narratives and Letters.* Washington, D.C.: U.S. Department of the Interior, 1955.

———. *The Houses of St. Augustine 1565–1821.* St. Augustine, FL: St. Augustine Historical Society, 1978.

———. *Menéndez: Pedro Menéndez de Avilés, Captain General of the Ocean Sea.* Sarasota, FL: Pineapple Press, Inc., 1992.

———. *Sixteenth-Century St. Augustine: The People and Their Homes.* Gainesville: University Press of Florida, 1997.

McCarthy, Kevin M. *Aviation in Florida.* Sarasota, FL: Pineapple Press, Inc., 2003.

Mitchell, Florence S. *A History of the Huguenot Cemetery 1821–1884, St. Augustine, Florida.* St. Augustine, FL: Friends of the Huguenot Cemetery, Inc., 1998.

Moore, Joyce Elson. *Haunt Hunter's Guide to Florida*. Sarasota, FL: Pineapple Press, Inc., 1998.

Morton, Henry Jackson. *St. Augustine, 1867*. St. Augustine, FL: St. Augustine Historical Society, 1996.

National Society of the Colonial Dames of America. *Turn Left at the Plaza: A History and Tour Guide of St. Augustine and Coastal Northeast Florida*. Jacksonville, FL: Miller Press, 1976.

Nolan, David. *The Houses of St. Augustine*. Sarasota, FL: Pineapple Press, Inc., 1995.

Owen, Lorrie K. *Dictionary of Florida Historic Places*. St. Clair Shores, MI: Somerset Publishers, Inc., 1999.

Page, David P., ed. *Peregrini pro Christo: An Illustrated Account of the Irish Missionary in the Diocese of St. Augustine, Florida*. St. Augustine, FL: Florida Catholic, 1967.

Panagopoulos, E.P. *New Smyrna: An Eighteenth Century Greek Odyssey*. Gainesville: University of Florida Press, 1966.

Pettingill, George W., Jr. *The Story of the Florida Railroads 1834–1903*. Boston, MA: Railway & Locomotive Historical Society, Inc., 1952.

Powell, Nancy, and Jim Mast. *Bloody Sunset in St. Augustine*. East Palatka, FL: Federal Point Publishing, Inc., 1998.

Quinn, Jane. *Minorcans in Florida: Their History and Heritage*. St. Augustine, FL: Mission Press, 1975.

Rasico, Philip D. *The Minorcans of Florida: Their History, Language and Culture*. New Smyrna Beach, FL: Luthers, 1990.

Redding, David A. *Flagler and His Church*. Jacksonville, FL: Paramount Press, Inc., 1970.

Reeves, F. Blair, ed. *A Guide to Florida's Historic Architecture*. Gainesville: University Presses of Florida, 1989.

Reynolds, Charles B. *Old Saint Augustine: A Story of Three Centuries*. St. Augustine, FL: E.H. Reynolds, 1893.

———. *"The Oldest House in the United States," St. Augustine, Florida: An Examination of the St. Augustine Historical Society's Claim That Its House on St. Francis Street Was Built in the Year 1565 by the Franciscan Monks*. New York: Foster & Reynolds Company, 1921.

———. *The Standard Guide to St. Augustine*. St. Augustine, FL: Historic Print & Map Company, 2004 reprint of 1892 edition.

Ripoll, Carlos. *St. Augustine and Cuba: The Monument to the 1812 Spanish Constitution*. New York: Editorial Dos Rios, 2002.

Ryan, William P. *The Search for Old King's Road: The First Route Into Florida*. Flagler County, FL: William P. Ryan, 2006.

Sewall, R.K. *Sketches of St. Augustine: A Facsimile Reproduction of the 1848 Edition with an Introduction and Index by Thomas Graham*. Gainesville: University Presses of Florida, 1976.

Shedden, David. *Florida Newspaper Chronology 1783–2000*. St. Petersburg, FL: Poynter Institute, 2001.

Solís de Merás, Gonzalo. *Pedro Menéndez de Avilés: Memorial*. Gainesville: University of Florida Press, 1964.

Speissegger, R.A. *Early History of New Augustine.* St. Augustine, FL: R.A. Speissegger, 1948.

Spencer, Donald D. *Florida's Historic Forts, Camps and Battlefields: A Pictorial Encyclopedia.* Ormond Beach, FL: Camelot Publishing Company, 2006.

————. *St. Augustine: A Picture Postcard History.* Ormond Beach, FL: Camelot Publishing Company, 2002.

Spornick, Charles D., Alan R. Cattier and Robert J. Greene. *An Outdoor Guide to Bartram's Travels.* Athens: University of Georgia Press, 2003.

Stewart, Laura and Susane Hupp. *Florida Historic Homes.* Orlando, FL: Sentinel Communications Company, 1988.

Stone, Elaine Murray. *Pedro Menéndez de Avilés and the Founding of St. Augustine.* New York: P.J. Kennedy & Sons, 1969.

Strode, William, and William Butler, eds. *Flagler College: Twenty-five Years of Progress & Achievement.* Prospect, KY: Harmony House Publishers, 1994.

Tanner, Helen Hornbeck. *Zéspedes In East Flrorida 1784–1790.* Coral Gables, FL: University of Miami Press, 1963.

Tellier, Mark. *St. Augustine's Pictures of the Past.* St. Augustine, FL: Mark J. Tellier, 1979.

TePaske, John Jay. *The Governorship of Spanish Florida 1700–1763.* Durham, NC: Duke University Press, 1964.

Topping, Aileen Moore. *An Impartial Account of the Late Expedition Against St. Augustine Under General Oglethorpe: A Facsimile Reproduction of the 1742 Edition With an Introduction and Indexes.* Gainesville: University Presses of Florida, 1978.

Van Campen, J.T. *The Story of St. Augustine: Florida's Colonial Capital.* St. Augustine, FL: St. Augustine Historical Society, 1959.

Vignoles, Charles. *Observations Upon the Floridas.* Gainesville: University Presses of Florida, 1977 reprint of the 1823 edition.

Vollbrecht, John L. *St. Augustine's Historical Heritage as Seen Today: With Historical Notes on the Oldest House.* St. Augustine, FL: J. Carver Harris, 1952.

Waterbury, Jean Parker. *Markland.* St. Augustine, FL: St. Augustine Historical Society, 1989.

————. *The Oldest City: St. Augustine Saga of Survival.* St. Augustine, FL: St. Augustine Historical Society, 1983.

————. *"The Oldest House" Its Site and Its Occupants 1650 (?) to the Present.* St. Augustine, FL: St. Augustine Historical Society, 1988.

————. *The Treasurer's House.* St. Augustine, FL: St. Augustine Historical Society, 1994.

Wessels, William L. *Born to Be a Soldier: The Military Career of William Wing Loring of St. Augustine, Florida.* Fort Worth: Texas Christian University Press, 1971.

Wickham, Joan. *St. Augustine, Florida 1565–1965.* Worcester, MA: Achille J. St. Onge, 1967.

Wright, J. Leitch. *British St. Augustine.* St. Augustine, FL: Historic St. Augustine Preservation Board, 1975.

Wyllie, H.S. *St. Augustine Under Three Flags, In Black and White.* St. Augustine, FL: Record Co., 1898.

Index

About the Authors

S teve Rajtar grew up near Cleveland, Ohio, came to Florida to go to college, earned degrees in mathematics, anthropology, law and taxation and decided to stay. He's been involved with the Boy Scouts for thirty years and is an activity leader with the Florida Trail Association. He has ties with local central Florida history through his wife's family, who arrived in Orlando in 1908. The combination of a love of the outdoors and local history has resulted in his establishment of over 150 historical tour routes through the communities of central Florida, which can be used by anyone to get "up close and personal" with the region's historic sites. He has written several books on various aspects of hiking and history and loves to guide tours by foot, bicycle and kayak.

K elly Goodman, Steve's daughter, is an Orlando native who spent much of her childhood in the central Florida outdoors. She was active in Scouting and similar programs and developed a love of local history and culture. A graduate of the University of Central Florida with a degree in psychology, this is Kelly's first foray into the literary world, as well as her first collaboration with her dad. Together with her husband, Will, she also recently experienced another first, with the birth of their first child, Nathaniel, on July 26, 2007.

Photo by Will Goodman.

Visit us at
www.historypress.net